Digital Photography
Top 100
4th Edition

Simplified®

TIPS & TRICKS

by Rob Sheppard

Visual

WILEY

Digital Photography: Top 100 Simplified® Tips & Tricks, 4th Edition

Published by
Wiley Publishing, Inc.
10475 Crosspoint Boulevard
Indianapolis, IN 46256
www.wiley.com

Published simultaneously in Canada

Copyright © 2010 by Wiley Publishing, Inc., Indianapolis, Indiana

Library of Congress Control Number: 2010923568

ISBN: 978-0-470-59710-1

Manufactured in the United States of America

10 9 8 7 6 5 4 3 2 1

Trademark Acknowledgments

Contact Us

For general information on our other products and services contact our Customer Care Department within the U.S. at 877-762-2974, outside the U.S. at 317-572-3993 or fax 317-572-4002.

For technical support please visit www.wiley.com/techsupport.

Wiley Publishing, Inc.

U.S. Sales

Contact Wiley at
(877) 762-2974 or
fax (317) 572-4002.

CREDITS

Executive Editor
Jody Lefevere

Sr. Project Editor
Sarah Hellert

Technical Editor
Michael Guncheon

Copy Editor
Scott Tullis

Editorial Director
Robyn Siesky

Business Manager
Amy Knies

Sr. Marketing Manager
Sandy Smith

Vice President and Executive Group Publisher
Richard Swadley

Vice President and Executive Publisher
Barry Pruett

Sr. Project Coordinator
Kristie Rees

Graphics and Production Specialists
Joyce Haughey
Andrea Hornberger

Quality Control Technician
Rebecca Denoncour

Proofreader
Penny Stuart

Indexer
Potomac Indexing, LLC

Screen Artists
Ana Carrillo
Jill A. Proll
Ron Terry

ABOUT THE AUTHOR

Rob Sheppard is the author/photographer of over 30 photography books, a well-known speaker and workshop leader, and is editor-at-large for the prestigious *Outdoor Photographer* magazine. As author/photographer, Sheppard has written hundreds of articles about digital photography, plus books ranging from guides to photography such as the *Magic of Digital Nature Photography* and the *National Geographic Field Guide to Digital Photography* to books about Photoshop and Lightroom including *Adobe Photoshop Lightroom 2 for Digital Photographers Only* and *Photoshop Elements 8: Top 100 Simplified Tips & Tricks*. His Web site is at www.robsheppardphoto.com and his blog is at www.photodigitary.com.

HOW TO USE THIS BOOK

Who This Book Is For

This book is for readers who know the basics and want to expand their knowledge of this particular technology or software application.

The Conventions in This Book

❶ Steps

This book uses a step-by-step format to guide you easily through each task. Numbered steps are actions you must do; bulleted steps clarify a point, step, or optional feature; and indented steps give you the result.

❷ Notes

Notes give additional information — special conditions that may occur during an operation, a situation that you want to avoid, or a cross reference to a related area of the book.

❸ Icons and Buttons

Icons and buttons show you exactly what you need to click to perform a step.

❹ Tips

Tips offer additional information, including warnings and shortcuts.

❺ Bold

Bold type shows text or numbers you must type.

❻ Italics

Italic type introduces and defines a new term.

❼ Difficulty Levels

For quick reference, these symbols mark the difficulty level of each task.

DIFFICULTY LEVEL	
▭	Demonstrates a new spin on a common task
▭	Introduces a new skill or a new task
▭	Combines multiple skills requiring in-depth knowledge
▭	Requires extensive skill and may involve other technologies

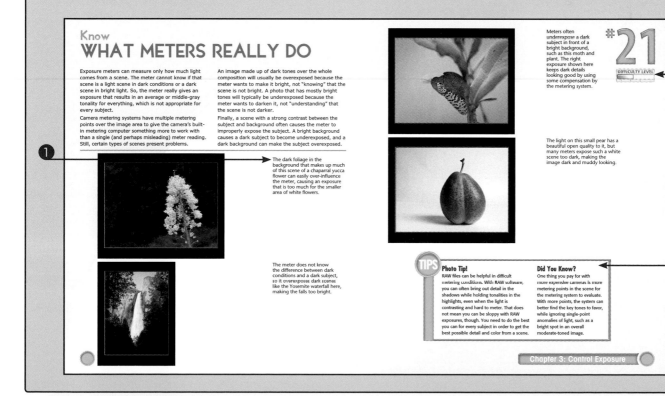

Know
WHAT METERS REALLY DO

Exposure meters can measure only how much light comes from a scene. The meter cannot know if that scene is a light scene in dark conditions or a dark scene in bright light. So, the meter really gives an exposure that results in an average or middle-gray tonality for everything, which is not appropriate for every subject.

Camera metering systems have multiple metering points over the image area to give the camera's built-in metering computer something more to work with than a single (and perhaps misleading) meter reading. Still, certain types of scenes present problems.

An image made up of dark tones over the whole composition will usually be overexposed because the meter wants to make it bright, not "knowing" that the scene is not bright. A photo that has mostly bright tones will typically be underexposed because the meter wants to darken it, not "understanding" that the scene is not darker.

Finally, a scene with a strong contrast between the subject and background often causes the meter to improperly expose the subject. A bright background causes a dark subject to become underexposed, and a dark background can make the subject overexposed.

❶ The dark foliage in the background that makes up much of this scene of a chaparral yucca flower can easily over-influence the meter, causing an exposure that is too much for the smaller area of white flowers.

The meter does not know the difference between dark conditions and a dark subject, so it overexposes dark scenes like the Yosemite waterfall here, making the falls too bright.

Meters often underexpose a dark subject in front of a bright background, such as this moth and plant. The right exposure shown here keeps dark details looking good by using some compensation by the metering system.

#21

DIFFICULTY LEVEL ❼

The light on this small pear has a beautiful open quality to it, but many meters expose such a white scene too dark, making the image dark and muddy looking.

TIPS

Photo Tip!
RAW files can be helpful in difficult metering conditions. With RAW software, you can often bring out detail in the shadows while holding tonalities in the highlights, even when the light is contrasting and hard to meter. That does not mean you can be sloppy with RAW exposures, though. You need to do the best you can for every subject in order to get the best possible detail and color from a scene.

Did You Know? ❹
One thing you pay for with more expensive cameras is more metering points in the scene for the metering system to evaluate. With more points, the system can better find the key tones to favor, while ignoring single-point anomalies of light, such as a bright spot in an overall moderate-toned image.

Chapter 3: Control Exposure

Table of Contents

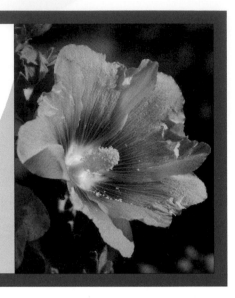

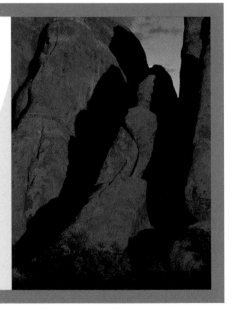

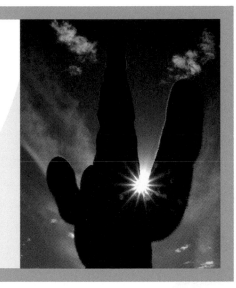

③ Control Exposure

④ Control Sharpness and Depth of Field

Table of Contents

6 Try Creative Photo Techniques

7 Organize Photos with Photoshop Elements

8 Basic Image Workflow with Photoshop Elements

Table of Contents

 Share Your Photos

Get Ready to Take Photos

Digital photography is a lot of fun. Because you can see your images as soon as you take the picture, anyone can take better pictures right from the start. You know immediately if you got the shot or not.

To get consistently better photos, it helps to get both you and your camera ready for taking pictures. Most people know that focusing the camera is important, but in many ways, it can be just as important to focus the photographer.

Choosing what and where to shoot is the first step that you must take before shooting. Read local newspapers, check out travel books, or browse online resources to find out what is happening in your area. You can find great photo opportunities at local fairs, botanical gardens, nature preserves, national parks, or even zoos; and when outside shooting is difficult, consider shooting indoors where

conditions are controlled. A digital camera allows much more flexibility for indoor shooting than film ever did.

The more you know about your equipment, the more you can concentrate on getting the photographs that you want and not on learning how to use your camera. Open up the camera manual and spend time with it and your camera so that you know what controls are available and how to use them.

When you go to shoot, you will be more satisfied if you are realistic; a day of shooting does not always result in lots of good photos. All photographers have bad days that end up with only mediocre photos — especially when the shooting conditions work against you! Enjoy the experience of having fun with digital photography and learn from it.

Select good
PHOTO OPPORTUNITIES

You are going to find that the best photo opportunities for any photographer are those subjects that you enjoy. Why not photograph those things you have an affinity for? If you enjoy gardening and appreciate the thousands of different variations of iris, shoot irises; or if you are a people-watcher and find pleasure in observing folks in action, choose places where you can find active people in settings that make great photographs.

When planning a trip, give yourself plenty of time to stay and take photographs. Allow yourself some flex time to compensate for bad weather or other shooting conditions that might prevent you from photographing. You might spend an entire day or more at a location, but the light never really becomes good enough to shoot. Avoid the scheduling trap of trying to see too much too quickly. You may miss the kinds of shots that you had hoped to capture because you saw everything, but shot little. Photography takes time, and time is often the most important factor in capturing truly great photographs.

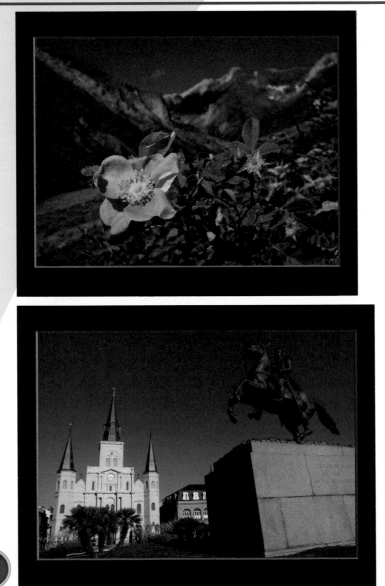

When shooting well-photographed places such as western mountains like the Eastern Sierras in California, take the traditional shot and then shoot creatively, too.

Being patient can pay off with the right light. The famous square in front of the St. Louis Cathedral in New Orleans needs early morning light to look its best.

People are easiest to photograph when they are involved in activities that keep their attention away from the camera.

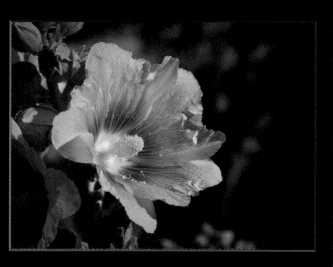

Gardens offer terrific opportunities for interesting and colorful close-up images, such as this shot of a hollyhock blossom in early morning light.

TIPS

Photo Tip!

When you find a good place to take photographs, visit it again and again. Your images will improve each time that you return because you will learn the best times and subjects for photos.

Did You Know?

Some of the best photo opportunities may be in your own backyard. Explore details, shapes, or colors that might make good photographs and give them a try. A digital camera's LCD review helps you refine your shots.

Photo Tip!

Use the Internet to learn where and when to shoot. Many online guides and forums provide all the information you need to find wonderful places and subjects to shoot that will suit your interests.

It starts with
FOUR LETTERS

Most photo enthusiasts have mixed feelings about the digital part of photography. Many of them enjoy the advantages of digital cameras, but they feel uncomfortable with computers. They often think that all this digital stuff adds a layer of complexity that can be difficult, so much so that it can prevent them from getting the most from new technology. By keeping in mind the letters *I*, *C*, *A*, and *N*, you can overcome any apprehension you may have about shooting digital photos.

I, *C*, *A*, and *N* represent possibility and potential. Put them together and you get "I can," banishing the thought, "I can't." There is no question that a lot of photographers get stopped by some of the new digital tools and throw up their hands saying, "I can't do this."

Everyone from teenagers to octogenarians can learn digital photography and love its possibilities. "I can" does not mean that you can do everything right away. After all, no serious photographer understood everything about a film camera without some study and practice. You might not know it all right away, and you might still be working on learning the technology, but with practice, you will be able to accomplish great things with your digital camera and the computer!

From your family to exotic foreign locations, possibilities for great photos are everywhere. A lot of your success depends on your ability to silence the self-critic and say, "I can do this!" for your photography. At left, an intimate portrait of brother and sister shot to emphasize the close relationship of the two people.

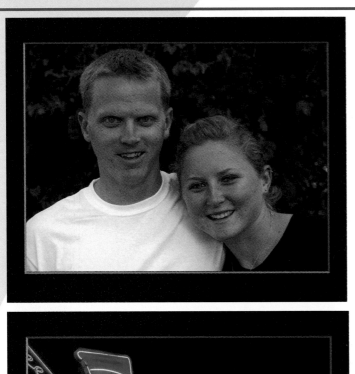

Travel gives you wonderful chances for new subjects, but remember that in popular locations like this in Las Vegas, Nevada, a lot of photographers have already taken pictures of striking lights. Just taking an attitude of "I can find something different here" can lead to new and interesting compositions.

Once you believe in possibilities, you can find good photographs almost anywhere. I like to keep a small digital camera with me wherever I go so I can capture whatever catches my eye, no matter what the location.

Working with layers in an image-editing program intimidates a lot of photographers. It looks so alien to photography that "I can't" escapes and runs amuck in their heads. That does not have to be the case. You might not understand layers yet, but you will discover how useful they are so you will say, "I can do layers."

TIPS

Photo Tip!

When you know that you will share a photo online, you do not need a high image resolution. Try cropping a detail from a large image before you resize it for the Web. A small bird in a mostly blue-sky print can become a large bird that fills the frame when it is cropped for the Web. To learn more about cropping, see task #69.

Did You Know?

Adjustment layers in Photoshop Elements allow image adjustments that can be readjusted as many times as needed with no effect on image quality. They offer you flexibility and a lot of power to change your image, plus they are a good way to get started using layers. See task #80 to begin working with layers.

MASTER YOUR CAMERA
to get great photos

To consistently produce the best photos with your digital camera, learn all that you can about it. Today's sophisticated digital cameras are amazing. Even pocket point-and-shoot cameras enable you to take excellent photographs with their superb automatic features and high sensor and lens quality. However, most digital cameras offer many additional features worth learning so that you gain important creative control over how photos are taken and ensure that you get exactly what you want.

One of the best features of all digital cameras is the LCD screen that lets you review the image and camera settings immediately after taking the photo. This enables you to check that you have composed the photo as you want and that the camera settings were set as you expected. Some cameras even include a swivel or rotating LCD for more versatility. Many digital cameras even provide a histogram to give you a visual impression of the exposure. These review features encourage you to make adjustments while you are still there with your subject.

You have made an investment in purchasing a digital camera. Although you do not have to know everything about it in order to use it well, the more controls you master on your camera, the better the return on your investment.

The instant review LCD monitor on a digital camera gives every photographer the chance to check the shot. This lets everyone become a better photographer because camera controls can be adjusted, and then the results immediately seen on the LCD.

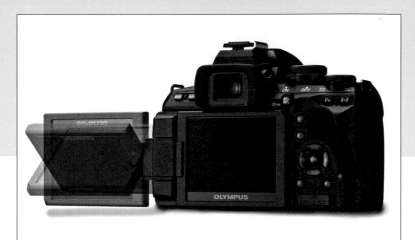

Digital cameras house a lot of great technology that works in the photographer's favor. A rotating LCD can be a great help in composing your picture when the camera must be held low or high.

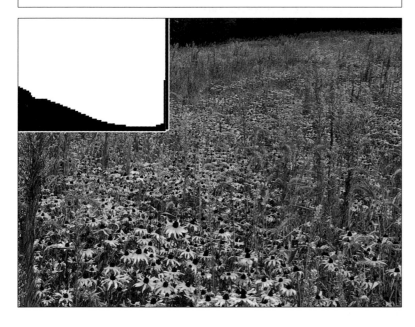

Advanced compact digital cameras and digital SLRs can display a histogram with the image on the LCD. You can get consistently better exposures if you learn to read a histogram (see task #25).

TIPS

Did You Know?

The more you learn about and use different features on your camera, the more possibilities you have for creative control. However, sooner or later you may forget what settings you have changed and shoot using the wrong settings. Use your camera's LCD review to make a quick check of things like exposure and white balance. Learn how to quickly check other settings or to set them to the defaults in order to avoid shooting with the wrong settings.

Caution!

Many digital cameras have shooting modes that automatically choose a faster ISO setting if there is not sufficient light. Make sure that you know what shooting modes allow this to avoid taking photos that have too much digital noise (which can come from high ISO settings).

CHOOSE THE IMAGE FILE FORMAT
to suit your needs

Each time that you press the shutter release, you capture an image with the image sensor. The image is then written to a file in a user-selected format with or without applying your chosen camera settings. Most digital cameras other than basic point-and-shoots offer two formats: JPEG and RAW.

Most digital photographers use the JPEG format. It offers a nice balance between image file size and image quality, plus it is universally recognized by software that can use photos such as word processors or page design programs. The JPEG format is a compression format; it uses a mathematical algorithm to smartly reduce the file size while losing minimal image quality. At high quality settings (which you should generally use), the loss is negligible, yet you can capture more images on a memory card.

RAW image files are proprietary files that have minimal processing applied to them by the camera, plus they hold more tonal information than JPEG files. A RAW file can be processed with much more flexibility and adjustment range than is possible with JPEG.

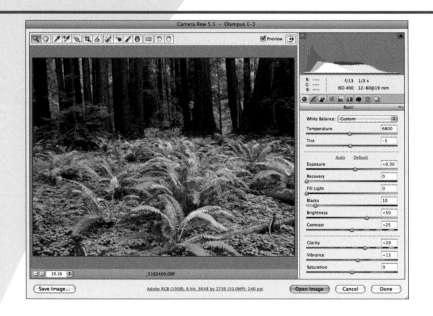

RAW format images are proprietary, data-rich files that you must convert before you can view and edit them.

Approximate Image File Sizes for 12MP Camera		
Format	Megabytes	Number of Images on 2GB Memory Card*
JPEG (high quality)	5.7	350
JPEG (low quality)	1.8	561
RAW	13.9	144

*This is only an estimate. JPEG and RAW file sizes vary depending on the detail in a scene.

These file sizes are typical for a 12MP camera. File sizes from other digital cameras will vary.

JPEG versus RAW Formats	
JPEG	RAW
All camera settings embedded in file	Image stored with minimal processing from sensor, allowing more post-shoot changes
Fastest, most convenient format	Most flexible, adaptable format
Smaller file size	Larger file size
Easily viewable images	Requires RAW conversion software
Camera shoot and file-to-memory speeds faster	Camera shoot and file-to-memory speeds slower
Fast to view	Slower to view
8-bit file (less picture information)	16-bit file (more picture information)

TIPS

Did You Know?

The RAW format is the best image format to use if you want to get the best possible pictures from your digital camera. Camera settings, such as white balance, contrast, saturation levels, sharpening, and other settings, are not applied to a RAW image file. After you shoot, you have control over these settings when processing them with a RAW image converter. Many photo enthusiasts shoot in RAW format most of the time, or choose RAW + JPEG if the camera offers that setting.

Did You Know?

You can shoot more JPEG images in a row compared to RAW before the camera's memory buffer is filled, making the camera stop in order to catch up. On the other hand, RAW allows instant changes to white balance after the shoot with no effect on the image quality.

Set the
IMAGE RESOLUTION AND COMPRESSION LEVEL

In addition to letting you choose a file format for your photos, most digital cameras enable you to choose the image resolution. Usually, you will choose the highest resolution — after all, that is what you paid for in the camera.

Image resolution is expressed in terms of pixels, such as 3648x2736 pixels. If you multiply these two numbers together, you get the total pixel count — for example, 3658x2736 = 10,053,888, or 10 megapixels (10MP). For most photography, 10MP easily gives excellent prints up to 13x18. More pixels in a picture are not about quality, but about image size. More pixels enable you to print at larger sizes, which could be one reason to buy a digital camera with a higher megapixel rating.

This is not a simple decision, however. More pixels on a small sensor can mean increased noise in the image (noise looks like grain in film or "snow" on a TV with poor reception). Also, as pixel counts increase, so does file size, meaning you need more memory to hold the same number of images, requiring you to purchase higher-capacity memory cards for extended shoots. You could gain space by choosing a smaller image resolution or a low JPEG compression. Unfortunately, both of these options reduce image quality. Choose the highest resolution and highest quality JPEG compression unless you have special need for small images, such as those used only on the Web (which needs a much lower resolution).

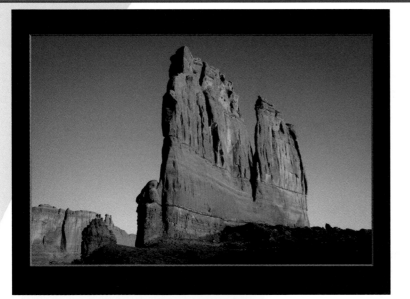

This photo is cropped slightly from a 10-megapixel camera with an image size of 3771x2514 pixels. This particular photo is the full image file.

This image is at a much reduced resolution of 1200x900 pixels. Yet, both look fine at this size because either resolution supports the small size of the images as shown on this page.

The cropped image shows the difference. The top photo is cropped from the larger image file and looks fine printed here.

DIFFICULTY LEVEL

The second one comes from the smaller file and starts to show loss of sharpness and pixilation. The point is that the small file is much more limited on how large it can be displayed or printed compared to the big image file.

TIPS

Did You Know?

By reducing the image resolution to store more photos in your camera, you reduce your ability to crop photos later and the opportunity to get the largest possible prints. Memory card prices are very reasonable for high storage capacities, so buy either extra or big cards so that you can store your images at the maximum image resolution and with the least image compression. This helps you avoid taking a prized shot that is too small or has too much compression to make a good print.

Did You Know?

Each time you save a JPEG file after editing it, your image degrades. Therefore, JPEG should not be used as a working file format when adjusting it in Photoshop Elements or any other program. Save a working file in an uncompressed image format such as TIFF (.tif) or Photoshop (.psd). JPEG can be used later for archiving finished files to save disk space.

Control your camera's light sensitivity with the
ISO SETTING

In traditional film photography, you choose film for a certain sensitivity based upon an ISO rating, such as ISO 100 or ISO 400. Digital cameras also enable you to change ISO settings, which are similar to, but not the same as, film ratings. Digital camera ISO settings come from the camera amplifying the signal from the sensor rather than a built-in rating as in film.

This sensitivity affects how you can deal with certain photo needs, from the amount of light to a desired shutter speed. Low settings such as ISO 100 are less sensitive, or "slower," than ISO 400 because it takes

a slower shutter speed to properly expose the image. A higher ISO setting enables an image to be recorded with a faster shutter speed.

Choosing an ISO setting is one of the most important settings that you can make. High ISO settings, such as ISO 800, enable you to shoot in lower-light settings with faster shutter speeds, but you may end up with more digital noise in your photos. Digital noise is similar to grain in traditional photography and is minimized when you choose a low ISO setting.

This photo was shot at ISO 1600 to enable a faster shutter speed, avoiding image blur in low levels of indoor light.

Digital noise is easily visible in most of this photo as a speckled pattern. Still, people expect indoor photos like this to have noise.

This photo was shot at ISO 100 to give the image the highest color and sharpness, plus best tonalities, while keeping noise low.

Digital noise is minimal throughout this photo, but it did require using a tripod because a slower shutter speed (1/3 second) was used.

 TIPS

Did You Know?

You generally get the best picture quality by using the lowest ISO setting your camera offers, such as ISO 100 or 200. A high setting, such as ISO 1600, will have considerably more digital noise.

Photo Tip!

Although digital noise is generally an unwanted characteristic of a digital photo, you can use it as a creative design element. In the days of traditional film, photographers often used grain to add a romantic look to their people and travel photos.

Did You Know?

When you edit a digital photo with an image editor such as Photoshop Elements, you are likely to get more noticeable digital noise when you perform steps such as increasing contrast, adjusting saturation, and sharpening an image.

Improve color with the
WHITE BALANCE SETTING

Color photography has always had a challenge with getting accurate color. A common problem is an undesirable color cast, such as a red, blue, or green haze over the image. This was difficult to deal with when using film and often required special films or filters to balance the color with the light.

Digital photography has really changed this because of white balance settings. Now you can select an in-camera white balance setting so that your camera records correct colors when shooting under a variety of different lighting conditions, such as incandescent light, tungsten light, sunshine, or clouds. You find icons representing presets for each of these in the white balance setting area. Auto white balance (AWB) gives less consistent results (even when working with RAW files).

Besides letting you choose an appropriate white balance setting, many digital cameras have a custom white balance setting that can record very accurate colors. Each camera deals with this setting differently, so you need to check your manual, though custom white balance requires that you have a neutral white or gray card for the control. If your camera offers such a feature (and most do), it is worth learning about and using.

This photo of the Santa Monica Mountains in California was taken at sunset with the white balance set to cloudy. Cloudy gives a warm sunset that looks more like traditional film-captured sunsets.

This photo was taken at sunset with the white balance set to AWB or auto white balance. With AWB, the camera does not know that a sunset should look warm and takes out much of that warmth in order to make a more neutral image.

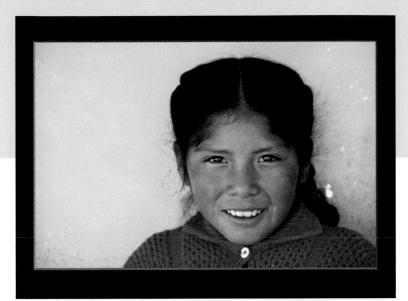

A strongly colored background can cause AWB to give false results. This portrait of a Peruvian girl was made using the shade preset.

The slight warm colorcast to this image is important because it reflects the time of day it was captured. A daylight preset was used to preserve that colorcast.

TIPS

Photo Tip!

Sometimes you can add a preset white balance setting to add an attractive color tone to a photo. For example, using a cloudy white balance setting can add warmth to an otherwise cold or blue-toned scene.

Did You Know?

Most digital image-processing software offers several color-correction tools. However, many of them work best if you have a pure white or neutral gray tone in your image. If your subject requires absolutely accurate color, consider placing a white or gray card in the same light as your subject for a reference shot, and then remove the card for your real photos. You can then use that reference shot to help you get very accurate color in your final photos.

SHOOT YOUR BEST
from the start

Digital photography is so adaptable and flexible that many photographers start thinking they do not have to worry so much when taking pictures because they can "fix it in Photoshop." That idea can get you into trouble.

Underexposure can cause problems with color in dark areas, as well as dramatically increased noise, no matter what camera you use. Overexposure can change highlights to detail-less white that can never be recovered. The wrong shutter speed will cause sharpness problems from camera movement during exposure to blurred subjects. An incorrect white balance can create colorcast problems.

You do not have to be a pro to shoot your images correctly from the start. Simply know your camera and be sure to make wise decisions for how you use it. This requires a little discipline and knowledge of photographic craft, which this book is designed to help you with.

Although image-processing software provides you with tremendous image-adjustment power, you can always do more with well-crafted photos than you can with marginally acceptable ones. You spend less time working on an image in the computer if you have an excellent image to begin with.

The wrong exposure and detail will also be captured wrong in a photo like this that holds a large range of tones.

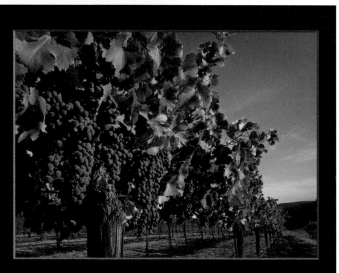

Part of the appeal of this photo of grapevines in a vineyard is its sharpness. That comes from the right technique of using a tripod, careful focusing, and exposure control from the start.

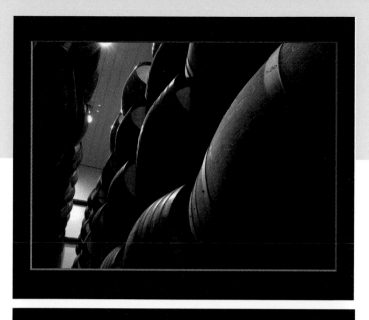

Choosing the right white balance preset (Tungsten) gave this warehouse shot the proper colors for the wine barrels.

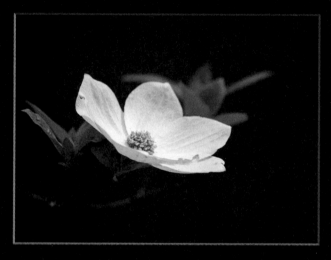

The wrong exposure on this shot would have washed out the white details of this western dogwood flower.

TIPS

Photo Tip!

Once you have your digital camera, get a good-sized memory card (prices are very reasonable now). Taking photos costs nothing, so get out and shoot as much as you can. This is the best way to become a better photographer. Try different exposure settings and compositions, compare them in the LCD, and shoot plenty of photos so that you have a choice among them.

Did You Know?

You can use any camera to quickly adjust exposure without using any dials. Point your camera at something dark, lock exposure (usually by pressing the shutter halfway), and then move the camera back to the composition in order to add exposure. Do the same with something bright to darken exposure. You do need to be careful of distances here because locking exposure on many cameras also locks focus. The "something," bright or dark, can be at a different distance from the camera than the subject, which would cause sharpness problems.

Pack for a
SUCCESSFUL SHOOT

Every photographer has a different comfort level with how much gear he or she needs to bring along, but it is easy to carry too much. Photographers develop back and shoulder problems from the weighty gear bags they tote around.

If you really must bring a lot of gear, take along a smaller bag and use it when you know you do not need the whole kit. It can be literally painful to lug a heavy camera backpack along steep trails when you never really needed that heavy telephoto lens that was included.

Staying comfortable during shooting also helps you photograph more successfully. It is hard to be creative if you are cold, bug bitten, hungry, or sunburned. Bring along items that will make your outing more enjoyable, productive, and safe.

Before you head off for a shoot, carefully consider what you should take with you in addition to your photography equipment. A few nutrition bars, water, gloves, bug repellent, sunscreen, and a hat can unquestionably contribute to your taking better photographs.

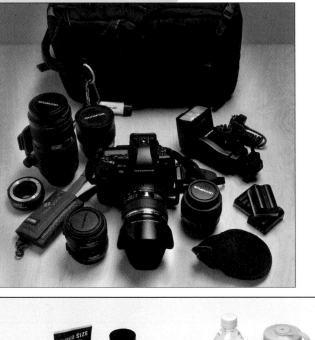

Think about what you need for any photo excursion. Avoid bringing more gear than you will likely use, but be sure to include the equipment needed for a specific subject, such as a telephoto for wildlife photography.

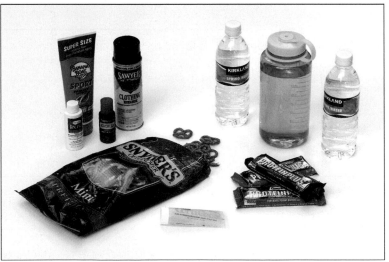

Water, sunscreen, insect repellent and bite medication, and snacks are just a few things that will make your picture-taking time more enjoyable.

This photo is a nice shot from Cape Cod when it was raining! Not having appropriate rain gear would have made this shot impossible.

DIFFICULTY LEVEL

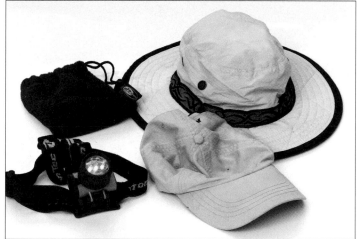

Take a hat to protect yourself from the sun and use a headlamp, such as the Princeton-Tec, to make your walks safe when walking in the dark.

TIP Did You Know?

Some of the most useful information for photographers is found on the Internet.

Sunrise/Sunset/Twilight/Moonrise/Moonset/Phase information:
 http://aa.usno.navy.mil/data/docs/RS_OneDay.html

Weather: www.weather.com

Outdoor photography: www.outdoorphotographer.com

Online mapping service: www.mapquest.com

Best state parks: http://usparks.about.com/cs/stateparks/a/bestparks.htm

Photo advice from the author: www.robsheppardphoto.com

Blog by the author: www.photodigitary.com

Consider Light More Than Illumination

Light is more than just something needed to make a photograph. The right light can make your images really come alive, whereas the wrong light can kill them. Although you definitely want to focus your attention on your subject and compose carefully to get the shots you want, you can greatly improve your photos if you are aware of what light is doing to both your subject and the rest of the picture. What often distinguishes really good photographs from all the rest is how light is used to capture the photograph.

To see the light (literally), you have to go beyond framing a subject in your viewfinder or LCD. You have to look at your scene in terms of

what the light is doing. Is the light making the subject easier to see, or does it obscure it? Does the light flatter your scene, or does it make it harsh and unappealing? Would your subject look better in another light? Is the light soft and diffused, or is it bright and intense? Does the light have a nice, warm golden glow, or maybe an unwanted colorcast?

Use the LCD on your camera to see what the light is doing to the picture as captured by the camera. When you do not have good light, consider ways in which you may improve it, or find another time to try again. The more you take advantage of quality light, the better your photos will be.

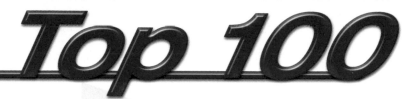

Top 100

PICK GOOD LIGHT
for better photos

Digital photography is all about capturing light on an image sensor; the better the light, the more potential you have for getting great photographs. The quality of light varies greatly from when the sun comes up in the morning to when it sets in the evening. Fast-moving clouds can change it even on a second-by-second basis.

A good way to learn what light is best for the subjects that you enjoy shooting is to shoot those subjects in all sorts of light and see what the photographs look like. This is such a great advantage of digital photography — you can easily do this with no cost for processing photos, and you can easily compare images on the camera LCD or in the computer.

Keep in mind that great light is not constant. Sometimes you must wait for those perfect moments to capture a perfect shot; or you may have to return to an interesting subject, simply because the light at the time just does not make the scene work as a photograph.

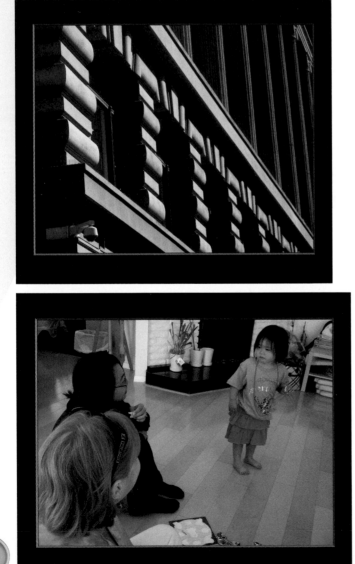

Light skimming the surface of an old building in San Francisco makes its lines and patterns stand out boldly.

Large windows in front of and to the left of the young girl fill the room with a soft, enveloping light.

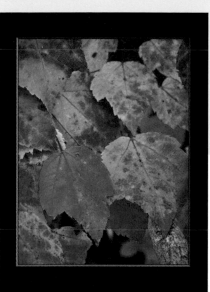

Soft light from the sky and not the sun makes these rich fall colors gain spectacular color in a photo.

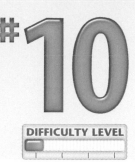

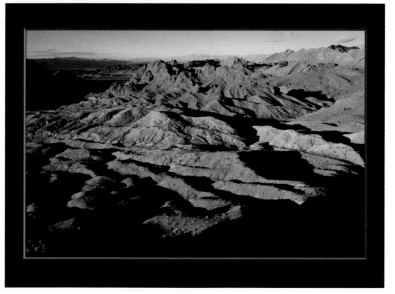

Early morning light skims the surface of this Mojave Desert landscape and gives its features texture and dimension.

TIPS

Did You Know?

Bad weather conditions offer great photographic opportunities that give your photos more variety than just good-weather images with blue skies. Look for dramatic clouds, thunderstorms, even rain or snow that can make light dramatic. Changing weather conditions are an excellent time to shoot because the light can be quite striking then.

Photo Tip!

Clouds can be very helpful to photographers because they can diffuse bright sun and reduce the overall light intensity and contrast, especially when photographing people. Clouds can make an otherwise clear sky a little more interesting. Have patience for clouds to move to where they will help you get better photographs.

Shoot effectively in BRIGHT SUN

DIFFICULTY LEVEL

Direct light from the sun ranges from perfect to awful as it illuminates your subject for a photograph. A big challenge in working with bright sun as the main light is that it is a bold and strong light. That makes it unforgiving if used poorly with many subjects.

Direct sunlight creates strong contrast with very bright highlights and dark shadows. A key to understanding the light from bright sun is to understand how important the shadows are. Shadows in the right places make your scene dramatic and powerful. Shadows in the wrong places make an attractive subject ugly and make your viewer struggle with even the best of compositions.

Another key aspect of bright sun is that the light has a very strong direction. That means that even a slight change in camera position often gives you a new light because it strikes the subject from a different angle in relation to the camera position. That change can be enough to make poor light become good light on a particular subject.

The shadows from bright sun can be as important as the sunlit areas of the image, as seen in this shot of rock formations called fins in Arches National Park.

Backlight, or light from behind the subject, can be a very effective and dramatic light, though you may have to experiment with it a bit in order to master it.

SHOOT IN THE SHADE
for gentle light

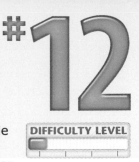

DIFFICULTY LEVEL

The drama of direct sun can visually overwhelm many subjects because of its contrast. One way of dealing with the harshness of bright sun, and inconvenient shadows, is to look for shade for your subject. Shade is an open light without the contrast of bright sun, meaning the light has no distinct shadows and highlights, yet it usually still has some direction to it. Direction in a light makes your subjects appear more three-dimensional.

Shade works especially well for people and flowers. You might find your subject in the shade, or you might move that subject into the shade. If neither is possible, you may be able to shade the subject itself. Have someone stand in a place to block the sun, or drape a jacket over a chair to create some shade. You can often find creative solutions to making shade on your subject.

Be sure to set your white balance to the shade setting in these conditions (see task #7). Shade contains a lot of blue light that comes from the sky, which your camera often overemphasizes. Shade settings remove that blue. Auto white balance settings tend to be very inconsistent in the shade.

A bright sky produced the gentle light on this western dogwood.

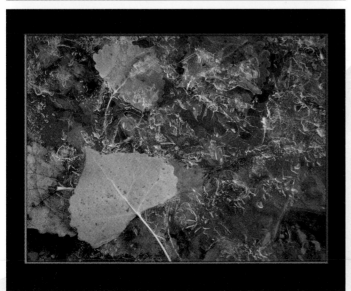

The sun is blocked from the subject so that the sky is lighting up this early fall scene of new ice.

 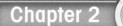

Take advantage of the
GOLDEN HOUR

The golden hour is a magic time when the sun is low to the horizon and casts a golden, warm light on the landscape, but only for about an hour that starts an hour or less before sunset and lasts up to as much as 30 minutes after it. Although both sunrise and sunset can give this type of light, the sunset usually has the warmest, most flattering light.

This has been a classic light for pro photographers, from those working for National Geographic to cinematographers creating Hollywood films. In fact,

whole films have been shot entirely at this time (which is one reason why films can be so expensive — but the light sure looks good!).

This light looks great at any angle, but the richest color and best tonalities often come when the light is at the side or even hitting the front of your subject. Front light on a subject is very unattractive in the middle of the day, but near sunset, it transforms into a radiant, beautiful light on many subjects.

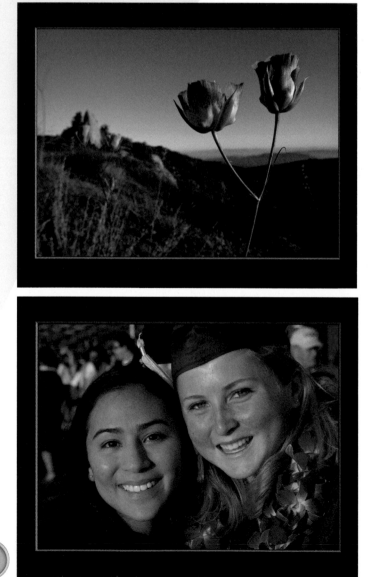

The side light shortly after sunrise gives dimension and warmth to this scene in the Santa Monica Mountains Recreation Area in California.

Low sun near the time of sunset gives nice, glowing skin tones to this double portrait.

Low sun at sunset gives a beautiful color to the sky and landscape in Arches National Park, Utah.

#13

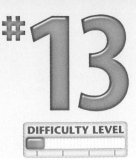

DIFFICULTY LEVEL

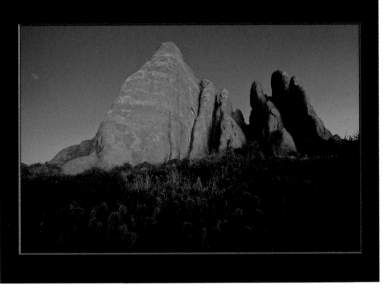

This landscape was photographed nearly 30 minutes after the sun had set. The still-bright sky gave it this unique look.

TIPS

Try This!

Do not pack up your camera just because the sun has set. If you are patient, you may find some truly outstanding light on your scene. Usually, the light gets duller just after the sun sets, but about 5–10 minutes later it often changes to a warm, soft, and wonderful light. There is no guarantee this will always happen, but when it does, you will be glad you had your camera.

Photo Tip!

When the light is low, and especially before sunrise or after sunset, your exposures often require slow shutter speeds. That can result in blurry pictures due to camera movement. Use a tripod or brace your camera against something solid if needed. You can also try setting a higher ISO setting and a wider aperture to allow for a faster shutter speed.

Control light with a
REFLECTOR

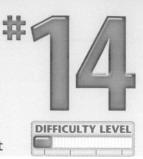

One helpful and inexpensive photographic accessory is a reflector. You can use anything white or light gray to reflect soft natural light toward your subject. Reflectors can also block light, effectively creating shade to reduce overly bright and high-contrast direct sunlight. Most portable light reflectors made for photography fold up to one-third of their open size, and they often offer a white side and a second colored side, such as silver, gold, or bronze.

A handheld reflector is especially useful for adding light to a subject's face for a portrait. Besides filling shadows with natural light, you can add a warm color tone by using a gold-colored reflector. When shooting a backlit subject, a silver reflector can be used to bounce more light into the shadows in order to reveal greater detail. Reflectors can also be used with flash and other lights.

White Fome-Cor® panels, which can be purchased at most art stores, make excellent inexpensive light reflectors. Although they are not as convenient to store and carry as collapsible light modifiers, they are lightweight and easily found.

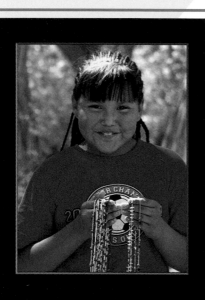

A white reflector in front of and below this Navajo girl brightens her face and helps to bring life to her eyes.

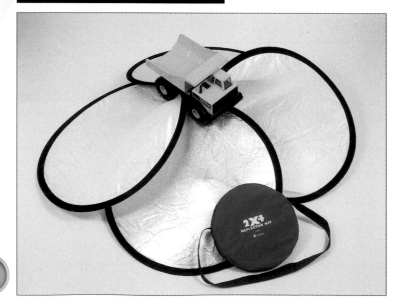

Reflectors come in all sizes and in different finishes, as seen in this lineup of Lastolite portable reflectors.

Open up harsh shadows with
FILL FLASH

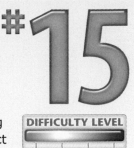

DIFFICULTY LEVEL

Bright sun can cause harsh light on faces, with deep shadows around the eyes or under hat brims. This shows up even stronger in the resulting photographs.

There is a solution, something that you can do immediately whenever you are faced with harsh shadows on a nearby subject. Nearly all digital cameras allow you to force the flash to fire in these conditions to fill in those harsh shadows. Some cameras have a "fill flash" setting of some sort, too, but all you really need to do is turn the flash on and use the "always on" setting. The camera then adds

flash to the dark shadows, opening them up and revealing your subject much better.

This works only for subjects that you are fairly close to, though the actual distance is affected by the power of the in-camera flash. Usually, fill flash works best at distances less than 8–10 feet. Pros often use accessory flash for added power to boost this distance. Fill flash limits the shutter speed and f-stop possible with digital SLRs (try using the P mode at first).

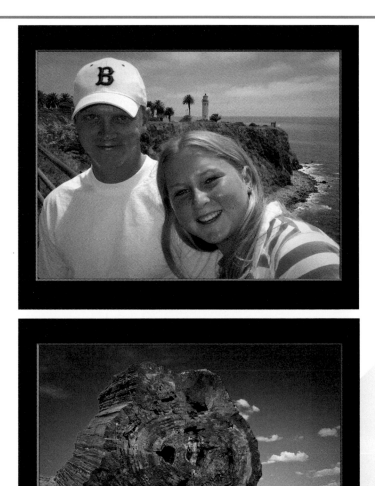

Without fill flash, you would never see the eyes on this brother and sister in bright sunlight. You can see the sun highlights and shadow on the young man's T-shirt. The flash is revealed in the catchlight in their eyes.

The colorful side of this petrified wood log was totally in the shade. Flash helped bring out its color.

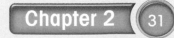

Illuminate portraits with
WINDOW LIGHT

Getting a good portrait is highly dependent on the quality and quantity of light available. That is one of the reasons why so many portrait photographers strongly prefer to shoot inside a photo studio where they have a high degree of control over lighting. One of the most useful lighting accessories in a portrait studio is a soft box, which is a large light box that diffuses the light from a flash or other light to make soft, natural-looking light for well-lit portraits.

You can get much the same soft, evenly diffused light in your own home without the expense of having a studio by shooting portraits with the subject standing or sitting in front of a window. Shoot when the light comes from the sky, not directly from the sun, or you can use the diffused sunlight that comes through a white sheer drape. You can change the direction of the light on your subject by moving the camera and subject at different angles to the window. This can give you everything from dramatic sidelight to open front light.

This candid portrait was taken with a large picture window to the right side. A white wall to the left acted as a reflector.

Here, one large window provided the light, and the strong direction to the light is controlled by the camera position.

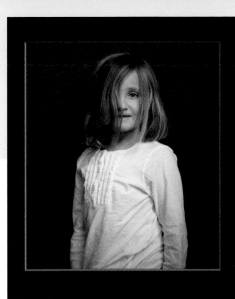

This young girl was shot near a wall, and the light came from a large window to the right.

Sometimes, direct sun from a window can work with a little help. A reflector on the left and below gave a nice light to the face, and a white wall on the right kept the shadows open.

TIPS

Did You Know?

Window light can change quite dramatically in color depending on where the light is coming from. Light from a blue sky is very cool in color, and clouds can give everything from warm to cool light. Try setting your camera's white balance to Cloudy or Shade for nice warm skin tones. You can even try using a custom balance setting with the light.

Apply It!

If the light from the window is too harsh, use a reflector to bounce light back to the subject. Just place the reflector opposite the light and reflect the light onto the subject. Large white art boards made of foam in between white paper, called Fome-Cor®, which can be purchased at most art stores, make excellent accessories for your window "studio." They can be quickly propped up and used as reflectors to modify and enhance the light coming from a window.

Get your flash off-camera for
DIRECTIONAL LIGHT

The flash on your camera is very limiting. It tends to make flat light, with harsh shadows behind your subject, and often creates red eyes in your subjects. Avoid those problems by getting a flash that allows you to move it off-camera. For digital SLRs, this means using an accessory flash with an extension cable (though some newer cameras do have wireless flash capabilities).

For small, compact, and point-and-shoot cameras, you can also use this technique by purchasing one of the little flashes designed to be triggered by your on-camera flash. (These can also be used with a digital SLR, but for more versatile light, the accessory flash with cord works better.)

You do not have to get the flash far off-camera for it to work well. Hold the flash with one hand off to the side and point it at your subject. This provides nice directional light with far more attractive shadows than the on-camera flash will do. You can also point the flash at a white wall or a reflector to create a very nice, softer sidelight.

Too often, pictures taken with the on-camera flash look like mug shots, with their harsh, flat light and unattractive shadows behind the subject.

Same subject, but what a difference! The light was held off to the right so the shadows would not fall behind the woman, plus she gains some attractive dimensional light on her face. A nearby table light adds a little light to the subject's hair on the right side.

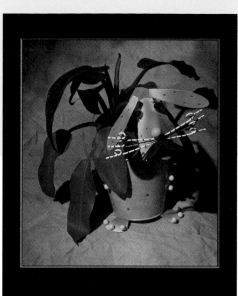

A flash to the left of a plant and its unique pot created a strong, dimensional light and gave enough light for high depth of field this close to the subject.

DIFFICULTY LEVEL

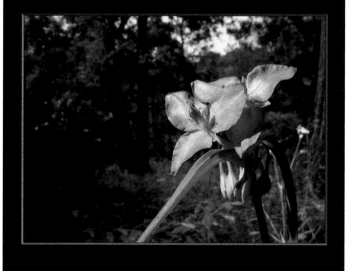

This close-up of a spiderwort flower looks like it was shot in sunlight. It was not! It was in the shade. An off-camera flash held to the left provided the light.

TIPS

Did You Know?

When you shoot close-up or macro photographs with flash, you usually gain high sharpness. This is because the flash gives a lot of light, allowing a small f-stop for more depth of field, plus flash has such a short duration that it freezes subject and camera movement.

Caution!

Vendors other than the major camera manufacturers make several excellent accessory flash units, though you will probably have to get the extension cord from the manufacturer. However, be careful if you decide to purchase an independent-brand flash other than the one made for your camera. Check to be sure it links with your camera so you can use all of its features.

USE BOUNCE FLASH
for better indoor lighting

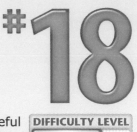

#18

Another way to create a more attractive light from a flash is to bounce it off a wall, a ceiling, or a reflector. Bouncing the light spreads it out, making it a gentler light and also generally more natural-looking. You need to have a flash that allows you to point the flash tube away from the camera, at a wall or ceiling. Many accessory flash units have a tilting flash head to allow this. You can also hold an off-camera flash so it hits a wall.

Bounce flash does absorb light from your flash. It requires more powerful flash units the farther the surface is from your flash. Be careful you do not get too close to a portrait subject if you are bouncing a flash off the ceiling, or you can get heavy shadows under the eyes. Also, be very aware of even slight colors to a wall or ceiling. If you bounce off such colored surfaces, that color will appear on your subject — perhaps a good thing if the wall is warm, but definitely not so good if the wall is green!

The flash here was bounced off the corner of a white wall and ceiling to get this big, gentle light that works well for a group.

The flash for this portrait was bounced off of a 3x4-foot piece of Fome-Cor® for a nice, attractive light on the woman.

Prevent
RED EYE

Flash can cause a distinct problem when shooting people in low-light conditions — their eyes flash red as if they are possessed. This dreaded red eye is caused by light from the flash reflected back from a subject's retina to the camera. To avoid getting photographs whose subjects have red eyes, many camera manufacturers have added red-eye reduction features. Although these features can reduce or eliminate red eye, they often make your subject blink or react poorly to the camera.

To avoid getting red eye, you simply need to shoot so that the angle between the flash and lens to the subject's eyes is more than five degrees. Using a high accessory flash, an off-camera flash, or bounce flash helps avoid getting red eye. Digital cameras do well without flash in bright interiors. You could try camera settings that do not require a flash. You are more likely to get red eye when shooting in a dark environment because the pupil is wider and more prone to reflect red light.

DIFFICULTY LEVEL

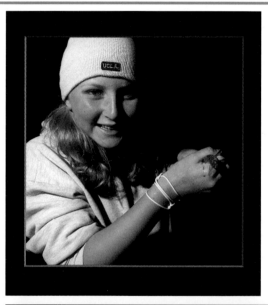

A night shot of grunion-catching almost guarantees red eye — unless the flash is off-camera as it is here.

Bounce flash is good for a group and never causes red eye.

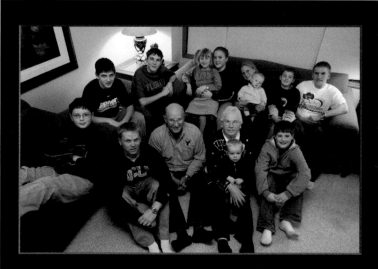

3

Control Exposure

Exposure systems in today's digital cameras are amazing. It was not all that long ago in the history of photography that cameras did not even have meters, let alone complete metering systems with the power of a minicomputer. A camera's metering system examines the light coming through the lens as it is reflected by the subject, compares that light with the surrounding light, and calculates an exposure that will give you good results. Even the cheapest of digital cameras offer metering that makes exposures far more reliable than in years past.

But great exposure that really expresses your interpretation of a subject is not so simple. Plus, poor exposure can quickly take your photos from good to unacceptable. Metering systems can misread the amount of light and give you a photo unlike what you have in mind. To improve your chances of getting the exposure you want, it helps to understand how to make the most of your digital camera's exposure system and its features. In fact, a really great aid to better exposure is the camera's LCD, its exposure warnings, and the histogram. If you are not happy with the picture that you took, you can shoot until you get what you want — and it does not cost a thing!

Top 100

UNDERSTANDING EXPOSURE
to get the photos you want

The right exposure is whatever makes your subject look its best in the type of photograph you create. That means exposure is definitely subjective. However, most people know when an exposure is right or wrong. Overexposed photographs are overly light, and detail is lost in the highlights. Underexposed photos are overly dark, and detail is lost in the shadows. The key thing about exposure is that important detail, dark or light, is captured properly so that the scene is light or dark appropriate to the subject.

Unfortunately, the world typically offers up a range of tones greater than what is possible to capture with a sensor. First, you might not be able to hold detail throughout the image with your exposure. Most digital photos look their worst with any overexposure or very dark underexposure. Good exposure results from the appropriate combination of shutter speed, aperture, and ISO speed. Exposure can be determined solely by the camera, interpreted by you (as the photographer) and the camera together, or solely by you.

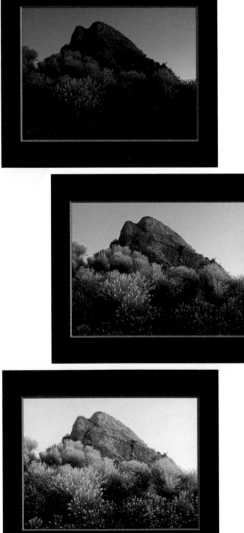

Underexposed
> Too little exposure for this scene of California chaparral resulted in a muddy-looking image hiding detail in the shadows.

Properly Exposed
> This well-exposed photograph holds color in the sky and reveals details in the shadow areas.

Overexposed
> Overexposing this photograph lost color in the sky and made the overall image look "washed out."

Incorrect Metering I

The dark trees and shadows of this scene over-influenced the metering system, causing overexposure so that the bright light washed out the white church.

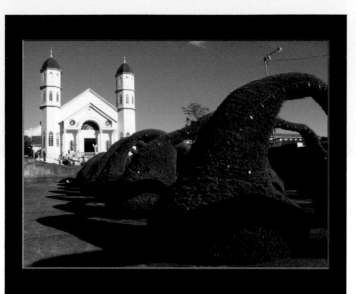

Incorrect Metering II

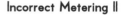

The bright sky in this image of a London monument caused the meter to read the exposure incorrectly, resulting in underexposure that made duller colors and whites that look dingy gray.

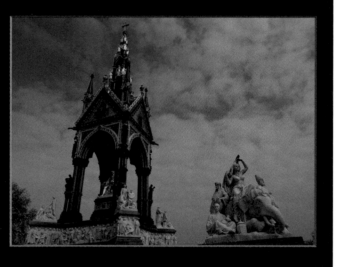

TIPS

Did You Know?

One advantage of using the RAW format is that RAW captures more tonal steps between pure black and pure white as seen by the sensor. The result is an image that allows more correction to exposure in RAW conversion software. Still, RAW is no magic bullet that fixes bad exposure. You still need to be sure you have not made an image too light or too dark because once bright areas become pure white, or black becomes pure black, no amount of adjustment retrieves detail in those areas.

Photo Tip!

If you are shooting in tricky light or you are shooting a scene that seems to be difficult to meter correctly, consider using the auto exposure bracketing feature if it is available on your camera. Auto exposure bracketing enables you to shoot three or more sequential shots, each with a different exposure. The camera automatically shoots at user-selected + and – exposure changes around the metered setting.

Know
WHAT METERS REALLY DO

Exposure meters can measure only how much light comes from a scene. The meter cannot know if that scene is a light scene in dark conditions or a dark scene in bright light. So, the meter really gives an exposure that results in an average or middle-gray tonality for everything, which is not appropriate for every subject.

Camera metering systems have multiple metering points over the image area to give the camera's built-in metering computer something more to work with than a single (and perhaps misleading) meter reading. Still, certain types of scenes present problems.

An image made up of dark tones over the whole composition will usually be overexposed because the meter wants to make it bright, not "knowing" that the scene is not bright. A photo that has mostly bright tones will typically be underexposed because the meter wants to darken it, not "understanding" that the scene is not darker.

Finally, a scene with a strong contrast between the subject and background often causes the meter to improperly expose the subject. A bright background causes a dark subject to become underexposed, and a dark background can make the subject overexposed.

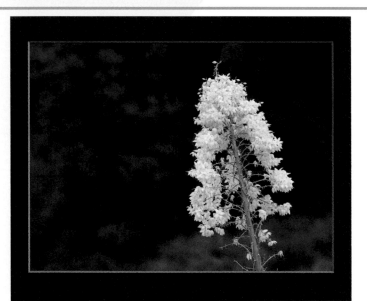

The dark foliage in the background that makes up much of this scene of a chaparral yucca flower can easily over-influence the meter, causing an exposure that is too much for the smaller area of white flowers.

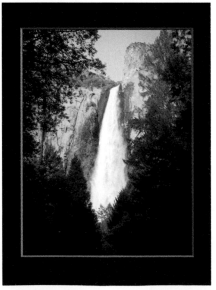

The meter does not know the difference between dark conditions and a dark subject, so it overexposes dark scenes like the Yosemite waterfall here, making the falls too bright.

DIFFICULTY LEVEL

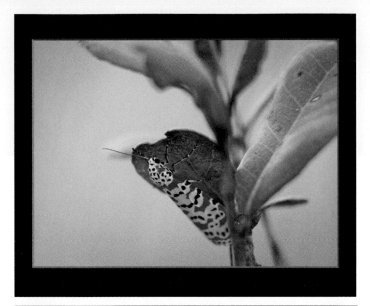

Meters often underexpose a dark subject in front of a bright background, such as this moth and plant. The right exposure shown here keeps dark details looking good by using some compensation by the metering system.

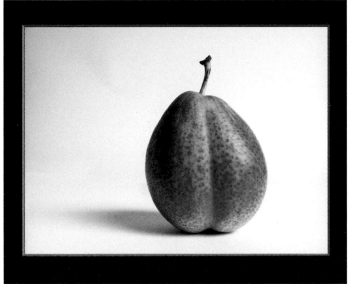

The light on this small pear has a beautiful open quality to it, but many meters expose such a white scene too dark, making the image dark and muddy looking.

TIPS

Photo Tip!

RAW files can be helpful in difficult metering conditions. With RAW software, you can often bring out detail in the shadows while holding tonalities in the highlights, even when the light is contrasting and hard to meter. That does not mean you can be sloppy with RAW exposures, though. You need to do the best you can for every subject in order to get the best possible detail and color from a scene.

Did You Know?

One thing you pay for with more expensive cameras is more metering points in the scene for the metering system to evaluate. With more points, the system can better find the key tones to favor, while ignoring single-point anomalies of light, such as a bright spot in an overall moderate-toned image.

Know when there is
NO PHOTO

"The camera is not the same as a person" may seem like an obvious statement, yet a common mistake many beginning photographers make is that they want the camera to act like they do in terms of seeing the world. The camera is restricted by technological limitations that your eyes and brain do not have.

This is especially important with exposure. Photographers see a subject and take the picture with the expectation that the "right" exposure will give a good picture. When the photo does not cooperate and results are poor, they think that they just did not adjust the camera right. In fact, the scene might be beyond the capabilities of the camera, even though you can see it perfectly.

This is most common in extreme lighting conditions. Your eyes can handle a huge range of detail from dark to bright in situations such as a scene where the light goes from brightest sun to dark, dark shade. The camera simply cannot handle such conditions and no exposure will be "right." Sometimes it is important to recognize when a good photograph is not possible and then move on to something that is.

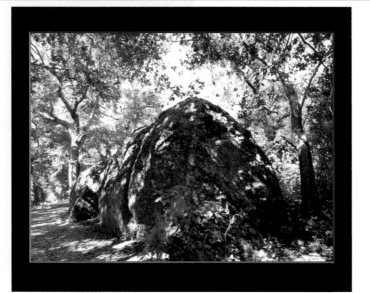

Unfortunately, there is no good exposure for a scene like this rock formation in the woods. The light is too spotty and too contrasty for the camera sensor to capture what you might see there.

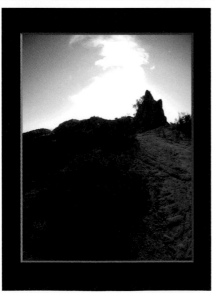

Extreme conditions of backlit clouds and shaded bushes are beyond the capabilities of a camera sensor even though you might see detail throughout the scene.

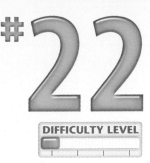

The light chops up this scene into bright and dark areas that no camera can handle properly.

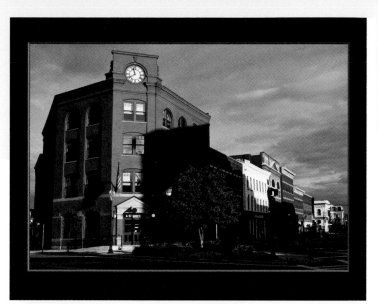

Indoors can be a problem when bright light from a window is too extreme compared to the rest of the scene.

TIPS

Did You Know?

The human eye is capable of seeing quite a range of tones in the real world from 10,000:1 to 1,000,000:1 depending on conditions and how the eye adapts to those conditions. The digital camera, on the other hand, has a range of approximately 1024:1. This is why you can see things in light that causes problems for a camera.

Just Say No!

Photographers often are so strongly attracted to a subject that they want to take its picture regardless if a good photo is possible or not. One thing that can help you become a better photographer is remembering that you always have a decision to not take a picture, to just say no to bad light and poor exposure.

Discover different
EXPOSURE MODES

Most digital cameras offer a variety of automatic exposure modes, including program, shutter priority, and aperture priority, as well as manual mode. Choosing an exposure mode determines what exposure settings you can select and what exposure settings the camera automatically selects based on other choices you have made.

In P or program mode, the camera automatically chooses both shutter speed and aperture settings. When you select the S or shutter priority mode (also called Tv for time value), you choose a shutter speed, and then the camera automatically chooses the aperture setting to get a good exposure. Select a shutter speed appropriate to the subject — a fast speed such as 1/500 second for action or a slow shutter speed such as 1/2 second for a blur effect.

In the A or aperture priority mode (also called Av for aperture value), you choose the aperture setting that you want, and the camera selects the appropriate shutter speed. Choose a small aperture such as f/16 for deep sharpness or depth of field, and a large aperture such as f/4 for shallow or selective focus effects.

When you want complete control over both shutter speed and aperture, choose the manual mode.

You usually select an exposure mode by turning a dial that includes settings like this one — P is program; Tv is shutter priority; Av is aperture priority; and M is manual.

For snapshot photos and general use, select the program automatic exposure mode.

Choose aperture priority mode when you want to control depth of field; in this mode, you select the aperture and the camera automatically sets the shutter speed.

Choose shutter priority mode when you want to control shutter speed; the camera then automatically sets the aperture.

TIPS

Did You Know?
Program-shooting modes (also called scene modes) such as Landscape, Macro, and Portrait offered by many digital cameras automate the process and often result in a good photograph. However, they are not likely to produce photos as good as you can get if you understand and correctly use the shutter priority or aperture priority mode settings.

Caution!
Many program-shooting modes allow the camera to automatically change the ISO setting if the metering system thinks a change is needed. Sports mode, for example, shifts to a higher ISO if it needs a faster shutter speed. When the camera selects a higher ISO speed, there is potential for more digital noise in the image. If you do not want to have excess digital noise, make sure that you know when to avoid using a mode that causes automatic ISO speed changes.

Choose an appropriate
PROGRAM MODE

Although built-in exposure meters are extremely sophisticated, they can give readings that do not provide the exposures you want. To give you more control over what light is metered, most digital cameras offer more than one exposure meter mode.

Some of the more common exposure meter modes are multisegment (called such things as ESP, Evaluative, and Matrix metering), center-weighted, and spot. The most useful is the multisegment mode, which takes multiple readings across the scene, and then smartly compares them inside the camera in

order to get a better exposure (it does not average readings). Multisegment, however, is often available only for autoexposure modes.

The center-weighted mode places most of the meter emphasis on the center and bottom of the image and is a good all-around mode for manual exposure. Spot metering reads only a tiny part of the image so that you can very precisely meter the most important light in a scene or a subject that is different than its background.

- ● This area is read by the multisegment metering mode.
- ● This area is read by the center-weighted metering mode.
- ● This area is read by the spot metering mode.

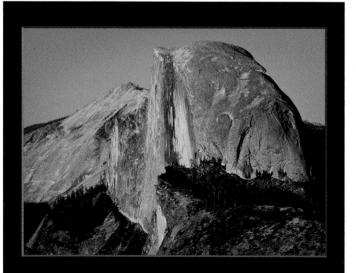

The multisegment metering mode is well suited for most images like this scene of Halfdome in Yosemite National Park.

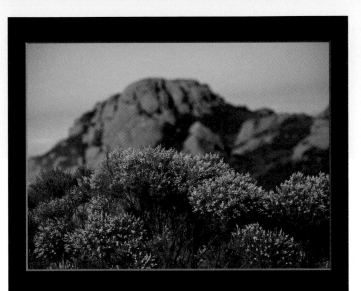

Bright light along the edges is less likely to fool the center-weighted metering mode, where priority is given to the center and bottom of the image.

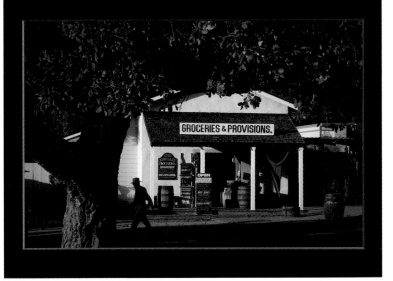

This scene was correctly metered using the spot metering mode to meter parts of the store in order to figure out the right exposure.

TIPS

Did You Know?

Many digital cameras have selectable autofocus points that enable you to focus on off-center subjects. Many cameras also link metering modes to these selectable autofocus points, such as favoring the focus point in multisegment metering, or linking the spot meter to a point. This feature makes it easy to focus on an off-center subject and to meter the light from that same point.

Photo Tip!

When your chosen exposure metering mode does not result in the exposure that you want, you have two choices. You can adjust the exposure either by using exposure compensation (see task #26) or by using the manual mode, in which you choose both the aperture and shutter speed settings without any assistance from the built-in meter.

USE THE HISTOGRAM
to get the exposure you want

Many digital cameras include a special graph called a *histogram* that shows the brightness levels of an image ranging from pure black on the left to pure white on the right. It can give you excellent information that helps you better adjust your exposure.

There is no such thing as a perfect shape to a histogram. It can reflect only the real-world brightness levels of your scene. Although the left side can be important, the key to reading a histogram is to watch the right side. If the histogram slams up against the right side so that its slope is abruptly chopped off, it is said to be *clipped*, and this represents an image with lost or *blown-out* highlight detail.

A gap on the right side of the histogram is a problem, too. It means your photo is underexposed and you are not fully using your sensor. In general, adjust your exposure so that highlight detail is retained without clipping and the histogram is not crammed to the right side or showing a big gap there.

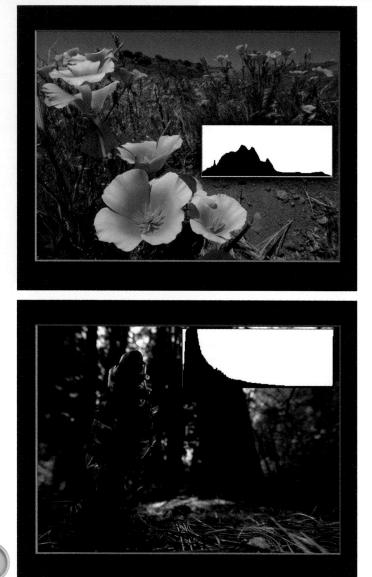

The photo here of California poppies is properly exposed, as seen in the histogram with a complete graph of brightness levels from left to right.

This snow plant in Yosemite National Park was exposed incorrectly as seen by the big gap at the right in the histogram. The whole image is dark and muddy-looking from underexposure.

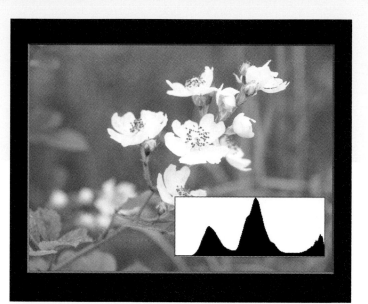

The blackberry plant and flowers in this photo are seriously overexposed and washed out. You can see the right side of the histogram is clipped off, meaning the bright areas are pure white instead of detailed highlights.

The range of tones for this finish-at-distance event at a track meet is perfect for the scene. Slight clipping such as seen in the histogram is normal when small highlights, like the edge-lit white fabric, are very bright.

TIPS

Caution!

Many digital cameras enable you to change the brightness of the LCD screen used to view images that you are about to take or have taken. Changing the brightness level or viewing the screen in bright light can cause you to misread the exposure. If your camera offers a histogram, you can use it to give you an accurate view of the exposure, regardless of the LCD screen brightness setting or bright light.

Did You Know?

Digital photo editors, such as Photoshop Elements, have a feature similar to the histogram on some digital cameras for reading the overall brightness of an image. The Levels command provides a histogram along with the ability to modify the tonal range and overall image contrast.

Improve exposure with
EXPOSURE COMPENSATION

Sometimes the built-in light meter in your camera can misinterpret a scene and give you a poor exposure. A good way of correcting this to get a good exposure is to use exposure compensation. Most cameras offer this feature, which often appears as a +/− button or menu choice.

Exposure compensation enables you to modify the exposure up or down from the metered reading by a specified amount. By doing this, you can continue shooting using the modified meter reading settings and get good exposures. For example, a +1 exposure compensation increases the exposure by one f-stop or the shutter speed equivalent, and −1 reduces it the same; a +1/2 setting increases the exposure a half step, and −1/2 reduces it by the same amount.

Exposure compensation can be particularly useful if your scene is overall very bright, such as on a beach or in the snow, or very dark, such as when a lot of shadow fills the image area. In those cases, the meter misinterprets the exposure. Make an exposure compensation adjustment and see if your histogram has improved.

Metered Setting

This photo was shot using the metered settings. The meter was over-influenced by the white steam clouds from the power plant.

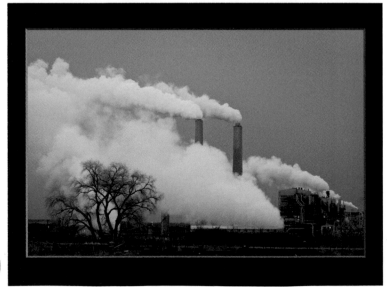

+1

This photo was shot with a +1 exposure compensation setting to make the image look more natural and bring out more details of the steam clouds as well as the rest of the scene.

Metered Setting

This photo was shot using the metered setting. The meter was misled by the dark trees through much of this scene in the Olympic National Park.

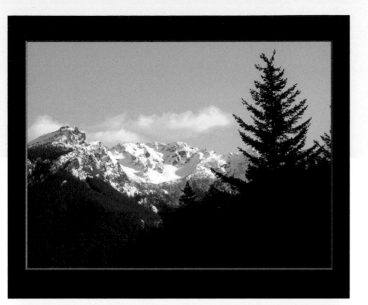

-1

A –1 compensation corrected the overexposure for the snow-covered mountains.

TIPS

Try This!

Many cameras include a feature called auto exposure bracketing. With this control, you set up your camera to take a series of photos (most often three, though some cameras do more) where one is at the exposure chosen by the meter, one is at less exposure, and one is at more exposure. You choose how much of a change there is between exposures. Most of the time, you will find that a half to full stop or step change between exposures works well.

Photo Tip!

There may be times when you want to shoot with more than the exposure compensation available on your camera. In those cases, check to see what exposure the camera is setting, then choose the manual shooting mode with an exposure more or less than the camera meter system recommends. Check your histogram to confirm the exposure.

Avoid blown-out
HIGHLIGHTS

If any photography rule should not be broken, it is that you should avoid blown-out highlights, except when they are unimportant to the subject or you want them for creative reasons. A blown-out highlight occurs when you use exposure settings that make part of the image pure white where there should be details.

The problem with pure white is that you cannot bring detail into a photograph where no detail exists in the image file. An annoying bright area that has no detail cannot be fixed by using the computer. No magic

bullets exist for this condition in image-processing software such as Photoshop Elements.

If your camera LCD has a histogram, it probably also has a highlight alert, which is a feature that shows blinking patches on bright white areas in the photo. These blinking patches mean that you need to decrease the exposure until no more blown-out highlights exist. Watch your histogram, though, because you do not want a gap at the right, either. A histogram clipped at the extreme right also indicates that you need to reduce your exposure.

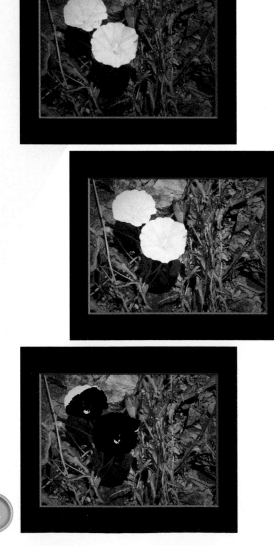

The right exposure holds the detail in these white bindweed blossoms of the California chaparral.

The wrong exposure blows out the detail in the same blossoms.

On many cameras, blown-out highlights appear as "blinking highlights."

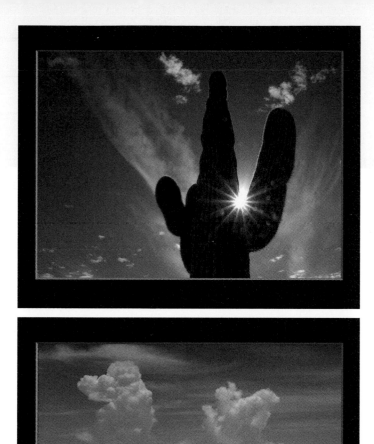

The pure white highlights from the flare around the sun are normal and should not be exposed for detail. This is a well-exposed photo of a saguaro cactus in the Arizona desert.

The white of the clouds is very important to this aerial scene shot while flying over Texas. Overexposure would hurt the texture and form of the clouds.

TIPS

Did You Know?

When shooting with a digital camera, most of the time you should choose exposure settings to properly expose for the highlight area of a scene. Using image-processing software such as Photoshop Elements, you can often bring details back into an underexposed area; you cannot, however, bring detail back from an overexposed highlight area where all the details are blown out, because there are few or no details in the near-white or pure-white areas.

Did You Know?

One place that pure white is acceptable is in spectral highlights. A *spectral highlight* is a bright spot from a shiny, highly reflective surface. Generally, spectral highlights are small and limited in size.

Shoot multiple exposures to get
MORE EXPOSURE RANGE

Photography and print professionals refer to the range between the darkest parts of an image and the lightest parts of an image as the tonal or dynamic range of a photo. A composition that has very bright parts, such as a bright white sky, and very dark parts where there are deep shadows, is said to have a wide tonal range and can be difficult to capture with a digital camera. The contrast of such a tonal range is often beyond the capability of the sensor.

One way to capture details in the shadow areas and in the highlight areas is to use a special digital technique. By putting your camera on a tripod, you can shoot the identical scene several times but with different exposures in order to capture a range of exposures that covers the dynamic range of the scene. The resulting images can be merged together using a special feature in Photoshop Elements (see task #89). Or sometimes you can shoot once using the capabilities of the RAW format and convert the image twice — once for shadow detail and once for highlight detail. You then merge the two together (see task #88).

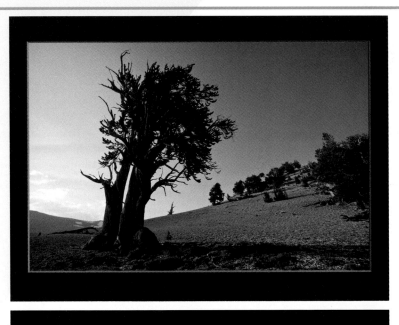

You could easily see bright clouds in the sky as well as great detail and color in the bristlecone pine's wood while standing at this scene, but the camera could not. This is a normal sort of exposure, about the best the camera can do.

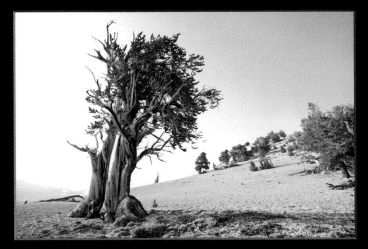

This bright photo was exposed to get a good rendering of the wood on the bristlecone pine.

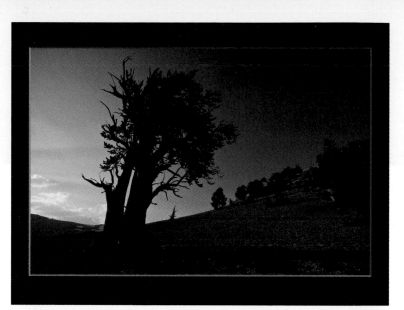

In this shot, exposure was based on getting good results from the sky and revealing the clouds at the lower left.

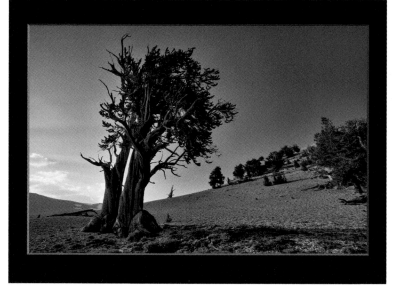

The final shot shows the combination of the good parts of the three exposures so that a more accurate rendering of the scene can be shown, rather than the incorrect interpretation that was limited by the sensor's capabilities.

TIPS

Did You Know?

Many photographers use a graduated neutral density filter to enable them to capture a wide dynamic range. This filter is half dark and half clear with a gradual blend through the middle. It can be a very useful tool to help limit bright light from part of the scene (such as the sky) while allowing dark areas to record normally (such as the ground), so that the sensor can better handle the tonal range of the scene.

Photo Tip!

You can expose a scene with a wide dynamic range to get excellent silhouettes. Silhouettes are dramatic pictures that look great if you keep the silhouettes dark from underexposure while you keep the background (such as a sunlit hillside) bright, but with detail and color. Check your histogram and LCD review to be sure you got the right exposure. You can always darken the silhouettes to pure black in an image-processing program such as Photoshop Elements.

Chapter

4

Control Sharpness and Depth of Field

Modern cameras and lenses enable you to take very sharp photos; however, incorrect focus, limited depth of field, and subject and camera movement sometimes produce blurry, unattractive images. Although sometimes you may want to blur a photo for artistic effect, blurring is usually a symptom of a poor-quality photo.

Although you need to understand how to control sharpness in a photo, it is equally important to be able to visualize the effect that you will get from shutter speed and depth of field. For example, you should know how depth of field is affected when you change the aperture setting from f/4 to f/8. One nice

feature of digital photography is that EXIF data — information including the shutter speed and aperture used for a particular photo — is saved with your file. Study your shots using the EXIF data and you will get better at choosing your settings. See task #46 to learn more about EXIF data.

Focus, shutter speed, and depth of field are three variables that enable a digital photographer to shoot more creatively. To develop the "mental view," shoot a series of photos as you try various combinations of these controls and then learn from their differences.

USE A TRIPOD
for top sharpness

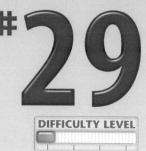

Lenses made for digital cameras are very sharp. To consistently get the full sharpness from those lenses, you need to own and use a tripod. A tripod is especially important when you shoot in low-light levels and use a slow shutter speed. The longer the focal length of lens you use, the more important it is to use a tripod because the magnification of the telephoto also magnifies any camera movement during exposure, which blurs a photo.

Besides enabling you to consistently take sharply focused photos, a tripod also makes it easy for you to shoot a more precisely and carefully composed photo.

Carrying and using a tripod can seem like a nuisance at first. However, once you discover how much of a difference it makes, it will be hard for you to take photos without one. Photographers that regularly use a tripod get better photographs. Carbon-fiber tripods are more expensive than aluminum, but they are also lighter and are more likely to be carried and used by a photographer.

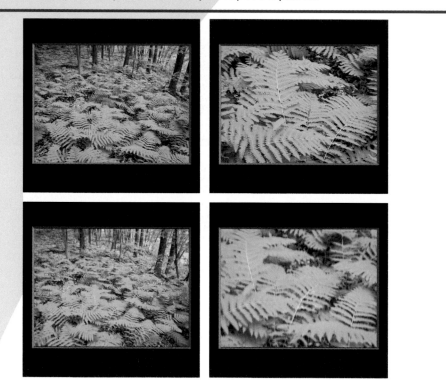

Compare these two photos. The first is shot with a tripod, the second is not. Blur causes the second to look just a little duller.

This enlargement shows the difference between the sharp image shot using a tripod and the blurry image resulting from camera movement occurring during a slow shutter speed.

SHOW ACTION USING
a fast shutter speed

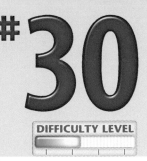

The world is full of fast action, and you can stop it in your photos by using a fast shutter speed. Choose at least 1/500 for fast action or you will get some blurring of your subject. Faster shutter speeds of 1/1000, 1/2000, and so on, give you even more options for stopping faster action.

Action is hardest to stop when it is close to you and moving across your image area from one side to another. Action gets easier to stop (and allows a slower shutter speed) when it moves toward or away from you and is farther away. Still, it can be helpful to check your LCD review to be sure your images show

that you are stopping action with the right shutter speed.

DIFFICULTY LEVEL

You may have to use your widest f-stops paired with fast shutter speeds and even change your ISO setting as your shutter speeds need to be faster. As shutter speeds get shorter, less light gets to the sensor, often requiring you to increase the ISO setting. Although there can be a trade-off in increased noise, it is still better to have sharp action with noise than blurry action without.

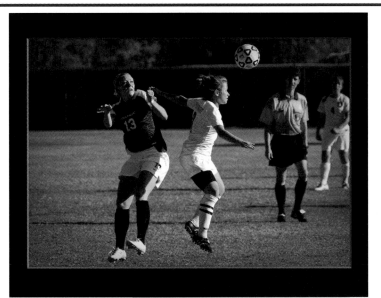

A 1/2000 shutter speed stopped this soccer action. The lens was used with its widest aperture, and the ISO setting was increased to 400.

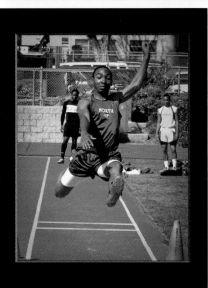

This long-jumper was captured at 1/500, also with the lens shot wide open to allow for the fastest shutter speed.

SHOW ACTION USING
a slow shutter speed

#31

Action looks great frozen in a photograph due to the use of a fast shutter speed. However, you can gain a really creative effect that shows action as movement-in-progress by using a slow shutter speed that blurs your subject. In general, this means shutter speeds of 1/15 second or less, but it depends on your subject. To avoid getting a blurred background, use a tripod to limit the blur to the moving subject. Try shots both with and without a tripod.

Choosing the right shutter speed is critical. Choosing one that is too slow yields too much blur, but choosing one that is too fast eliminates any sense

of movement. The digital camera is ideal for this because you can experiment with different speeds and quickly check the results on your LCD.

If the light is too bright, you might not be able to get a slow enough shutter speed. In such cases, you can use a neutral density filter (a dark gray filter) to block some of the light entering the camera, which enables you to choose a slower shutter speed. To learn more about photographing with a neutral density filter, see task #51.

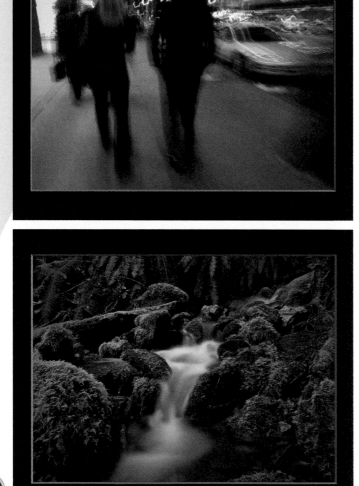

A 1/2-second exposure captured the feeling of movement on the nighttime streets of New York.

A 10-second exposure created the soft look to this small stream in the Olympic National Park in Washington.

Add drama by
PANNING

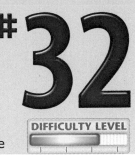

#32

DIFFICULTY LEVEL

Another technique for showing action is to follow a horizontally moving subject with your camera while using a slow shutter speed. This is called *panning* and gives varied effects depending on the shutter speed. The result can be a dramatic photo showing the subject in a variety of blur/sharp views contrasted with a nicely blurred background with blurred horizontal lines that emphasize the movement.

The challenging parts of this technique are to choose the right shutter speed, pick the right background, and pan with the subject so that the moving subject is not double-blurred because the panning speed does not match the speed of the moving subject.

Getting the effect you want when panning requires a lot of experimentation and practice. Do not get hung up on a lot of details: Just set a slow shutter speed and photograph a moving subject as you follow the movement with your camera, and then check your LCD to see the image you captured. You will get a lot of junk, but you will also start finding some interesting and creative interpretations of movement.

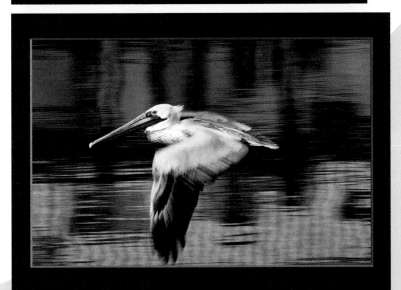

A 1/2-second exposure while panning with the action captured the feeling of movement of this horse and carriage in St. Augustine, Florida.

A shutter speed of 1/125 was used to freeze the flying pelican against the wonderfully colored and blurred background of a seaside harbor.

Understanding
DEPTH OF FIELD

Depth of field is the amount of sharpness in your photo from front to back. Depth of field is affected by distance to the subject, focal length, and aperture or f-stop. The farther you are from the subject, the more depth of field increases; the closer you are, the more depth of field decreases. If you photograph a distant scene, you can just about use any aperture and get enough depth of field. But if you are doing close-ups, you need to check your f-stop and focal length if you want deep depth of field.

Wide-angle lenses give more apparent depth of field than telephotos. In fact, short focal length lenses of any kind increase depth of field, which is why compact digital cameras have a lot of depth of field (the lenses have very short focal lengths).

As you change your f-stop, you change your depth of field. Here is a set of f-stops starting from wide or large to small: f/2, f/2.8, f/4, f/5.6, f/8, f/11, f/16, f/22. Depth of field increases as the f-stop is changed toward f/22, and it decreases as the choice goes to the front of the line at f/2.

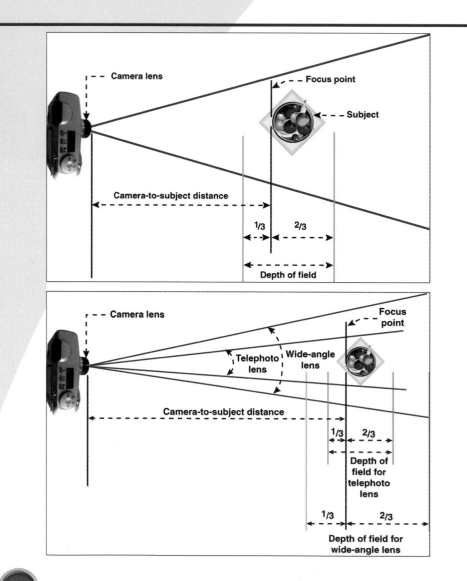

Depth-of-field sharpness is not evenly spaced around the focus point. At normal distances, one-third of the depth of field is in front of the focus point, and two-thirds is behind the focus point.

Shorter focal length lenses (wide-angle lenses such as 28mm) have more apparent depth of field than long focal length lenses (telephoto lenses such as 100mm).

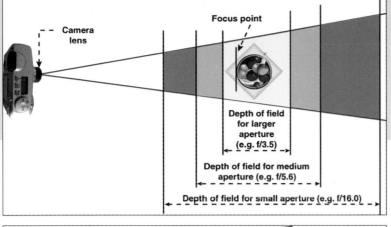

Aperture size or f-stop is a key factor in depth of field. Small apertures result in greater depth of field. Wide f-stops result in less depth of field.

#33

DIFFICULTY LEVEL

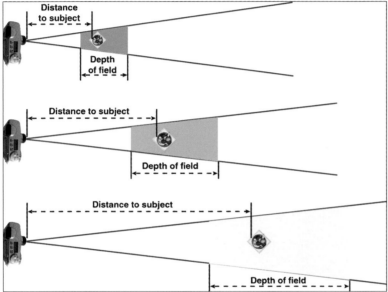

Camera-to-subject distance also affects depth of field. The farther away a subject is from the camera, the greater the depth of field will be.

TIPS

Did You Know?

The larger the aperture, the "faster" the lens is because it lets in more light than a slower lens or one with a smaller aperture — in the same amount of time. A fast lens can be very useful in low-light conditions but is also much larger and heavier than other lenses.

Photo Tip!

When you want the maximum depth of field and you are shooting in low light, or you are shooting close-up shots, you may find that the movement of the camera caused by pressing the shutter release button results in unwanted image blur. To avoid this, use a tripod and set the self-timer so that the camera can take the photo without you pressing the shutter release button.

Control focus creatively with
DEEP DEPTH OF FIELD

Deep depth of field can be dramatic. A landscape, for example, that is sharp throughout the image is a classic way of capturing such a scene. If you are at a distance from your subject, you will find that with wide-angle and moderate focal length lenses, standard image sharpness covers your scene with almost any f-stop you set.

When this changes, though, you cannot simply use any setting that program mode autoexposure provides. If you are close to the subject, if you want to have sharpness starting with something close and going way back into the background, or if you are using a telephoto lens, you need to select a small aperture to get maximum depth of field.

Use aperture priority exposure as described in task #23. Choose one of the smaller f-stops your lens allows, such as f/11 or f/16 for a digital SLR or f/8 for a compact digital camera. Remember that small apertures often result in slow shutter speeds that require the use of a tripod or some other way of supporting your camera during the exposure.

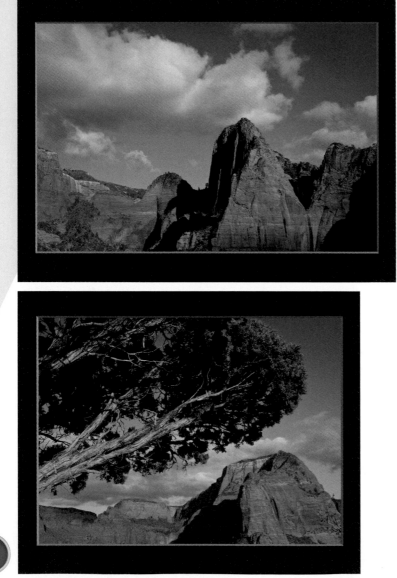

A distant scene, such as this rocky landscape of Zion National Park in Utah, generally has enough depth of field at standard, program autoexposure settings.

A wide-angle lens combined with a small aperture makes it easy to get great depth of field in a landscape (f/13 and 19mm).

This image was taken with a small f-stop of f/16 and a wide-angle lens to give this intimate landscape a deep depth of field.

This image was taken with a small f-stop of f/13 in order to guarantee all parts of this scene from the nearest buoys to details in the background were sharp.

TIPS

Did You Know?

Sharpness and depth of field are affected by the size of the print. A small print often looks sharper than the same image printed much larger. Larger images can dramatically show off a great photo, but they also magnify any faults in the image, including sharpness problems. Depth of field actually appears to shrink with larger prints.

Photo Tip!

Most digital SLRs have a depth of field preview button. This button can help you see the sharpness in an image as you look through the viewfinder. It stops the lens down to the taking aperture. This makes the image very dark, but if you look closely (and this may take some practice), you can see how the background sharpness changes as the f-stop is changed.

Create cool effects with
SHALLOW DEPTH OF FIELD

Many beginning photographers always try to get everything in focus. That is not always practical (you may have to use too slow a shutter speed) or even effective with your subject. A shallow depth of field, where the subject is sharp and surrounding objects in front of or behind the subject (or both) are soft from lack of sharpness, can create a dramatic image that viewers can clearly see. In addition, a shallow depth of field can help your subject stand out against what would otherwise be a confusing background if sharp.

Photography is all about controlling a wide range of variables and understanding the effects you get. When you use a longer focal length, a wide-open aperture, or a close distance to the subject in order to get a shallower depth of field, you are specifically controlling what your viewer can and cannot see in a photograph. This can be a very strong way of showing off your subject and giving some power to your composition.

A wide-aperture or f-stop setting plus a telephoto lens limits depth of field, as seen in this photograph of goldenrod flowers photographed at f/5.6.

Here, a telephoto lens combined with a wide aperture of f/4 softens the foreground and background, which makes the thimbleberry flowers stand out.

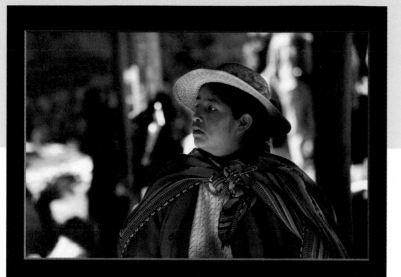

This image was taken with both a telephoto and a wide aperture of f/5.6 to separate this Peruvian woman from the busy market around her.

Using a lens with a long focal length and selecting a large aperture created a shallow depth of field to isolate the fall leaves from rest of the photo.

TIPS

Did You Know?

Due to the small size of the image sensor used in many compact and pocket digital cameras, the lens has a very short focal length, giving it inherently more depth of field. If you mostly want to shoot photos with maximum depth of field, such a camera is wonderful. If, instead, you want to be able to shoot subjects with blurred backgrounds, try stepping back, and then zooming to the longest, most telephoto focal lengths and selecting the widest possible f-stop setting.

Photo Tip!

When you are taking a portrait, try using a long focal length with a wider f-stop (such as f/4 or f/5.6) to get a small depth of field to focus attention on your subject and to blur the background. This also allows a faster shutter speed, helping to make sure the sharp part of the image is as sharp as possible.

Understanding
FOCAL LENGTH

Technically, *focal length* is the distance in millimeters between the optical center of the lens and the image sensor in a digital camera when the lens is focused on infinity. However, focal length by itself does not describe how much of the subject is seen in the image area, as is commonly thought. This is affected by the angle of view, which is highly dependent on both the focal length and the size of the image sensor (this has always been true with film, as well, where the film size changed with format type).

To make it easy to compare angles of view, the camera industry often uses the term "35mm equivalent focal length." This is simply a way to compare focal lengths to a single reference and does not mean the focal length actually changes. Long focal length lenses (or telephotos), such as a 200mm "35mm equivalent focal length," have a narrow angle of view and magnify the subject within the image area. To capture a wider angle of view, you need a wide-angle lens (or shorter focal length).

35mm "equivalent focal length" is equal to the focal length of the lens X the camera's "focal length multiplier"

You can usually find the focal length multiplier for your camera in your camera's documentation.

A zoom lens gives you a range of focal lengths that can be used as needed. This lens is a 14-42mm Olympus zoom that offers a 35mm equivalent focal length range of 28-84mm.

This photo shows an early morning prairie shot with a 35mm equivalent focal length of 16mm to show off the beetle with its surroundings.

The same scene was then shot with a smaller angle of view to focus in on the details of the milkweed beetle and its leaf by using a lens with a focal length equivalent of 100mm.

TIPS

Did You Know?

Many zoom cameras have an X rating, such as 2X or 4X, which is not directly related to the focal length. It just means that the maximum focal length is "X times" longer than the minimum focal length. For example, a lens with an 8X zoom lens means that the longest focal length is 8 times the shortest focal length. This can be misleading because it does not tell you what you are really getting in angle of view from your lens.

Photo Tip!

Some digital cameras have a digital zoom feature that gives you an even longer focal length than you get with the optical zoom. Optical zoom is done solely through the optics of the lens and uses the maximum quality of lens and sensor. Digital zoom is actually a crop of the center of the composition which is then enlarged digitally — it may help in a pinch but is extremely inferior to optical zoom.

CONTROL PERSPECTIVE
with focal length

When you stand in the middle of railroad tracks that vanish into the horizon, you are experiencing *perspective*. Perspective is also experienced by how you perceive similar objects as they change in distance — they are large when close and get smaller with distance. When using your camera to see perspective, you can use focal length to control perspective and therefore the feeling of depth in a photo. Wide-angle lenses deepen the experience of perspective in a photograph, and telephoto lenses flatten out perspective.

This can be a very creative control for a photographer. Instead of simply zooming your lens to change the size of your subject in the frame, try moving closer or farther from the subject. If you back up and use a telephoto setting, perspective is flattened, bringing the background closer to your subject. Get closer with a wide-angle setting and the background seems to jump back into the distance. Both effects really change the impression of the scene within the photograph and are worth doing some experimenting with.

A wide-angle lens up close created an image with a very deep perspective on these prairie flowers.

A telephoto lens captured perspective of the same flowers with a very different look, where the colors and forms look "flattened" or much closer together.

This photo was taken with a wide-angle lens to give more of a feeling of space and depth along a winter shoreline.

In this photo, a slight telephoto focal length was used to flatten the scene slightly, making the storm look more intense.

TIPS

Did You Know?

Hollywood uses perspective tricks all the time to create drama in movies. For example, the director of photography for an action film might use an extreme telephoto to flatten perspective and compress distance so that it looks like a truck is about to run over the hero, when in fact, the truck is not that close. Or in a romantic film, a wide-angle lens on a heroine alone in a park might be used to deepen perspective and make her look even more alone.

Photo Tip!

One way to discover how strong perspective can be in photographs is to do some experiments with a zoom lens. Try it at its widest focal length and get close enough to your subject that the subject nearly fills the image area from bottom to top. Then zoom into the most telephoto focal length and back up until the subject once again fills the image area from bottom to top. Now compare the images and the relation of subject to background.

CONTROL BACKGROUND
with focal length and aperture

Controlling the background in a photo is often a key factor in getting a good composition. You can easily control the background with a long focal length lens, which has a shallow depth of field and a narrow angle of view. The shallow depth of field helps to create a soft-focused background. The narrow view makes it easier to change the background by moving the camera location to the left or right, or even up or down a few inches, with minimal effect on the composition of the subject.

Several factors determine how much you can control the background. The distance from the camera to the subject and the distance between the subject and the background are two important factors, along with the focal length. The closer the camera is to the subject, the narrower the depth of field will be, which helps to blur the background. Likewise, the farther the background is from the subject, the more you can blur the background. A tripod is a good aid to precise composition and successful control of the background when shooting with a long focal length lens.

The longer the focal length of a lens, the more a slight move to the right or left may change the background. In this first photo, the leaves are seen against dark areas of the background.

In this second photo, the leaves are seen against bright areas of the background for a totally different look to the image.

The softly blurred background with contrasting colors helps to isolate and focus attention on the bluebells in the foreground.

In this image of a mother and child, the background is simplified because a telephoto lens was used to compress distance and to soften what is seen in the background.

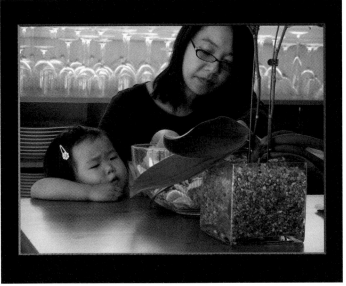

TIPS

Did You Know?

Aperture settings are written as f/4.0 or f/8.0. But, in fact, the aperture size is really a fraction, 1/4.0 or 1/4, and 1/8.0 or 1/8, which means that an f/4.0 aperture is actually larger than an f/8.0 aperture because one-fourth is larger than one-eighth.

Photo Tip!

The greatest depth of field is obtained by selecting the smallest aperture. When shooting with a small aperture, you need to use a slower shutter speed to get a proper exposure. This is why you need to use a tripod when the objective is to shoot with the maximum depth of field.

Chapter 5

Take Better Photos

Taking good photographs has more to do with a photographer's vision than the brand of camera used. The time you spend shooting, reviewing, and digitally processing your photos plus the knowledge you have of your camera is worth more than buying and using expensive photographic equipment. Expensive digital cameras do have certain features that specific photographers need, such as high-speed shooting for sports photographers, but if you really want to improve your photographic success, learn how to shoot better. Learn to choose subjects that you are passionate about. Understand and choose good shooting conditions. Determine your own photographic vision.

You also need time to shoot, study, edit, and wait. You may need to wait for better light, less

wind, or even for the subjects that you want to arrive. When conditions are good and you are ready to take pictures, you must know your camera well enough that you can start shooting immediately without fumbling with your camera. The exciting world of digital photography offers every photographer many benefits that make it easier, faster, and cheaper to learn to make excellent photographs more often than film ever did.

Better photos is, of course, a relative term. A great photo for grandma may be completely different than a great photo for a camera club. However, in this chapter, you learn what it takes to take better photos, regardless of the end use. You learn to recognize what it means to go beyond simply capturing subjects and finding images that you can be proud of.

Top 100

LOOK FOR PHOTOGRAPHS,
not subjects

Today's digital cameras consistently enable the taking of decent, sharp images of a subject — a snapshot. However, a good photograph goes beyond that simple rendering of a subject and becomes something interesting on its own, regardless if a viewer knows the subject or not. A good photograph is the difference between someone picking up a picture and commenting politely on the subject or telling you that you have a great shot. Of course, as photographers, we want the latter.

A photograph is something that is crafted, carefully made with attention to how the image is exposed and composed. A very simple, yet effective, way to focus on the photograph instead of simply capturing a rendition of a subject is to use the review function of your LCD monitor. After taking a picture, look at it in the LCD and ask yourself if you like this "photograph," not just if you captured the subject. How does this little photograph appeal to you on its own, irrespective of its relation to the subject?

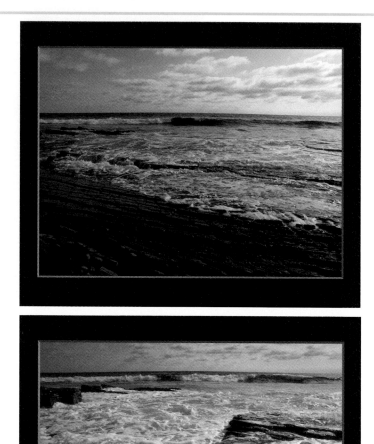

Certainly nothing wrong with this photo of a rocky beach in Southern California, but it is little more than a record shot of this beach. That is okay for a snapshot, but for a good photograph, you want more.

Compare this to the upper photo on this page. This image was crafted as a photograph with careful attention to angle of view, height to the water, and composition. It is a much livelier image.

Certainly not a terrible photo of a birthday girl, but the subject powers the photo, so if you do not care about this girl's birthday, the photo will not hold your interest. The photo contains too many distractions for the viewer to really engage with the girl.

The scene changed here because the camera's zoom was employed to go in close to the girl so you can see her interest and to eliminate distractions. This creates an image that goes beyond a simple record of the birthday party.

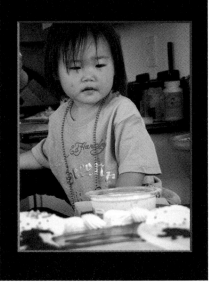

TIPS

Photo Tip!

When you are shooting in less-than-ideal conditions, look for inventive ways to "find the photographs." If the light is bad over a large area, look for the good close-up. Or wind that is too strong to enable you to take close-up photos may help you get creative soft-focus photos if you use a slow shutter speed to capture blowing flowers.

Did You Know?

A surprising number of excellent photographs have been taken in "bad" weather that seems to affect the subject badly. Heavy fog, thunderstorms, and snow blizzards often make for excellent photographs that are interesting beyond the subject. The next time that you think the weather is bad, go shoot and see what you get. It costs you nothing to take digital photos!

Consider the
POSSIBILITIES

Each time that you press the shutter button to take a picture, many different variables come into play, including exposure, composition, lighting, depth of field, angle of view, and ISO setting. If you shoot totally automatically, you still need to make some decisions. To get better photos, think about how you can change the variables to take many different photographs. Pros call this "working the subject."

The more you experiment and study your results, the more you will know what you like and how to further develop your own personal style. Compare your images in the LCD review as you go. This can help you see fresh and interesting photographs that you might have missed if you only looked at the images back home on the computer.

A story that illustrates this: A famous photographer was asked to review another photographer's portfolio. He looked quickly through the images and said, "Take a couple of weeks and go shoot a few thousand more photos." He replied this way because the other photographer had not yet considered enough of the possibilities.

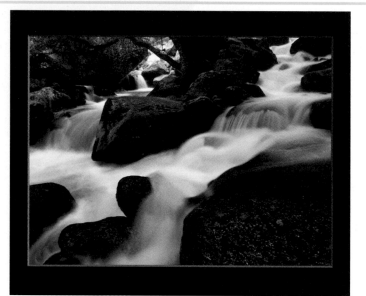

These two photos are of a stream in Yosemite National Park, yet they look dramatically different. The first is a wide shot of the whole stream showing it flowing among the rocks.

This second image came from zooming in on some interesting details of water and rock to give a more abstract-looking photo.

These two images have the same pictorial elements of flowers, sky, and rocks, but they create very different impressions with the viewer. The first photo was shot stepped back from the flowers so you could see the whole bush.

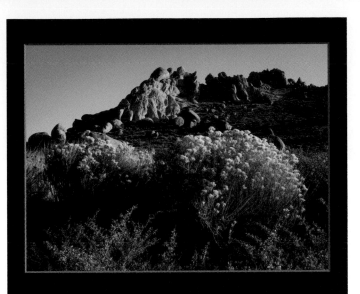

In this shot, the camera position was much closer, almost in the rabbitbrush flowers. This created a different emphasis on what was important in the photo and how the viewer would look at it.

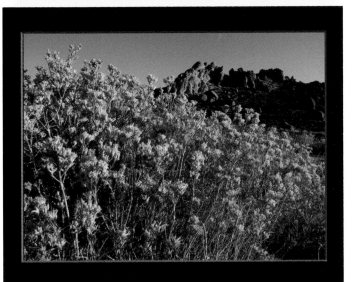

TIPS

Apply It!

You can sometimes get new and interesting photographs by going to extremes. Shoot at extreme f-stops, extreme shutter speeds, and extreme angles of view. A great exercise is to shoot your subject with a zoom lens, shooting one shot with the widest setting, and then the very next with the most telephoto. Do not simply zoom, but find different and interesting photos. Continue doing this until you have shot 20–30 photos. This teaches you a lot about choice and focal length.

Photo Tip!

The sunburst effect from a bright sun in a photo is fairly easy to accomplish with any digital camera that allows you to set your aperture (with either aperture-priority auto exposure or manual exposure). Stop your lens down to one of the smallest f-stops possible with your lens (f/8 with a compact digital camera or f/16 with a digital SLR). Then shoot toward the sun, with the sun in the image and near something dark (for the sunburst to flare against).

Compose for
MAXIMUM EFFECT

How you compose your photo strongly affects how your image affects a viewer and how clearly your subject is shown. The rule of thirds (though really not a rule, but a guideline) gives you some positions in an image where you might place the main subject, horizon lines, or strong verticals. Imagine a tic-tac-toe board overlaid on the image. Horizons often look good placed where the horizontal lines are, and strong vertical picture elements can go where the vertical lines are. The subject then seems at home at any one of the four points where the lines intersect.

Using a digital camera with a zoom lens enables you to try different compositions without having to move as much. You can shoot a wide-angle photo and then zoom in to compose a much tighter view of the subject. The angle to the subject is another important part of composition that you control when you look for high or low places that you can photograph from. Look for creative angles that show your subject or scene in new and interesting ways.

This photo was composed using the rule of thirds. You can see it with and without a grid showing the guideline in action (some cameras even have a rule-of-thirds overlay that can be chosen for the viewfinder or LCD view).

You can see the bristlecone pine tree fits the rule-of-thirds guide very well and creates a nicely balanced image.

The rule of thirds is a good guideline, but not something to follow as if it were law. This photo uses the rule as a start, and then stretches it for effect.

Composition is ultimately about making the subject a star. Keep the photo simple by including only what is needed to support your subject and by keeping out distractions.

TIPS

Apply It!

One way of thinking about composition is to consider it based on these three words: include, exclude, and arrange. What do you include in your photo from edge to edge? What do you exclude from the photo? How do you arrange the elements of the photo? Where does the subject go? Where should the horizon sit? How close to the edges can you place important parts of the scene?

Did You Know?

It takes effort to see new ways to compose. Yet, if you took a dozen good photographers and asked them to shoot the same subject, there would be many, many different compositions. Find a subject and see how many different compositions you can shoot as an exercise to further your composition skills.

Compose for
IMPACT

People see pictures all the time, typically from the minute they wake up until they go to sleep at night. Any photos you create compete with this huge volume of imagery whether you like it or not.

One way of getting attention for your photos is to compose in such a way that your photos have added impact. Impact comes from the use of a technique that grabs viewers' attention and stops them long enough to really look at your photo.

You do not need to make every image have high impact. That can be wearing for a viewer and it can overwhelm your subjects, but having impact in at least some of your photos lifts the quality of all of them.

Impact from composition means finding an uncommon and unexpected composition. Shoot from a high angle for a subject always seen from below, or try a shot with your camera on the ground. Look for compositions that deliberately break the rule of thirds. Search out compositions that are different and unique.

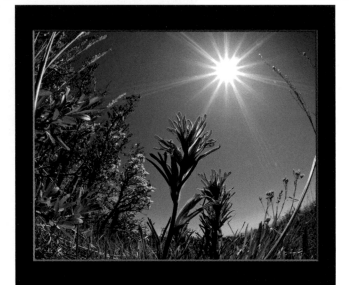

This paintbrush flower image is definitely not your normal sort of composition. It is way outside the rule of thirds and shot from a very low angle with the camera literally on the ground.

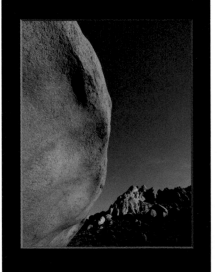

Here you see a very extreme angle where wide-angle focal length is used with the camera very close to the foreground rock.

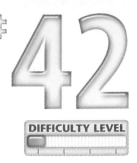

Silhouetting a subject against a sunset is always dramatic, but the photo gains more impact when the subject is kept out of the center of the frame.

Filling the image area with pumpkins gives this image a bold color and dramatic composition.

TIPS

Apply It!

As you shoot photos with impact, remember that simply applying a technique can fight your ultimate photo. How is that? When a technique is not appropriate to the subject, it can overwhelm it, making the subject struggle to be seen by the viewer. The impact technique might create some initial interest for the viewer, but the viewer will get frustrated by the technique's fight with the subject.

Did You Know?

Advertising photographers use high-impact techniques all the time. They must create images that grab the viewer's attention — that is the whole purpose of advertising. Look at ads now with a different perspective. Ask yourself how a compositional technique might have been used to create impact, or see if you can discover other ways the photographer worked to gain attention through something unexpected.

Use the
FOREGROUND

A very effective technique for improved compositions is the use of a strong foreground. You will see that throughout the book because this is one of my favorite techniques. It works well for almost any subject. You can make your subject the strong foreground element, with the background creating an interesting environment behind it; or you can use a strong foreground as a frame that creates depth and compositional impact because of the relationship of the foreground to the background.

You can shoot with a lot of depth of field, as described in tasks #33 and #34, so that the foreground and background are both sharp. You can also create a much different effect by making a foreground framing element out of focus so that it strongly contrasts with the sharp subject in the background, as explained in task #35. What usually does not work is to have the foreground with an "in-between" focus that is neither out of focus nor really in focus (though it can be okay to have a foreground subject sharp and a background not quite as sharp).

The lupine flowers in the foreground come together as a very strong compositional element to the photograph. The abandoned background house creates a setting for the flowers.

A very strong foreground of a shadowed column and its top creates a strong and very graphic composition in this photo.

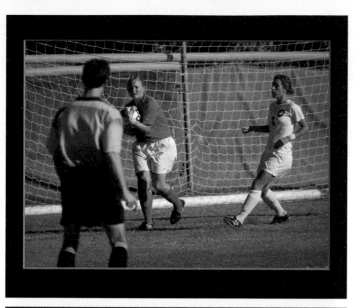

The out-of-focus foreground referee creates a strong frame to the action and gives the image a stronger feeling of reality.

Shooting along a snow-covered dock created a strong foreground frame for a Maine winter sunrise.

TIPS

Did You Know?

Many of the world's most successful and well-known photographers have a style that makes their work notable and can help inspire you to try new ideas. Check out the works of Frans Lanting, Freeman Patterson, Pete Turner, and Annie Leibovitz — to name just a few. David Muench's landscape work is a place to see some great inspiration for the use of foreground in a photo, too.

Did You Know?

If you want to sell your photographs in an art show or display them in a gallery, you are more likely to have your work shown if you have a distinct style, shoot on a theme, or both. A series of random photographs with no connection can be considerably less interesting than a group of photos with a consistent style or theme.

SHOOT DETAILS
to create interest

Although the first and natural inclination is to shoot an entire subject, shooting tightly composed details can create captivating photos. Detail photos often are more interesting than full-subject shots because you can take a photograph that shows either detail that the viewer had never noticed or detail that may cause the viewer to take a closer look while wondering what the subject is.

Capturing just part of a subject emphasizes the detail ordinarily overlooked when viewing the entire subject.

When composing detail photos, look for picture elements such as form, color, texture, or shape.

When shooting details, be aware of the fact that you can shoot an increasing level of detail, too. For example, you can shoot just part of a tree with an interesting shape, such as a specific branch, a few leaves, a single leaf, or even just part of a leaf showing the intricate lines and texture. As you move in to concentrate on increasingly smaller detail, you may want to consider using a macro lens or macro feature.

The close-up photo of this red currant flowering stalk was taken to reveal details and color not as well seen in photographs that show the entire bush.

The wonderful pattern of agave leaves is emphasized by getting close and focusing in on their details.

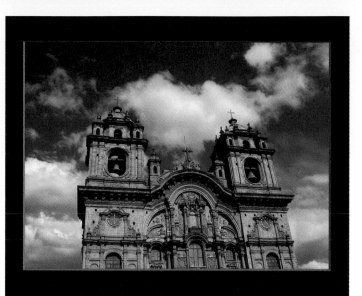

Here is a photo of a church in Cusco, Peru. It is a fine record shot but not as engaging as the detail photo.

This close-up shot of the door of the church in Cusco shows much more color and drama than the overall shot. Plus it shows the viewer details that cannot be seen in the full church image.

TIPS

Apply It!

To catch viewers' interest, take a photo of just part of a subject to let them imagine what the rest of the subject looks like, or to even make them wonder what it is that they are looking at. Also, detail-oriented photos can frequently reveal details to viewers that they would not normally have noticed.

Photo Tip!

When shooting a detailed photo with a small subject, use a macro lens or shoot in macro mode if one is available on your digital camera. Shooting with a shallow depth of field can often add to the success of the photo.

BRACKET
your compositions

One sure way to get better compositions is to *bracket* them. This means taking multiple compositions of the same subject, changing something about the photograph each time.

One way to do this is to take your best photo of the subject, then ask yourself, "Where is the next photo of this subject?" You take that picture, then ask yourself again, "Where is the next photo?" This forces you to really look at your subject and to find true photographs that go far beyond a simple snapshot.

With the digital camera, take a picture and then look at it in the LCD. Look at it and see what you could do differently with that same subject, and then try that shot and review it in the LCD. Do the same thing — look critically at the little picture and ask yourself how it could be changed (not simply improved). Your objective is to try lots of different compositions that may lead you to better shots, not necessarily to make every shot better than the previous one.

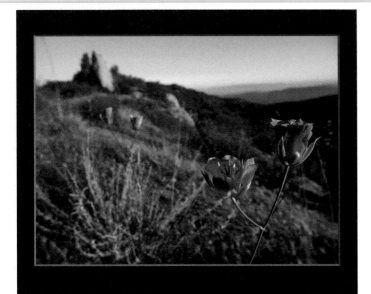

The four photos seen on these pages show an approach to working some spring flowers in the Santa Monica Mountains of California. The first one shows the flowers against the mountaintop scene itself.

In this photo, the camera position is lower so that the mariposa lily flowers are outlined against the sky.

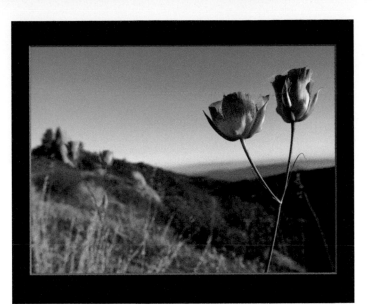

Here, the same low camera position is used, but the camera is closer to the flowers so that they become bigger in the composition.

45

DIFFICULTY LEVEL

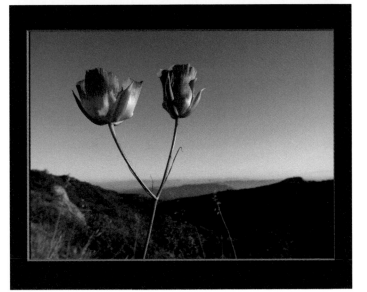

In this final image, the camera position changes, moving to the left so that the background is simpler.

TIPS

Photo Tip!

Turn your camera's auto rotate off to get a better view of your verticals. Auto rotate turns verticals so that they appear vertical when the camera is held horizontally — this puts the long side of the photo into the short side of the LCD and wastes a lot of space. If you do not auto-rotate, you have to rotate the camera to better see your verticals, but you see them at maximum size within the LCD monitor.

Did You Know?

Most photographers rarely shoot verticals. This is partly because cameras are not designed for easy vertical photography. Because of photographers' tendency, then, to mainly shoot horizontals, you can get striking photos that most other photographers do not have simply by shooting verticals more often.

Shoot better by
STUDYING EXIF DATA

When you take a digital picture, the camera records or "writes" the image to an image file, and includes other useful information called *metadata* (literally, data about data) such as the date and time that the picture was taken. The camera also records settings such as shutter speed, aperture, exposure compensation, program mode, ISO speed, metering mode, and flash information.

All this photo-specific information or metadata is written to the image file in an industry-standard format called the *EXIF* (exchangeable image file) format. Most image-processing software today, including Photoshop and

Photoshop Elements, allows you to read this data in a file info or similar menu option. Your operating system also allows viewing of basic metadata such as shutter speed and f-stop used. With a PC, right-click the photo and look at its Properties. With a Mac, you can right-click or Control+click a photo and choose Get Info. Also, you can read EXIF data from image-management applications such as Adobe Photoshop Lightroom, and ACD Systems ACDSee (www.acdsystems.com). Metadata also includes information that you can write to the file, such as copyright and caption information in the IPTC data (International Press Telecommunications Council).

View EXIF Data in Your Camera's Display

EXIF data can help you learn from your photos by checking things like shutter speed or f-stop. Check your camera's manual to see how to display it on your camera.

View EXIF Data in Photoshop Elements Editor

1 Open the file with the EXIF data you want to view, and then click File.

2 Click File Info.

The File Info window opens.

③ Click the Camera Data tab to reveal your camera's EXIF data, including the shutter speed, f-stop, ISO, and focal length settings.

④ Click the Description tab and enter data about your image, such as a description or copyright information.

⑤ Click OK when you are finished working with the EXIF data.

TIPS

Apply It!
EXIF data can be useful for learning how to take better photos. After taking a few photos with different f-stops to control the depth of field, or when shooting multiple shots with different exposures using exposure compensation, look at the image and the EXIF data to learn what settings look the best for your photo's needs.

Did You Know?
Besides being able to read the EXIF data that the camera writes into a digital photo file, you can also add your own textual information. Open an image in Photoshop Elements Editor and click File, then File Info to open the File Info dialog box. Click the IPTC tab to show text boxes where you can type image titles, copyright notices, location information, and much more.

TAKE BETTER PHOTOS
with patience, practice, and effort

Photography is an art. As is true with all art, the creation of good art takes practice, patience, and effort. Camera marketers would have you believe that if you buy expensive digital cameras, you can expect to immediately get wonderful photographs. Because you are reading this book, you undoubtedly have discovered this is not true. It is like the story of the traveler asking for directions in New York City, "How do I get to Carnegie Hall?" The New Yorker answers, "Practice, practice, practice."

Then you often must be patient, waiting for the right light, the perfect gesture, the wind to stop, and so on. Time spent shooting and patience to wait for the best shooting conditions significantly affect your photographic success.

Finally, the difference between a snapshot and a great photo often comes from the effort the photographer puts into the picture-taking. Cameras are good enough to take okay snapshots easily, but the great shot comes with that extra attention and effort to create and capture something special.

Sometimes traveling to a distant location can inspire you to find new and exciting photos.

Or just keep a small digital camera with you at all times so you can photograph a special and memorable family event.

That extra effort for a perfect shot may mean getting up before dawn to capture a great sunrise from the top of the Santa Monica Mountains.

Maybe the scene will test your patience as you wait for a grasshopper to crawl to the right position in your composition.

TIPS

Did You Know?

Professional photographers typically shoot a lot of photos. For example, a sports photographer shoots hundreds of images in a single football game, continually striving to get the best shots he or she can. With digital cameras, the cost to shoot each photo is less, and you have the advantage of instantly viewing the photo that you took.

Did You Know?

One of the best ways to learn more about photography is to shoot often and shoot several pictures of the same subject or scene using different camera settings and compositions. Then study the results as you go, by viewing them on your LCD and making changes to your photographic effort as needed in order to improve the shot. You can learn even more by viewing them along with the EXIF data on your computer screen later.

Find photos all year and
AVOID HIBERNATION

When winter comes, many photographers quit taking as many photographs as at other times of year, even to the point of none at all. Yet winter weather can offer some really terrific photo opportunities and help keep your photography skills sharp all year.

There are some things to keep in mind about cold and snow photography. First is that your camera is largely not affected by the cold, but your battery is. Take along spare, charged batteries in your pocket that you can trade out with a cold battery.

Photograph snow and ice with sunrise and sunsets. Winter sunsets are early and often have great color. Both sunrise and sunset color reflects in the snow and ice.

Watch your exposure. Snow is white and should usually look white in a photograph, not gray. Snow scenes often cause a camera to underexpose them. Try increasing your exposure compensation by a full step (most digital cameras have this). This is variable and depends on the light. Underexposure can cause you problems with poor tonal definition and color in the dark areas as well as increased noise.

Cameras often underexpose snow and make everything too dark. Snow should be white and colors should be bright. Use plus exposure compensation to get better exposure.

Sunrise can be cold, but it is also a wonderful time for great colors on the snow. Snow reflects sunset colors well, too.

Get out right after a snowstorm for terrific snow forms and patterns. Remember to be careful of exposure of such white scenes.

48

DIFFICULTY LEVEL

Changing weather is common in winter and is a great time to be out photographing. Photos are possible at these times that you will never see at any other time.

TIPS

Try This!

If you are not comfortable, you will not enjoy photographing. Dress for the weather. Find a pair of flexible gloves with a good grip. A store that sells hunting clothing often has great gloves for photographers, too (although you might have to try out a camouflage fashion). Use a two-glove system when it is really cold — a lighter pair of gloves for shooting, then a large pair of mittens to go over them between shots. Wear warm boots and socks.

Caution!

Never blow on a cold camera because that can create damaging frost, especially on lenses. Also, never bring a cold, exposed camera into a warm, damp room (which can include a car sitting in the sun) — that causes condensation in places you do not want. Put your camera away in a zipped camera bag as it warms up, or put the cold gear or whole camera bag inside a garbage bag before bringing it into a warm room.

Chapter 6

Try Creative Photo Techniques

Although digital cameras make it easy to take snapshots to document the events around you, photography can be so much more than that. To develop your visual eye and increase your ability to effectively use your camera to capture your unique vision of the world, you need to take pictures, lots of pictures. This means getting out to experiment and try different ideas with your photography. The more you shoot and study your work, the better your photography will be.

A great thing about digital is that there is no cost to experiment. If something seems interesting, try it out! See what it looks like on the LCD monitor. Experiment freely with different features on your camera. Push settings to the extreme to see what results

you get. So often photographers get timid when using their camera, afraid to do something wrong. Fear not! You cannot hurt anything by taking pictures. And if you try something and it does not work, so what? You can learn what not to do, then delete the faulty image from your memory card.

Sometimes you will just shoot to play and learn from that play. Playing with a digital camera can be easy and fun, but you have to allow yourself to do it. Many photographers want to make every photo a serious endeavor. Yet, the more you play to see how you can shoot creatively, the more you understand how to shoot well! Have some fun with digital photography!

Top 100

FOCUS ATTENTION
on your subject

You can focus a viewer's attention on the subjects in your photographs in many ways. One way to do this is to simply fill that image area with your subject so the viewer has no other choice than to see the subject. When you frame up a tight shot of a subject, try taking two steps closer to make it even more dramatic in that photo.

Another way to do this is to look for contrast. Contrast in tonality, color, texture, background, focus, perspective, and other visual design elements makes your subject different from the rest of the photo.

The next time that you shoot, look over your scene carefully to find elements that might contrast with your subject. Can you use a telephoto lens for shallow depth of field to contrast sharpness, or can you use a wide-angle lens to contrast a huge expanse of open space with a tiny subject that draws a viewer's attention? Whatever strategy you use, placing more attention on your subject often results in a better photograph.

A telephoto lens and a large aperture were used to make these orchid flowers stand out against a blurred background.

The plain sky behind this egret keeps attention on the bird.

A tight, "up-close-and-personal" composition keeps the focus on the woman's face.

49

DIFFICULTY LEVEL

A low angle keeps the umbrella contrasted with the blue sky.

TIPS

Photo Tip!

Use a telephoto lens when you want to isolate a subject from its background. Long focal length lenses have a shallow depth of field, and they therefore enable you to show a sharply focused subject against a soft, out-of-focus background. When you want to isolate a subject with a telephoto lens, use a large aperture setting to keep your subject in focus while creating a soft background. See tasks #33 to #38 for more about focal length and depth of field.

Photo Tip!

Sometimes the best way to focus attention on a subject is to keep your composition as simple as it can be. This strategy helps to minimize the number of distracting elements that may compete with the main subject.

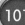

Shoot color for
DRAMATIC PHOTOS

Color is a tremendously powerful part of a photograph. It is more than simply "realistic" or a reflection of the world in color. Certain colors evoke emotions and create moods; others blend in and are hardly noticed. Red, for example, is always a color that is quickly noticed, even when it takes up a small part of a photo. Scenes or subjects can go from spectacular to relatively uninteresting, depending on the colors contained in the image frame. Heavily saturated bold colors can be dramatic, but so can soft, subtle colors — the key is to look at the colors available to you in a scene and consider how they make or break your photograph.

Also, look for deliberate color contrasts. Move so your subject contrasts with colors behind it. Complementary colors create very strong color relationships, such as red/green, blue/orange, and yellow/violet. Another great contrast is saturated (the most vibrant) against unsaturated (or dull) colors. A third to look for is cold and warm contrast, but you can also look for an image with all similar colors for a very distinct mood.

The bold yellow flowers gain even more drama because of their contrast with the blue sky.

This is not simply a photograph of a type of red clover. It is also a photo about color as the small area of red contrasts with a large area of green.

The predominate green of this photo of sumac leaves sets off and accentuates the red leaf. Another way of looking at it is that the red leaf is an accent color to the green.

DIFFICULTY LEVEL

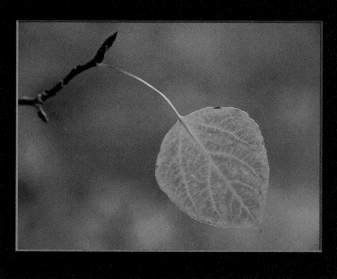

Simply emphasizing one bold color backed by similar colors in a photo can also be an effective way to use color photographically.

TIPS

Did You Know?

Color can sometimes say more in a photograph than the subject. Bold, contrasting colors that are balanced between the subject and its surroundings can give the viewer an entirely different impression of the photo and subject compared to a shot where bold colors overpower the subject.

Did You Know?

Some colors are more appealing than others. One of the reasons that the time just before and shortly after sunset is known as the "golden hour" is that the rich, warm, golden light bathes subjects in a very attractive rich, warm color. In contrast, colors in the blue family illuminate scenes in a cool, less-friendly color.

Show movement with a
NEUTRAL DENSITY FILTER

DIFFICULTY LEVEL

A slow shutter speed records a moving subject as being partly to wholly blurred and offers you a great way to interpret movement. However, sometimes you cannot choose a slow enough shutter speed when shooting in bright light. Limitations of available apertures may require a shutter speed too fast to show motion. In such cases, you can use a neutral density filter to get a longer shutter speed.

A *neutral density filter* is nothing more than a dark, neutral-toned glass lens filter that reduces the amount of light that gets to the image sensor in your digital camera without having any effect on color.

Neutral density filters are usually rated as 2X (also labeled 0.3), 4X (or 0.6), and 8X (or 0.9), and they decrease the light by 1, 2, and 3 stops, respectively. Hoya and Singh Ray filters even include variable density filters. Generally, when you use a neutral density filter and a slow shutter speed to show motion, use a tripod.

To learn more about showing motion in your photos, see tasks #31 and #32.

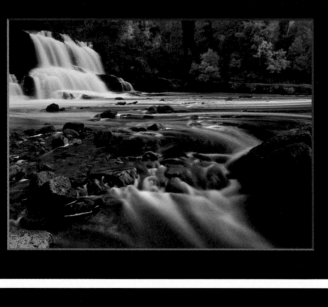

The combination of light clouds, f/22, and a neutral density filter allows an exposure of 10 seconds to show off the movement of this water.

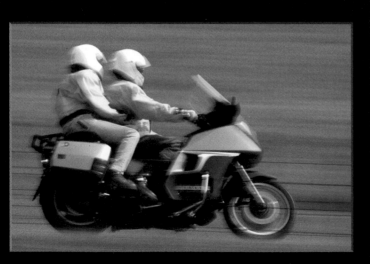

Without the use of a neutral density filter, this photo of a motorcycle could not have been taken because there was too much light to use a slow enough shutter speed to create this panning effect.

Control color and reflections with a
POLARIZER

A *polarizer* is a filter that attaches to your lens. Polarizers have three primary uses: to intensify skies, to remove light reflections, and to enhance or deepen the color saturation in outdoor scenes. When you use a polarizer to intensify skies, you gain the strongest effect when shooting at a right angle to the sun. All polarizers can be rotated, which enables you to control the level of the effect.

To affect reflections on glass or water, look through the polarizer and rotate it until the reflections diminish. A polarizer is useful, for example, when you want to shoot through a glass window and show what is on the other side, or to shoot toward water and show what is beneath the surface. For outdoor scenes, the polarizer removes glare from shiny surfaces such as rocks or leaves, allowing the color underneath to show through.

When you use a polarizer to enhance colors, watch what happens to the scene as you rotate the polarizer. Be careful not to overuse the effect because it can result in a contrasty and harsh-looking photo.

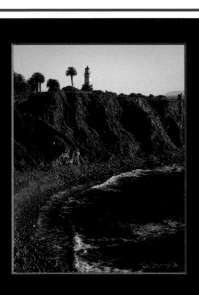

A photo taken without a filter shows okay colors, but nothing dramatic.

A polarizer was used for this photograph. It darkened the sky, enriched the color on the cliffs, and made the water look better as well.

Shoot photos for a
PANORAMA

For as long as photographs have been taken, it has always been a challenge for photographers to capture the beauty found in wide-sweeping scenes. Wide-angle lenses do okay, but often show too much foreground or sky. Digital photography gives you the opportunity to shoot multiple photos across a scene, and then stitch them together in a long panoramic shot by using one of the digital stitching applications or a feature such as Photoshop Elements Photomerge.

You do have to carefully shoot images for stitching so that they blend together seamlessly. No matter what you do, you must overlap each photo by one-third to one-half so that the images have duplicate detail to allow a seamless blending. Using a tripod is important, plus keeping the camera level so the individual shots line up properly. Finally, maintain the same exposure and white balance throughout your photos (it often helps to use manual exposure for that purpose). Avoid shooting moving subjects such as clouds or ocean waves that make photos too different to be combined.

These four overlapping photographs of a landscape in the Alabama Hills near Lone Pine, California, were taken with a camera mounted on a tripod with a head that allows panning.

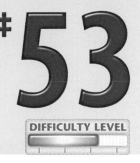

This photo was created by digitally stitching together the four photos shown on the previous page. Photoshop Elements was used to stitch the images together.

TIPS

Did You Know?

You can use the Photoshop Elements Photomerge feature to combine multiple photos both horizontally and vertically across a scene into a single, large photo. If your digital camera does not have a wide enough focal length to capture what you want of a scene, you can shoot overlapping photos that cover the entire area you need captured both left and right as well as up and down, and then combine them in Photomerge. Follow the same ideas discussed about photographing a panorama.

Did You Know?

You can take multiple photos of vertical subjects and create vertical panoramas as easily as you can create horizontal panoramas. Good subjects for vertical panoramas include tall trees and buildings. Shooting from a distance with a telephoto lens can help minimize unwanted perspective distortion caused by using a lens with a shorter focal length.

Did You Know?

You might wonder why not shoot a scene with a wide-angle lens and simply crop it to a panoramic frame. You can certainly do that, but you also have to realize that two challenges arise from that technique. First, you can shoot wider with a multiple image panoramic than you can with any wide-angle lens. Second, a cropped image is a much smaller image compared to what you get when you combine multiple photos.

 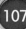

Shoot photos with a "WOW!" FACTOR

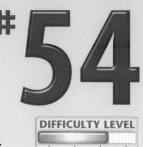

DIFFICULTY LEVEL

Photographs are everywhere. You see them almost from the time you wake up until the time you go to bed. For your photos to stand out in that crowd, you need to at least occasionally make pictures that really grab viewers, photos with a "Wow!" factor.

You do this by finding images that are unexpected and surprising for the viewer. A beautiful photo of a mountain looks like a lot of other beautiful mountain photos unless you can find a way to really make it different. Sometimes the trick to getting a photo with a high "Wow!" factor is being in the right place at the right time and then using your skills to capture the perfect shot.

However, you can get "Wow!" images more often by deliberately looking for ways that compel the viewer to get involved with the image. Great ways of doing this include the use of striking, unusual color; a new angle of shooting for a particular subject; great timing that captures action not usually seen; and exceptional light on the subject, light that goes way beyond simple illumination.

A unique and striking moment of action in a soccer game gives a "Wow!" factor to the photo due to timing and shutter speed.

Waterfalls are always attractive, but it takes something extra to gain a "Wow!" image from the popular Bridalveil Fall in Yosemite National Park, such as bold contrast in light and dark from a low sun nearing sunset.

Shoot scenes with
LOW CONTRAST

DIFFICULTY LEVEL

Soft, diffused light tends to reduce contrast and can be used to produce wonderful photographs. Unlike bright light that can create more contrast than you can capture on an image sensor (or film), soft light enables you to show good detail in all parts of an image, and it enables you to get excellent, smooth gradations that can make superb photographs.

Learn to look for low-contrast light and take advantage of it when you find it. Early morning or late-evening twilight is usually a good time to find low-contrast light with good color. Mist, fog, haze, or clouds can also create excellent low-contrast light that is a joy to shoot. Besides reducing contrast, these lighting conditions can also reduce color saturation and enable you to capture monochromatic images that can be simple and powerful.

Finding low-contrast light is not always easy. Some geographic areas rarely have anything but brightly lit skies, and other places are known for rarely having direct sunlight. Being able to shoot in low-contrast light is often a matter of place, time, and chance.

A morning fog reduced the contrast in this California landscape, giving a rich tonality to the scene and proving you do not have to have sunny weather for great shots.

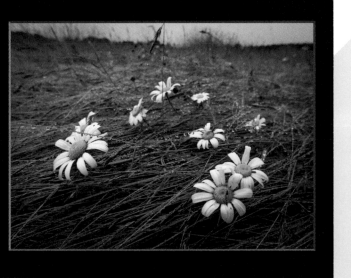

A rainy day gave a unique look to these flowers in a Maine field.

Shoot in
ALL SEASONS

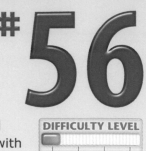

DIFFICULTY LEVEL

As the seasons change, you always find excellent opportunities for great photos, yet some photographers bring their cameras out only at certain, limited times. If you want to expand your photographic skills and gain the best possible photos, get out and photograph through the whole year in your area. In early spring, you can find new buds that can be fascinating to watch as they open. Spring also brings a nice contrast between the dark browns of winter plants and the green colors of the new spring plants.

Summer brings lush greens and many flowers at its beginning, with shades of brown and hints of fall appearing toward the end. Undoubtedly, the rich bold colors of fall can be a key factor for getting extraordinary photos that are hard to match when shooting at any other time of the year. Winter brings new opportunities with its bold, stark patterns and forms that will challenge you to improve your composition skills. Do not let your camera hibernate!

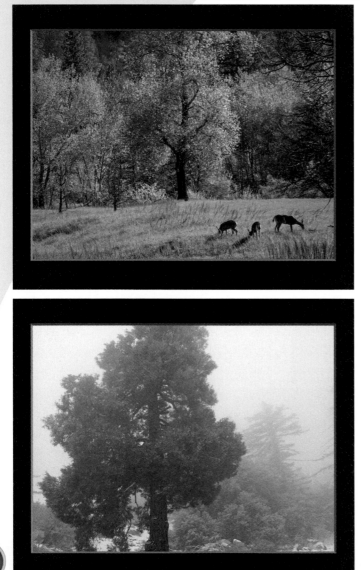

Spring is a time of new growth and wonderful soft greens. Wildlife is often more active then, too.

Winter requires warm clothing, but it can also offer great opportunities for striking photographs.

Shoot
PATTERNS AND SHAPES

As a photographer, you can choose from many pictorial elements to draw attention to your photographs. Patterns and shapes can often become the strongest elements in a photograph, and you can find them everywhere after you develop a skill for noticing them and capturing them with your camera.

Our minds are always working to make sense of what our eyes see by looking for patterns and shapes in the complex and often over-cluttered environment in which we live. The result is that patterns and shapes are pleasing. Patterns are formed by the repetition of objects, shapes, lines, or colors. Sometimes it is the pattern or shape that makes a photograph a good one, rather than the subject itself. In fact, many good photographs feature a strong pattern or shape made by something not even recognizable.

DIFFICULTY LEVEL

When you find a pattern or shape, think how you should shoot it to make an interesting photograph. Perhaps you can use light to make a silhouette of a shape, or maybe even use a strong light to strengthen the pattern or shape.

A pattern of ferns fills the frame and creates a lively image.

Several patterns are at work in this image: the pattern of repeating support beams, the pattern of arch shapes, and the pattern of light, dark, and color in the windows.

COMBINE
flash and ambient light

An effective way of giving your photos a very professional look is to use flash and balance its brightness to the ambient or existing light so that the camera records both. Most digital cameras allow you to use fill flash with existing light quite nicely, as explained in task #15.

However, this task is about using flash as a pure light source, not simply something to fill shadows. To do this well, use an accessory flash for your camera that gives you enough power to deal with bright ambient

light. In addition, a flash cord helps get the flash off-camera for a more directional light. Most cameras have a setting that automates the exposure between flash and ambient light, but it varies from one manufacturer to another. Check your manual. Also, try keeping your flash at its normal strength while you turn down the exposure for the ambient light for a most dramatic effect — a simple way of doing that is to shoot manual exposure and use a shutter speed that underexposes the ambient light.

This is a standard photo of a zebra at a drive-through animal park. The light is rather bland.

This is the same zebra shot at the same time! This image shows how flash and shutter speed can change an outdoor scene. The background is made dark by using a fast shutter speed with the camera on manual exposure, and the zebra stays bright from the flash used on automatic.

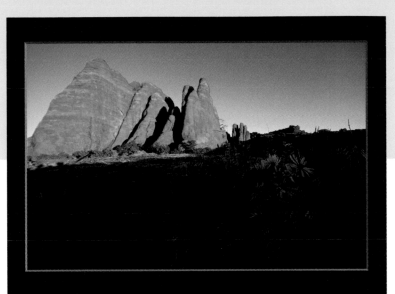

This low-angle shot of a scene in Arches National Park was exposed to make the rock formations look good. The shadowed area is too dark.

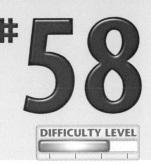
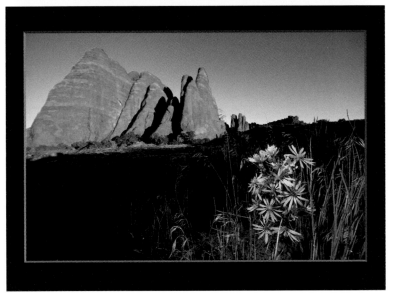

Now a flash is held off-camera to the left to light the fall-blooming aster, while the existing light lit the rocks behind.

TIPS

Photo Tip!

Try modifying your flash so that it gives a less harsh light. Many modifiers are on the market, such as those from LumiQuest, which spread out the light over a reflector or diffuser. This, in turn, makes the light gentler on the subject, giving smoother tonal gradations from highlight to shadow.

Did You Know?

The exposure for the ambient or existing light is based on shutter speed plus f-stop. The exposure for flash is based on f-stop only — shutter speed affects whether the flash is recorded (sync speed or slower) or not (faster than sync speed). When you combine flash with ambient light, you are essentially making a double exposure — an exposure for the flash and an exposure for the ambient light. This is why you can use shutter speed to make the ambient light darker and have no effect on the flash exposure.

EXPERIMENT
to create unique photos

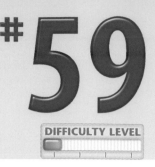

DIFFICULTY LEVEL

One of the best ways to really expand your photography is to experiment freely to find new ways of getting better images. Remember that taking pictures with digital cameras costs nothing, so you can break all the photography rules and guidelines that you know as you experiment. Shoot with a slow shutter speed without a tripod. Zoom or pan your lens with the shutter open while shooting with a slow shutter speed. Shoot a subject that you ordinarily do not shoot. Take 20 photos while shooting from ground level. Take 20 photos with your camera set to the smallest aperture. Shoot using extremes — extreme vantage points, extreme focal lengths, extreme aperture settings, and extreme distances to the subject.

When you shoot a popularly photographed subject or scene, think carefully about all the obvious and common shots that are taken and then try to come up with new ways to shoot the same subject or scene. Change the angle of view or the vantage point, or shoot from a distance and frame the subject with some foreground element. Experiment and think about how you can apply the good results to other subjects.

A slow shutter speed was used as the camera moved downward during the exposure. In addition, a cooler white balance setting than normal was used for this moody image.

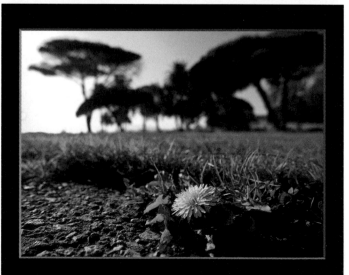

The camera was literally set on the ground to capture a very unique view of a commonly available subject.

SHOOT AT NIGHT
for drama

Night exposures used to be difficult with film. Exposure was unpredictable and colors could shift. You never knew what you would get. Digital changes all of this. Now anyone can get great night shots. With the camera's LCD review, you immediately know if the shot looks good or not so you correct any problems while you are still with the subject. Long exposures and night scenes create rich, glowing colors that can make spectacular photographs. City streets at night, building interiors, or nighttime reflections in windows are good subjects to shoot.

In addition, digital gives you a lot of options as to how to render the colors of the lights. A daylight white balance setting creates a warm scene, and tungsten makes the lights more neutral (and may actually make it seem colder because you expect night lights to be warm).

When you shoot in low-light levels, you can try using the highest ISO settings on your digital camera along with the widest aperture. This can get you handheld street scenes. For other shots, use a tripod to get the sharpest photographs.

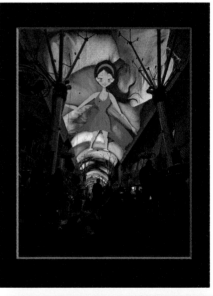

A wild scene in the covered area of downtown Las Vegas was shot with a camera braced on the ground, using a tungsten white balance.

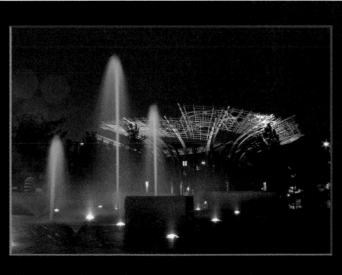

A dramatic nighttime scene outside of Dallas, Texas, was created with a camera stabilized with a beanbag and with a daylight white balance.

Organize Photos with Photoshop Elements

Because there is no cost to take pictures with a digital camera once you own the camera, you will likely find that you take a lot of pictures. That can be a lot of fun because the result is that you have more good photographs and more pictures of subjects you care about. The challenge now is what to do with all of these pictures so that you can find them when you need them.

A number of programs on the market today let you organize and work with your photographs. Photoshop Elements is a good choice for many photographers because it offers a complete package of organization and image processing at a low price. The latest version of this program, Photoshop Elements 8, expands on

past versions and adds some useful new features for photographers that can make the upgrade well worth the cost.

Organizing your photos requires some discipline because no program can actually do this for you. Photoshop Elements gives you the tools you need to get your photos organized, but cannot do the actual organizing work. In this chapter, you learn how to use Photoshop Elements to import your photos, to sort good pictures from bad, to group your photos into albums that allow you to find pictures more easily, as well as other organizing tasks. In addition, you learn how important it is to back up your pictures to keep them safe for future use.

Top 100

IMPORT
your photos

First things first. In order to work with your images in the computer, you need to get them into that computer and saved to the hard drive. In addition, you need to have them recognized by your organizing program, which is Photoshop Elements in this book. Photoshop Elements can help you both import and organize.

It is important to understand that the Organizer in Photoshop Elements does not actually hold your photographs. The picture files are stored on your hard drive. The Organizer simply creates a map to where

those photos are located, and that is essentially what you have when you see your pictures in Organizer. You can import your photos from memory card to hard drive, including copying them from the card into a specific folder and renaming the files as well as having the program recognize them by Organizer.

When you first open Photoshop Elements, choose the Organizer button to go into that mode. All importing is done through the Organizer mode.

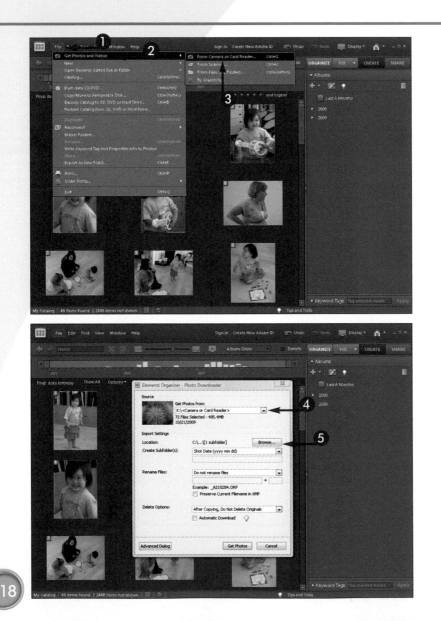

Note: The Mac version of Photoshop Elements has no Organizer. Organizer is a program specific to Windows. Adobe does add a version of Bridge for Photoshop Elements on the Mac. Bridge is a browser that lets you look directly at photos on your hard drive. It does include the ability to quickly go through images, find, delete, or rate them, but it does not have the functions of Organizer.

① Click File.

② Click Get Photos and Videos.

③ Click From Camera or Card Reader.

The Photo Downloader dialog box appears.

④ Click the Get Photos From arrow to select your camera or card reader.

⑤ Click Browse to select where you want the photos to go on your hard drive.

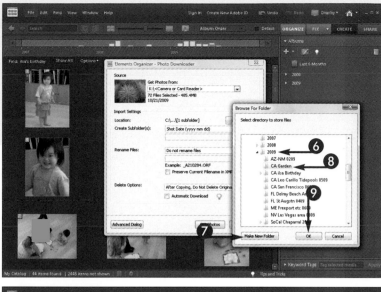

The Browse for Folder dialog box opens.

⑥ Navigate to the folder you want to use in the directory tree that appears.

⑦ Click Make New Folder for a new group of photos.

⑧ Name your new folder.

⑨ Click OK.

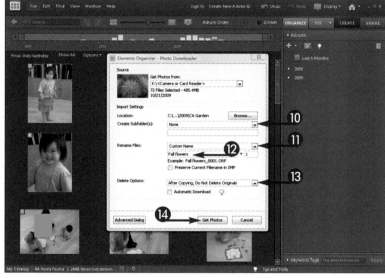

⑩ Click to select or create subfolders in the new folder, such as based on dates photos were shot, or choose no subfolders.

⑪ Click to rename your photos or keep the original file name.

⑫ Type a new name for your photos if needed.

⑬ Click to leave photos on the memory card so that your camera can reformat the card properly.

⑭ Click Get Photos.

The photos will now be imported to your computer and included in the Organizer.

TIPS

Did You Know?

Many photographers simply use their camera and the cable that came with it to download photographs. A memory card reader can be a better option because it requires no power, can be left plugged into the computer, and is usually significantly faster than using the camera.

Caution!

You may be curious about the Automatic Download check box in the Photo Downloader dialog box. It sets up your computer to automatically download photos based on criteria set in Preferences. This is really not for everyone because it does not allow you to put photos into specific folders for each download, nor can you rename photos.

Did You Know?

You can go further with your import by selecting specific images from your memory card for importing. This way you can separate different subjects, for example, that are on a single memory card. To do this, click the Advanced Dialog button at the bottom of the Photo Downloader. This gives you a larger window that shows thumbnails of your photos. You can check the ones you want to download.

 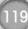

SORT
the good pictures from the bad

Now that you have all of your pictures on your hard drive and recognized by Organizer in Photoshop Elements, you need to go through your pictures to sort the good ones from the bad ones. Although it is true that you can save every single picture that you take if you have enough storage space on your hard drive, that makes it harder for you to find photographs in the future. Going through a mess of images that includes both good and bad photographs is more difficult than going through a smaller collection of your good images.

With Photoshop Elements, you can compare pictures, look at pictures in different sizes, and discover which pictures work well for you and which do not. To save hard drive space and eliminate clutter there, delete images that really do not satisfy you. Few photographers really go back to such images, so trust your instincts.

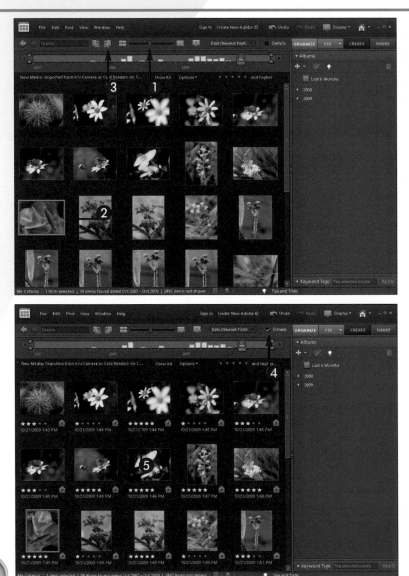

Set Up Your View of the Photos

① Click and drag the thumbnail slider to change the sizes of your photo thumbnails.

② Ctrl or Cmd+click photos to select images that you want to rotate.

③ Click the appropriate Rotate icon to rotate the selected photos.

④ Click the Details check box to show ratings (■ changes to ☑).

Note: You can also click the View menu and then View Details to show ratings.

⑤ Click the small stars under the photos to rate your photos.

You can use a system such as 1 star for rejects, 5 stars for best photos, and other stars to define which you like or dislike.

Delete Photos You Do Not Want

⑥ Click the first star at the upper right of the thumbnail display.

⑦ To limit photos to only those with one star, click the box to the right of the stars and select the Only option.

⑧ Select all photos with Ctrl or Cmd+A.

⑨ Press Delete.

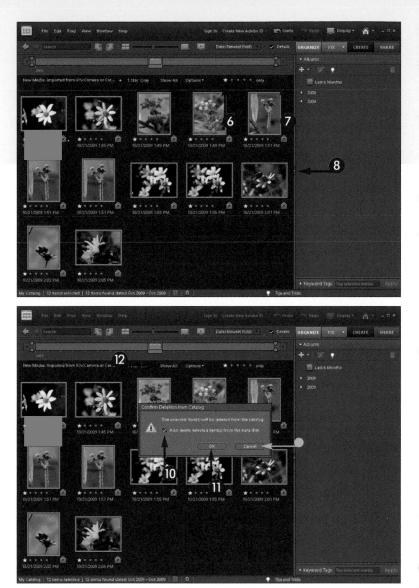

The Confirm Deletion from Catalog dialog box appears.

⑩ Click this check box to also delete selected item(s) from the hard drive to throw out your rejects (■ changes to ☑).

Make sure that the check box to also delete selected item(s) from the hard drive is unchecked to remove photos only from Photoshop Elements view (☑ changes to ■).

● If you feel that you made a mistake, you can click Cancel and change the ratings.

⑪ Click OK to finish the process.

⑫ Click Show All to get your photos in view again.

TIPS

Remember!

You have the choice as to whether you delete images from just the control of Photoshop Elements or off your computer altogether. Whenever you press Delete to remove any photos, a dialog box asks if you simply want to remove the photo from Photoshop Elements' view or remove it off of the hard drive completely. Most photographers choose the latter because there is little reason to save photos on your hard drive if you do not care enough about them to organize them in Photoshop Elements.

Try This!

The sizes of your images in the multi-photo, thumbnail view can be too small to see details clearly. Enlarge the image to know if it is really worth keeping or not. To see any image at a large size, double-click it. This shows you the photo filling the thumbnail area without any other photos. This helps you focus in on the details in your photos, such as sharpness or exposure problems. Double-click again to go back to the thumbnail view.

CREATE ALBUMS
to group your pictures

The Organizer is there to do exactly that, help you organize your photos. You started that organization when you imported your photos to a specific folder on your hard drive. Now suppose you wanted to group your photos based on that folder or on specific needs you have, such as family photos beyond a single folder. Albums let you do exactly that. These are virtual groupings of pictures that have no effect on the original location of the photos. They are like a bin

you can use to put similar photos into. You can create albums based on events such as birthdays, locations such as a recently visited city, family members, and much more.

Albums do not duplicate photographs. They only create references to where the pictures are on your hard drive. For that reason, individual pictures could be in many albums, which can help you find them faster in different ways.

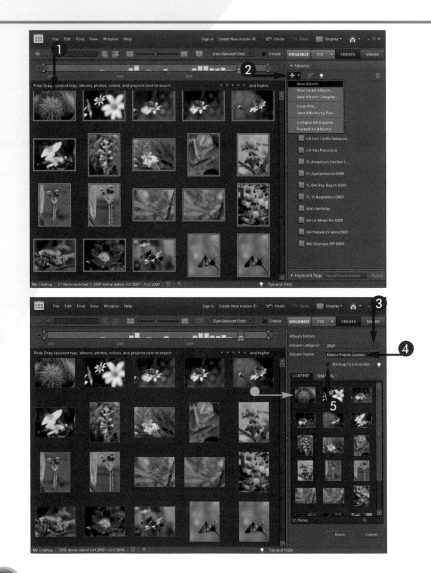

① Ctrl or Cmd+click photos to select individual images, or click a photo and then Shift+click the last image in a group to select photos in order.

You can also use Ctrl or Cmd+A to select all photos.

② Click the large green plus sign under Albums and choose New Album to add an album.

The Albums section of the task panel can be opened or closed by clicking the arrow next to the word Albums.

The Album Details panel appears.

● Your selected photos appear in the Items box.

③ You can group albums by using the Album Category function, but start with None (Top Level).

In the example shown, 2009 was selected because there was a 2009 group of albums already started.

④ Type a name for your album.

⑤ Uncheck Backup/Synchronize unless you have a Photoshop. com account (☑ changes to ■).

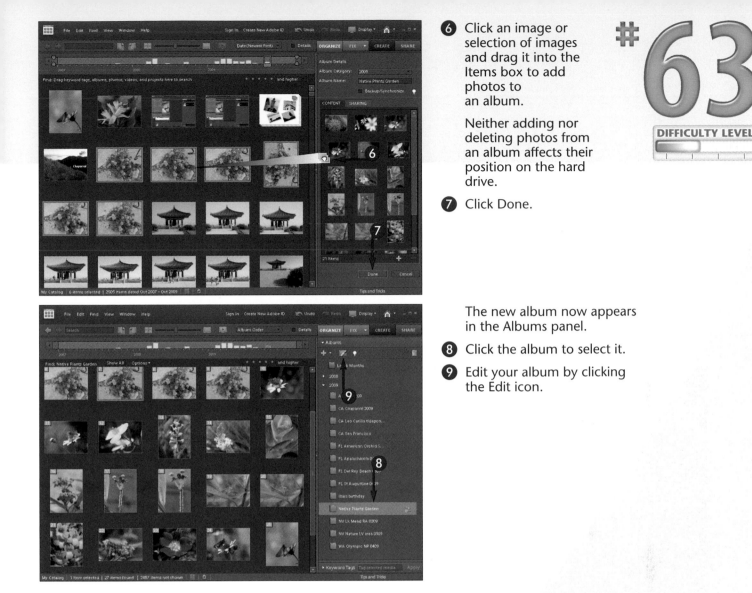

6 Click an image or selection of images and drag it into the Items box to add photos to an album.

Neither adding nor deleting photos from an album affects their position on the hard drive.

7 Click Done.

The new album now appears in the Albums panel.

8 Click the album to select it.

9 Edit your album by clicking the Edit icon.

TIPS

Try This!

You can easily create groups of albums by using album categories such as a year or other grouping. You can create an album category by clicking the same green plus sign (➕) used for creating an album. Farther down in that menu, you see New Album Category. Click that to get a dialog box that allows you to name that category and decide on its level. You can then click and drag any albums into the new category in the Album panel.

Did You Know?

You can add photos to an album at any time. Whenever you see a photo that belongs in an album, click it and then drag it to the album. It is automatically put into the album and appears there whenever that album is opened. Remember you are only creating references to photos and not actually moving any. This can be a very useful way of keeping track of types of photos. For example, you could create an album with a child's name on it and then drag in photos of that child every time they appear in your images. This way, you build up a collection of images of that child in the album.

USE KEYWORDS
to tag your images

Keywords are words that you add to your photo's metadata (information about the image held in the file). You should understand that keywords do not work for everyone. You may find that albums along with the built-in Photoshop Elements timeline give you all the organization you need. Keywords do take time and effort, and you may prefer to put that time and effort into other things.

However, keywords can be an important way for you to organize and find your pictures because keywords are searchable. Think of it this way — albums are large groupings of pictures that you can readily access as a group. Keywords give you the ability to put specific tags on your photos that allow you to search for very specific images.

Keywords can be as detailed as you want. You can simply add words to large groups of pictures, or you can add a lot of very specific keywords to individual pictures to create a very specific database.

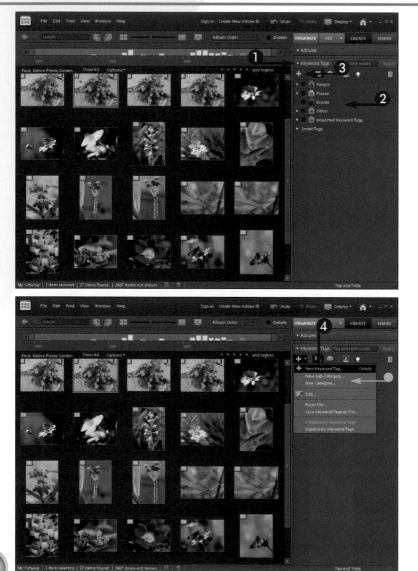

❶ Click the Keyword Tags arrow to open the keyword part of the Organize task panel.

For more space, close Albums by clicking that title's arrow.

❷ You can start with the keywords listed.

❸ Click the large green plus sign under Keyword Tags.

A drop-down menu appears.

● You can choose New Category or New Sub-Category to create your own category for keywords.

❹ Choose New Keyword Tag to add a keyword.

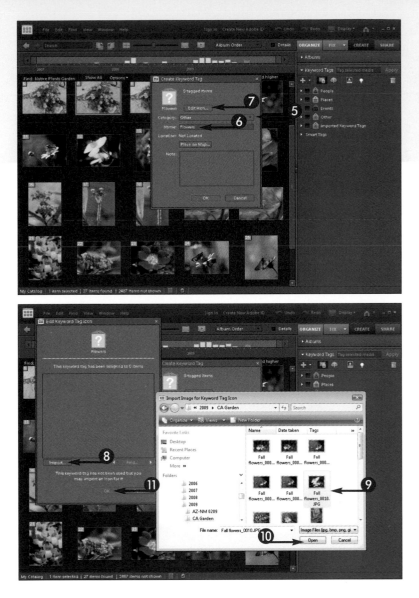

The Create Keyword Tag dialog box appears.

⑤ Choose a category.

⑥ Type a name for your keyword tag.

⑦ Choose an icon if desired by clicking Edit Icon.

64

DIFFICULTY LEVEL

The Edit Keyword Tag Icon dialog box appears.

⑧ Click Import to look for something to use as an icon.

An Import Image dialog box appears.

⑨ Find a photo that looks interesting, perhaps from the same group of images.

⑩ Click Open to select this photo for your icon.

⑪ Click OK to use this new icon for your keywords.

⑫ Click OK in the Create New Keyword Tag dialog box.

Note: *Having an icon for every keyword tag is not required.*

TIPS

Try This!

When all of the task panel controls are open, your interface can get cluttered and confusing. Click the little arrows at the left of the panel category titles to open and close a category of control, such as Albums. Simplify the workspace by closing panel categories you are not using.

Important!

Pick keywords that help you find your photos. Your keywords should be unique to your type of photography. Adding keywords that others use but do not fit your images will make your searches confusing. Ask yourself, "What do I need to find?" in order to create keywords that work for you and your needs.

Customize It!

You can add as much or as little information as you want to keyword tags. The Keyword Tags dialog box includes the option to add notes or a specific address for a location. These are not requirements, only options that some photographers use frequently, others not at all. Use what you need and what works for you.

USE KEYWORDS
to tag your images

With keywords, you are creating a database of information about your photos. Keywords are not captions, however. Not all programs recognize keywords, so they are mainly to help you find photos in Photoshop Elements and other Adobe products.

The best time to do keywording is when you first import pictures into Photoshop Elements. At that time, you remember more things about your pictures anyway. It is also easier to add keywords then because all of your newly imported pictures are right in front of you.

Because keywording is about creating a database, you can add a set of keyword tags to just one picture, to a few pictures, or to hundreds. Keywords allow you to be very specific, down to putting a specific name on something that appears only in one picture. Keywords work across all pictures within Organizer so that you can find pictures throughout Organizer by simply searching for keywords.

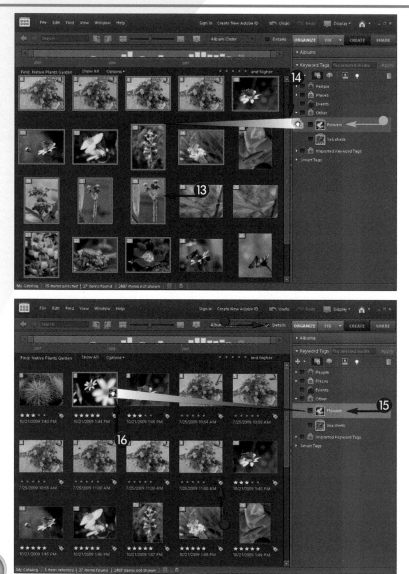

● A new keyword tag appears in the category you chose in step 5.

⓭ Select the photos that need this keyword.

The selected photos have a blue frame around them.

⓮ Click and drag the selected photos onto the tag and they gain that tag.

You can click and drag multiple times, with different groups of photos, to add more keyword tags to photos.

● A small keyword tag icon appears below your photos when Details is checked.

Note that this does not tell you what keywords have been added, only that keywords have been added.

⓯ To put a keyword on specific photos, click the tag in the panel.

⓰ Drag the tag and drop it on the photo.

When more than one keyword tag is added to a photo, the icon at the lower right of the image changes to a new, yellow tag icon.

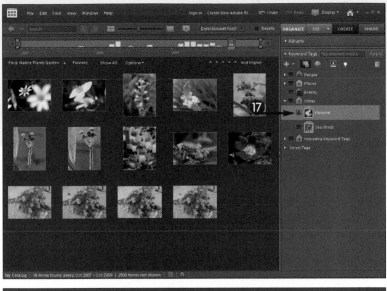

⓱ Find specific images based on your keyword by clicking the check box in front of a specific keyword tag.

Click additional tags as appropriate to narrow your search.

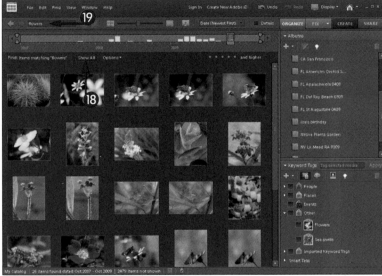

Another way of searching is to use the search box.

⓲ To search for images throughout your image files, click Show All.

⓳ Type a name in the search box to show photos related to that name quickly.

Every photo with that name in a keyword or in the file name now shows up.

TIPS

Remove It!

You may decide that you do not want a particular keyword tag associated with a specific photo. It is easy to remove one or more tags from a photo. Right-click the photo in question. Even if you use a Mac, you should get a right-click mouse or set up the use of your mouse or touchpad for right-clicks. At the bottom of the context-sensitive menu that appears, you will find Remove Keyword Tag. Click that to go further and a submenu appears that shows all of the tags now attached to your photo. Clicking the tag you want removed removes it.

Customize It!

Take any existing keyword tag and customize it for your needs. Once again, right-click any keyword tag to get a context-sensitive menu. This gives you a number of options from simply editing your keyword or keyword category to adding a whole new keyword to the category. You can add subcategories to your keywords to give them a hierarchy of use, plus you can totally remove keywords or categories from Photoshop Elements as needed.

CHANGE THE ORGANIZER
interface as needed

Photoshop Elements was originally developed to provide a more photographer-friendly interface and experience with the software than Photoshop. Its interface reflects that in its dark gray tone. This truly makes the photographs the star of your computer screen, not the software. In addition, you can do more with this interface. You can change the way the Organizer interface looks and consequently acts in order to customize it for your needs.

You can affect the look of the interface with the buttons in the top menu bars, such as Album Order or thumbnail size icons, and in the View and Window menus. Do not be afraid to try different looks for your interface as you do different things — you can always change back to the original look by reclicking the button or menu item. However, do not simply use something because it is there or because someone else uses it. Be sure that it really does help your work in the program.

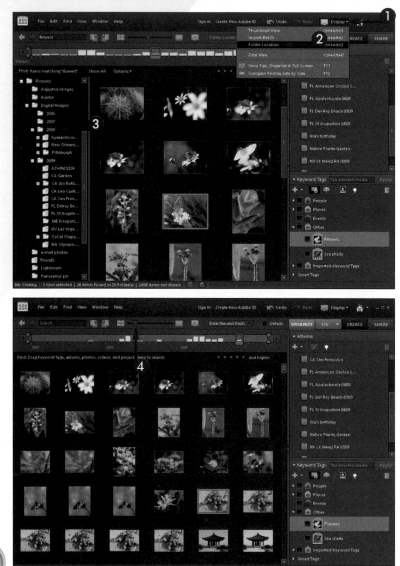

① Click the Display button to change your display views.

② Click Folder Location view to show a directory tree.

③ In the Folder Location view, you can click a folder directly to find photos.

If Photoshop Elements is not managing pictures in a folder, right-click the folder to add them.

④ Change your thumbnail size with the thumbnail slider.

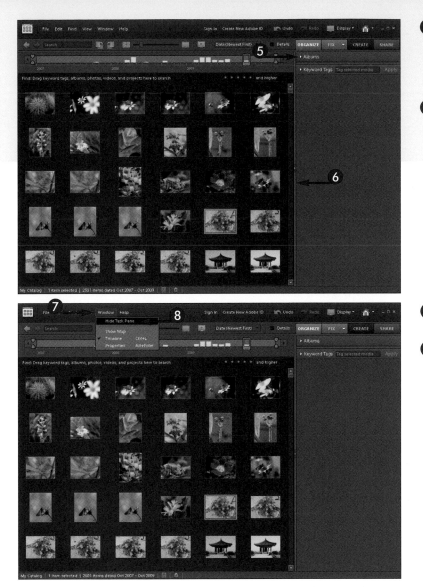

⑤ Click the small arrow next to a right panel category to expand or collapse the panel section.

⑥ Click and drag along an interface edge to make it larger or smaller.

⑦ Click Window to change what the interface shows.

⑧ Click Hide Task Pane to give a large image viewing area; click Show Task Pane to give the normal view.

TIPS

Try This!

Use the light-bulb icons (💡). Photoshop Elements scatters tips throughout the program to help you when you do not understand a particular control or option. Click the icon to display a tip offering you information on how to use the control or option.

Did You Know?

You can control many features of Photoshop Elements with keyboard commands. These allow you to quickly access controls with just a couple of keystrokes. These keystrokes are listed next to the controls in the menus. For example, you can turn on and off the detail display for thumbnails by using Ctrl or Cmd+D.

Try This!

The timeline in the Photoshop Elements Organizer can help you find photos by date. This is on by default because so many people remember when a photograph was taken. The timeline helps them narrow a search to a specific time. It can be turned off in the Windows menu. Click the timeline to select a specific time; photos appear below from that time. You can also drag the left and right sliders to limit the dates to show images.

BACK UP YOUR PICTURES
to protect them

Backup in digital photography is so easy and protects your images so well that you should be backing up your images right from the start. Whenever you read news stories about people displaced by a natural disaster, you always read how people saved their photo albums. If you back up your digital files, you also have a convenient way of taking your images with you when disaster strikes, too.

Backup is much more than disaster preparedness, however. Digital files are very vulnerable to hard

drive failure. If your photos were on a drive when it failed, your photos are lost forever. There is a saying in the computer industry that it is not if your hard drive will fail, but when.

Backing up your photos onto accessory hard drives that plug in to your computer is very easy. These have come down so much in price that many photographers back up their pictures on more than one for added protection.

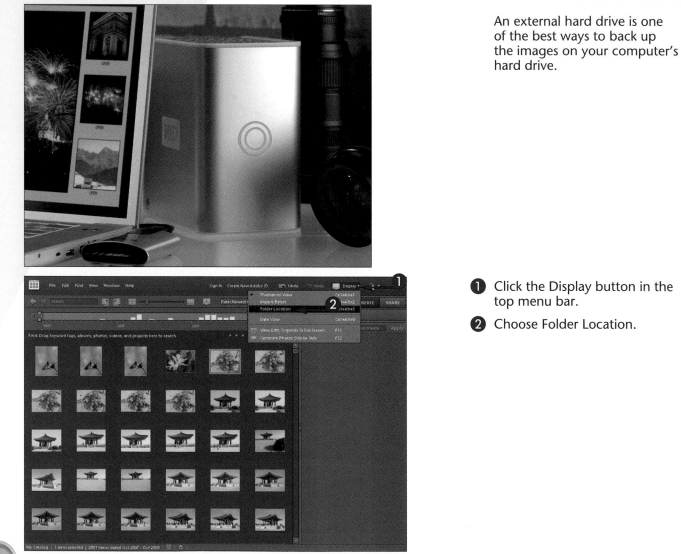

An external hard drive is one of the best ways to back up the images on your computer's hard drive.

❶ Click the Display button in the top menu bar.

❷ Choose Folder Location.

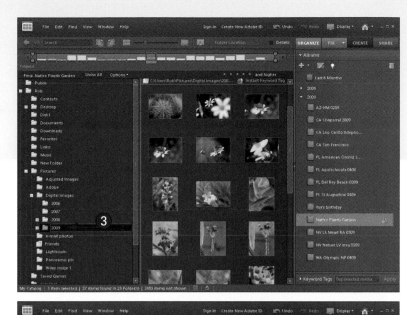

The Folder Location panel opens.

③ Find a folder you want to duplicate for backup in the folder tree.

④ Reveal the external hard drive using the panel's slider on the right.

⑤ Click the folder you want to duplicate.

Move the folder tree up or down to do this.

⑥ Drag the folder to the external hard drive.

The folder is saved on the external hard drive.

TIPS

Try This!

When you go down to the store to look at hard drives, you will see a range of choices based on total gigabytes available as well as overall size of the drive. You need enough storage space to handle your needs for several years. If you shoot JPEG, you need less space than if you shoot RAW. Hard drive prices are relatively low, so get enough gigabytes of storage. Small portable hard drives designed for laptops are more expensive than other accessory hard drives. However, they can be handy for accessing your photographs from your laptop or other computer. In addition, you can easily store such a hard drive in a location separate from your main computer, giving you added protection.

Did You Know?

Backup software can make your backups easier. Once you set up backup software for specific folders and a specific accessory drive, the software remembers those locations. The next time that you ask the software to back up, it simply compares what is in those two locations and adds only what is new. Use Time Machine for the Mac, or check into Déjà Vu software from Propaganda Productions to back up to one or more drives. A good and easy-to-use backup program for Windows is Save-N-Sync from Peer Software.

Basic Image Workflow with Photoshop Elements

After you have taken photos with your digital camera and have downloaded them to your computer, they are ready to be digitally processed. Using an image processor such as Photoshop Elements, you can substantially improve the quality of an image, plus transform or alter your digital photos in an almost infinite number of ways. This chapter requires familiarity with basic Photoshop Elements commands; to learn these commands or refresh your memory of them, see *Photoshop Elements 8: Top 100 Simplified Tips & Tricks* (Wiley, 2010).

The first thing you should do before making any adjustments is to evaluate each photo so you have an idea of what needs to be done to the image. A key to working an image in

Photoshop Elements is to keep focused on the photo and not on how many features of the program you can remember. Tasks #67 to #78 offer you an order of processing that can be used as the basic steps of image-processing workflow. Follow them in that order and you will gain a solid and consistent way of working your images.

Developing a consistent workflow will help you to better process your photos to get the results you want. The order of the steps that you take to work on your images is important. However, if you use features such as Undo History and adjustment layers, you can go back to early steps and change settings or delete the steps entirely and start from that point on.

Top 100

Learn the best
WORKFLOW

The order of the steps that you take to process your digital photos matters. As you alter dark areas of a photo, for example, you also change relationships among the tones and colors throughout your photo. By making changes in a consistent way, you also affect every part of the image consistently. That workflow helps you make better adjustments. Every photographer has a slightly different overall workflow, but it is important to establish a consistent way of working on your images in order to optimize their quality.

One good way of getting the best from your image is to do the following four things early and in this order: adjust blacks and whites, correct midtones, fix color, and make local or small-area changes. Note that color comes after the first tonal adjustments — if you do not have blacks set properly, especially, colors will never quite look right. You may also notice that the photos for this task do not show Photoshop Elements. It is important to think about adjusting the *photo* as seen here, not about using tools in Photoshop Elements.

Here is a sunrise photo of natural dunes along the coast of Northern Florida that came straight from the camera without any adjustments.

Blacks and whites give an image contrast and better color, although at this point, the photo looks too dark in the midtones.

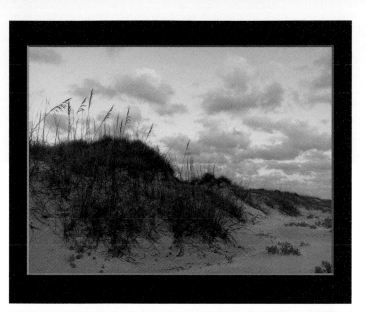

Midtone adjustments give the photo its brightness and liveliness, as well as making colors look better in its middle tones.

Color has not been directly adjusted on this image until this point, yet color is affected by the other changes. Now color is adjusted so the color fits the subject.

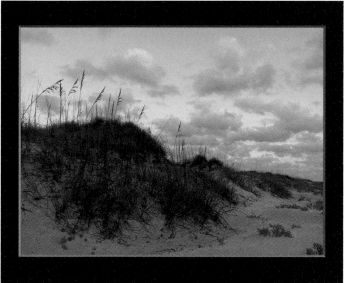

TIPS

Did You Know?

Whenever you change the size of a digital photo, the image quality decreases to some extent. Because of this, you should generally complete your adjustments on the original-sized image and increase or decrease image size only when you know the specifications of the print size and the target printer (see task #91).

Caution!

In this chapter, you learn the basics of working on an image by applying adjustments directly to the pixels of the photo. In the next chapter, you learn to use adjustment layers so adjustments are not applied directly to pixels. It can be okay to adjust pixels directly, but realize that when you do, you are limited as to how much adjustment can be done. As you change pixels, they start to lose quality and adaptation to adjustment.

PROTECT AND PRESERVE
original photo files

Saving a digital photo file is not all that hard. The challenge is remembering to save it properly. One of the most common mistakes those new to digital photography make is to save a digital photo file over the original file after processing it in Photoshop Elements or any other image-processing program. If you do this, you no longer have an original image file, which can later prove to be a disappointing loss. Even though you think that you have made the photo look better, over time your skills and knowledge of digital

photo adjustment will improve, and you will wish you had the original file.

Never overwrite your original image files; they have the most "picture information" you will ever have. Any image processing that affects pixels makes it impossible to go back to original image data. If you make a mistake, or later, you want to try reprocessing an image to reinterpret the photo, you need that original digital photo file.

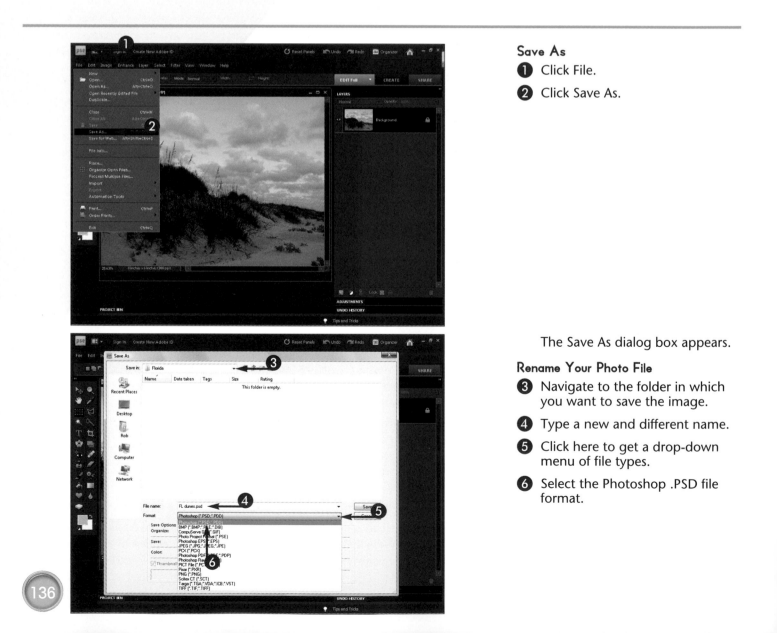

Save As

① Click File.

② Click Save As.

The Save As dialog box appears.

Rename Your Photo File

③ Navigate to the folder in which you want to save the image.

④ Type a new and different name.

⑤ Click here to get a drop-down menu of file types.

⑥ Select the Photoshop .PSD file format.

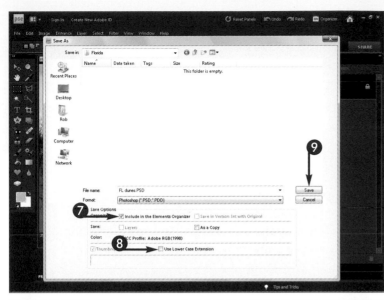

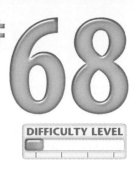

68

⑦ Check Include in the Elements Organizer (☐ changes to ☑) to allow Organizer to track your new image file.

⑧ Check or uncheck Use Lower Case Extension to change how the file extension is shown, as upper- or lowercase.

⑨ Click Save.

You now have a working file that cannot be confused with the original.

Whenever you have spent more than 30 minutes or so working on your image, protect your work by saving your file. (Choose File and then Save or press Ctrl/Cmd+S).

Save Before Sharpening and Resizing

After you have completed all of your work on the photo and before you have increased the size of the image or sharpened it, you should save the image as a master file that can be adjusted for printing and other specific uses.

● Sharpen an image and change its size only to output the image to a specific printer and display size.

TIPS

Did You Know?

Although Photoshop Elements gives you multiple options for saving an image file, only three are of value for most photographers. The PSD, or Photoshop, format is a good working format and allows you to save layers. TIFF is a common working format that can also be opened in most programs. JPEG should be used only for e-mail and archiving, never as a working file format.

Did You Know?

All images from a digital camera need sharpening to reveal the true sharpness of the original image by using Unsharp Mask or Adjust Sharpness. Any sharpening should be applied to an image only when you have sized an image for use and saved it for that purpose. The optimal settings for sharpening are highly dependent on the subject and the size of the original file.

CROP AND STRAIGHTEN
your photos

If your photo needs to be cropped, cropping should be done right away to remove unneeded parts of the image, parts that can distract you from proper adjustment of the photo. Cropping simply allows you to cut part of an image out from the larger original frame and delete those unneeded parts of the image. One common problem with photos is that they are not "tight" enough, which means the subject is too small in the image area. Cropping a photo removes the excess image around the outside so you can better emphasize your subject and composition.

There are other reasons why you might have problems in a photo besides too small a subject, such as distractions along the edge, problem parts of a background, or a crooked image. All of that can be fixed with a judicious use of the Crop tool. It helps to do this crop at the beginning of your image processing so you can work with a clean image without problems.

Do not overdo cropping, though — you are removing pixels, which results in lowered image quality if done too much.

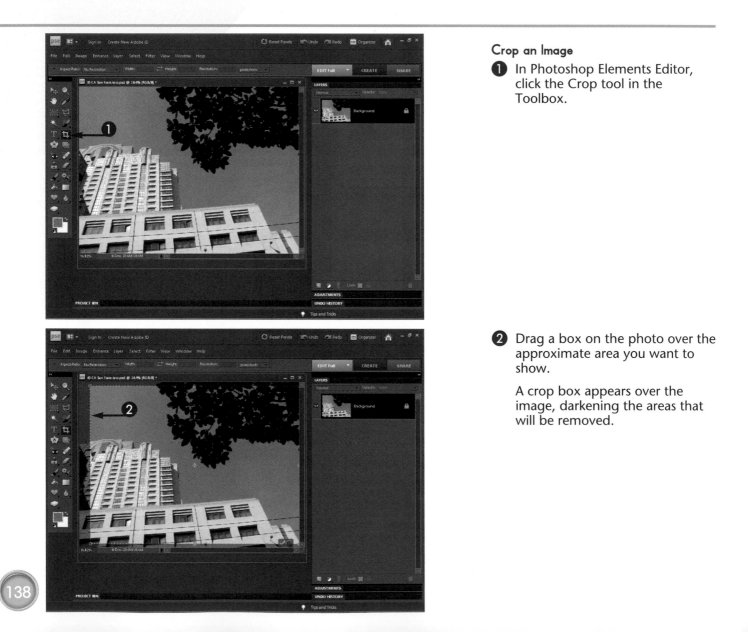

Crop an Image

1 In Photoshop Elements Editor, click the Crop tool in the Toolbox.

2 Drag a box on the photo over the approximate area you want to show.

A crop box appears over the image, darkening the areas that will be removed.

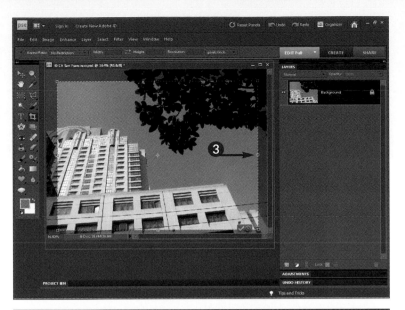

3 Click and drag any of the small squares along the sides.

In this example, the top and right edges of the crop box are dragged inward.

69

DIFFICULTY LEVEL

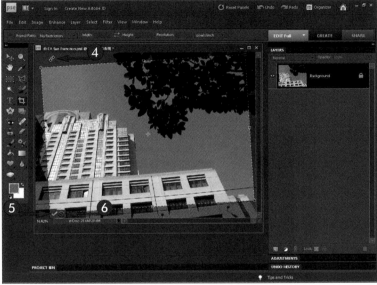

Rotate the Cropping Area

4 Position your cursor outside of the box, and it changes to a curved cursor that allows you to click and rotate the crop box to straighten an image.

5 To finish, click the check mark at the bottom of the crop box or simply press Enter/Return.

6 To cancel the cropping, click here.

TIPS

Photo Tip!

Straighten an image with the Crop tool (🔳). When you click and drag a crop box, make it long and skinny and drag it so that it goes around the horizon. Position the cursor outside the box to get the curved cursor (↻), and then click and rotate the crop box until it parallels the horizon. Now click and drag the crop box edges to the right size and accept the crop.

Did You Know?

Many photographers want to crop an image to a specific size, such as 5 x 7 inches or 8 x 10 inches, which is usually best to do at the end of the processing. The reason is that you really should have a master file that can be cropped to any specific size. If you crop to that size too early, you have to recrop and lose pixels to change that cropping.

Process for
STRONG BLACKS AND WHITES

Many photographers go into Photoshop Elements and immediately start trying to adjust color, or they use the Brightness/Contrast adjustment. Neither is a good idea. You need to establish good blacks and whites appropriate to your image first because they strongly affect colors and contrast. Colors usually need a black somewhere in the image to look their best, and Brightness/Contrast does not allow the proper adjustment of blacks and whites.

The way to do this is to use Levels, which is under the Enhance menu (choose Enhance, Adjust Lighting, and

then Levels). You get a Levels window that may look unfriendly to photography, but it is really easy to use for this purpose. You only care about the black-and-white sliders under the graph. Press Alt/Option while you slide the black slider to the right and the image turns white. This shows the black threshold screen — as you move the slider, colors and then blacks appear. The blacks are pure blacks in the photo. With the white slider and Alt/Option, a black screen appears. Usually you move the white slider left until white specks just appear.

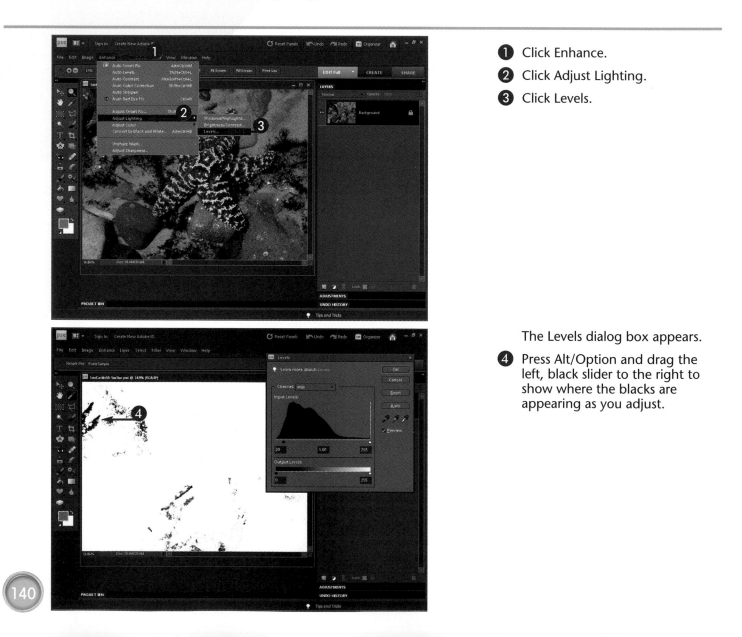

1 Click Enhance.

2 Click Adjust Lighting.

3 Click Levels.

The Levels dialog box appears.

4 Press Alt/Option and drag the left, black slider to the right to show where the blacks are appearing as you adjust.

5 Press Alt/Option and drag the right, white slider to the left to show where the whites are appearing as you adjust.

● You will immediately see an increase in contrast and color for the image.

6 Click OK.

Photoshop Elements applies your changes.

Note: If the image becomes dark, you can correct that in task #71.

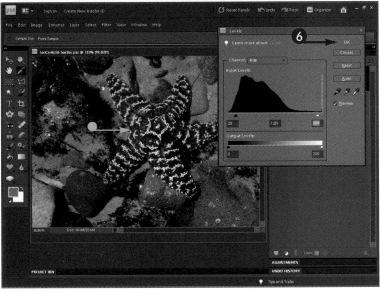

TIPS

Did You Know?

There is really only one black-and-white tone in a photograph. The plurals, blacks and whites, are commonly used, however, as seen in this task. The reason for that is because you are adjusting multiple areas of black and white, so most photographers use the shortcut, blacks and whites, to refer to them.

Apply It!

How much black or white do you use in your photo? This is very subjective and depends on your subject as well as your aesthetic needs. Unless you are after a special effect, you do have to be careful not to go too far or the photo will look harsh and may start to lose gentle tonalities. Black is more subjective and can be increased or decreased as appropriate. White most often needs only the minimum adjustment.

Adjust
MIDTONES

The midtones of a photo include the tones between black and white. They can be defined by highlights with details, shadows with details, and middle tones in an image. These tones bring brightness and life to your photo. Colors are strongly affected by how you adjust these tones.

A good way to deal with these tones is with curves because it allows you to adjust each area of tonality separately. In Photoshop Elements, this adjustment is called Color Curves and is found under the Enhance menu. This adjustment window includes some sample

adjustments or effects of certain curves adjustments in a table of styles. You can see a preview image — just click to select any adjustment.

The curve itself is a graph with a diagonal line that moves with adjustments. It is called "curves" because you can create different curves on this graph. You cannot directly move the center line to create those curves in that line as you can in Photoshop. Instead you set it by adjusting specific parameters with sliders. That changes the curve, known in this case as a *parametric* curve.

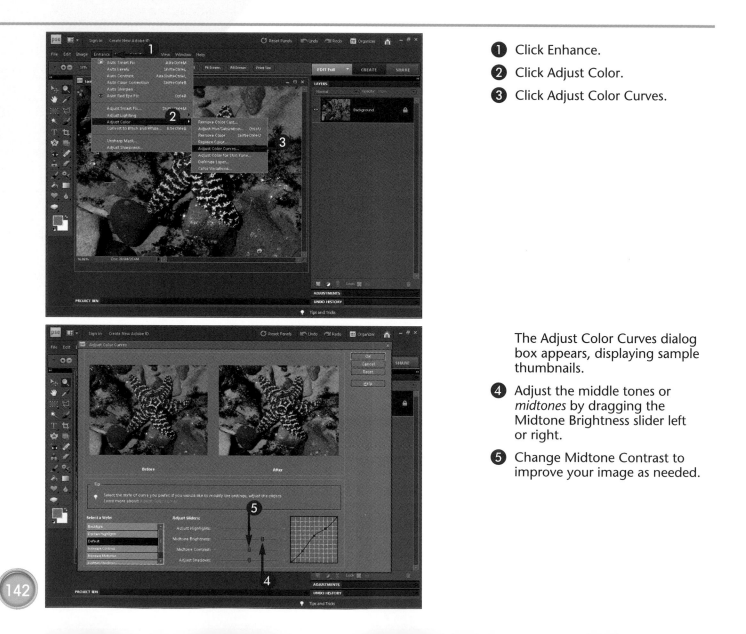

1 Click Enhance.

2 Click Adjust Color.

3 Click Adjust Color Curves.

The Adjust Color Curves dialog box appears, displaying sample thumbnails.

4 Adjust the middle tones or *midtones* by dragging the Midtone Brightness slider left or right.

5 Change Midtone Contrast to improve your image as needed.

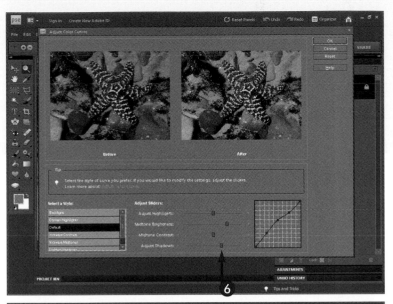

6 Adjust the dark areas by dragging the Adjust Shadows slider.

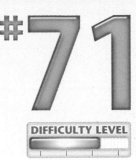

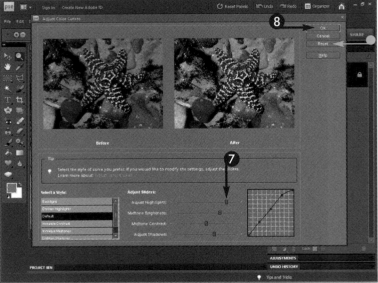

7 Adjust the highlights by dragging the Adjust Highlights slider.

8 To apply your changes, click OK.

● You can reset your curve adjustments back to the midpoint at any time by clicking the Reset button.

TIPS

Photo Tip!

You can also adjust midtones with Levels. This does not give as much flexibility as Color Curves, but it is quick and easy. If you have an older version of Photoshop Elements without any Color Curves, you have to use Levels. When you finish blacks and whites with Levels, open Levels again just for midtones. Use the middle-gray slider to make midtones brighter or darker. By using Levels twice for these adjustments, you keep them separate in the Undo History.

Did You Know?

Photoshop Elements has a great help function. In most adjustment boxes, you see a tip (look for the light-bulb icon) about that adjustment, and often a link to more specific help information. Random tips also appear with a light-bulb icon (💡) at the bottom of the screen. In addition, you can always type a question in the small question box to the right of the Help menu or in the search box that appears in the Help menu on the Mac.

Easy
COLOR CORRECTION

Digital cameras do not always see colors the way our eyes do. This is especially true when the light is colored and brings a colorcast to the scene. Such colorcasts are captured all too well by a camera, even though our eyes do not see them.

An easy way to color-correct an image is to use Levels a second time (do this as a separate adjustment). At the bottom left of the Levels control window, you will find three eyedroppers. Ignore the black-and-white ones (they represent rather heavy-handed black-and-white point adjustments). The gray

eyedropper should be called the white-balance eyedropper (Adobe labels it "Set gray point," which is very misleading).

After you select this eyedropper, move the cursor onto the photo. Wherever you click the photo, Photoshop Elements makes that point a neutral tone. So try to click something that should be neutral black, white, or gray. If the first click does not give you the right colors, keep clicking different tones until the photo looks right.

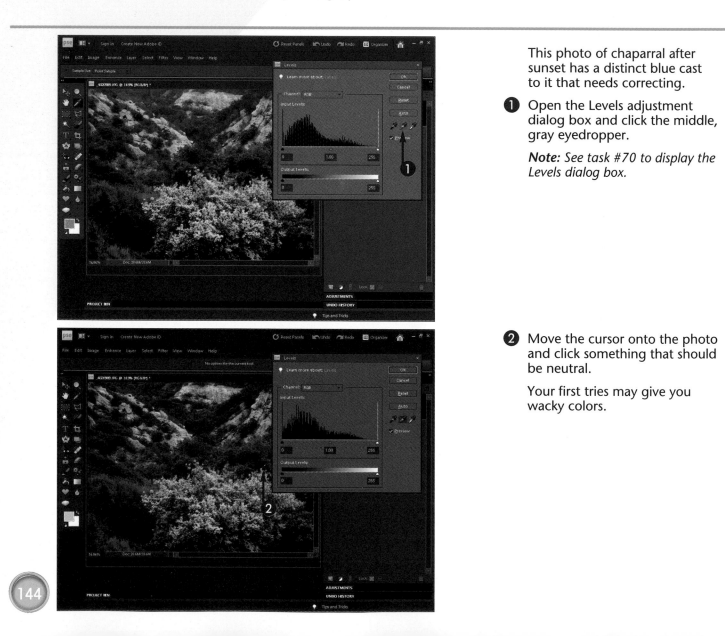

This photo of chaparral after sunset has a distinct blue cast to it that needs correcting.

1 Open the Levels adjustment dialog box and click the middle, gray eyedropper.

Note: See task #70 to display the Levels dialog box.

2 Move the cursor onto the photo and click something that should be neutral.

Your first tries may give you wacky colors.

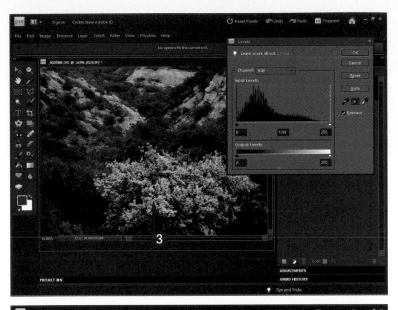

③ As you try different spots on the photo, you will find the photo changes overall color quite dramatically.

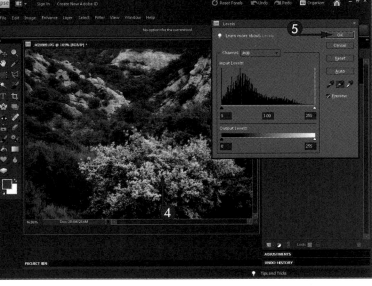

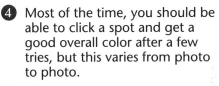

④ Most of the time, you should be able to click a spot and get a good overall color after a few tries, but this varies from photo to photo.

⑤ When you are satisfied with the photo's appearance, click OK.

Photoshop Elements applies the changes to the image.

TIPS

Did You Know?

As you adjust an image and reopen Levels, you may notice that the graph or histogram has white lines breaking it up. This is called *combing* or a *comb pattern* because it looks like a comb for your hair. This represents gaps in your image data. Some sources may suggest that this is bad, but it may or may not be important — it really depends on your photo. You have to see if there are problems in your image, not arbitrary lines in a graph.

Did You Know?

Using the center eyedropper with Levels is a quick and easy way to deal with colorcasts in a photo. You might read that you cannot change the white balance of a JPEG file. The image shown here was deliberately left as a JPEG file so that you can see that such changes are indeed possible. It is true that there are limits to what can be done before you start to see the image quality deteriorate.

Adjust color with
HUE/SATURATION

The Hue/Saturation adjustment in the Enhance menu under Enhance Color directly affects color. Hue changes the color of a color, whereas saturation affects its intensity or richness (a third control, lightness, is available, but in general, is not very effective and should not be used). Many photographers go right to Hue/Saturation when they want to affect color in a photo, but it should not be used until first blacks, whites, and midtones have been adjusted, and then colors can be corrected.

Saturation can be quickly overdone, so strong adjustments are best done when limited to specific colors. The default for the changes is all colors under Edit: Master. At that setting, keep your overall saturation change to a minimum, up to 10 to 15 points maximum. To do specific colors, click the Edit drop-down menu to get a list of colors. Choose the most appropriate and use Hue to tweak an off color, and Saturation to increase or decrease the intensity of a color. You can also dramatically change a color by making a major change to hue (for example, to change the color of someone's jacket).

① Click Enhance, Adjust Color, and choose Adjust Hue/Saturation.

The Hue/Saturation window opens.

② Limit overall saturation adjustments (Master) to a maximum of 10 to 15 points.

③ Click here for a drop-down menu to select the range of colors you want to adjust.

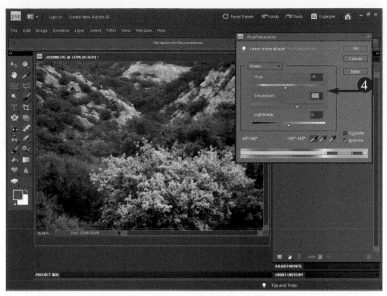

④ Change the hue or saturation of the specific color chosen and Photoshop Elements limits that change to the chosen color.

DIFFICULTY LEVEL

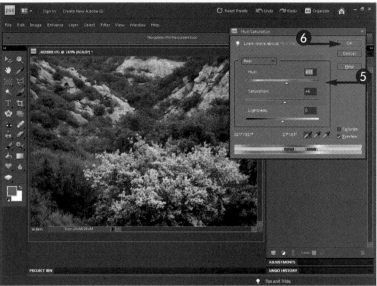

⑤ Repeat steps 2 and 3 as needed for adjusting other colors.

You can now adjust colors based on their specific needs so that you do not over- or underadjust unrelated colors just because you adjusted them all with Master.

⑥ When you like the way the image looks, click OK.

Photoshop Elements applies your changes.

TIPS

Did You Know?

You can get very precise color adjustments in Hue/Saturation by moving your cursor onto the photo. Click something in the photo that has the color you are working with. This now shifts the spectrum in the color bar at the bottom of the dialog box to show you how the adjustment will now be matched to a specific range of color based on what is in your photograph.

Did You Know?

Many adjustments and commands can be made by using keyboard commands. You can find keyboard commands by going to the adjustment you want in the menus — to the right of the name of the adjustment are any available keyboard commands. A good command to start with is Ctrl (Win) or Cmd (Mac)+0 — this makes the photo as large as possible in the work area.

CONVERT RAW FILES
with Adobe Camera Raw

When you use the RAW format in your camera (all digital SLRs and many compact cameras have it), your image is recorded to the memory card with much more tonal and color information than can be saved with a JPEG file. This additional data offers you considerable control over how you adjust your photo in Photoshop Elements. You can make more extreme adjustments and improved color corrections because the program has more data to work with.

Because RAW files are proprietary to each camera manufacturer, there are differences in these files

among manufacturers and even specific camera models. In order to use the Adobe Camera Raw software that comes with Photoshop Elements with your camera's RAW files (or any other RAW image file converter), you must have the latest version that recognizes your camera's files or it will not work.

You can open RAW files from Organizer into Editor, or you can open them by using the Open dialog box in Editor. Regardless, you get a new Camera Raw interface to work with that sits over your Photoshop Elements Editor interface.

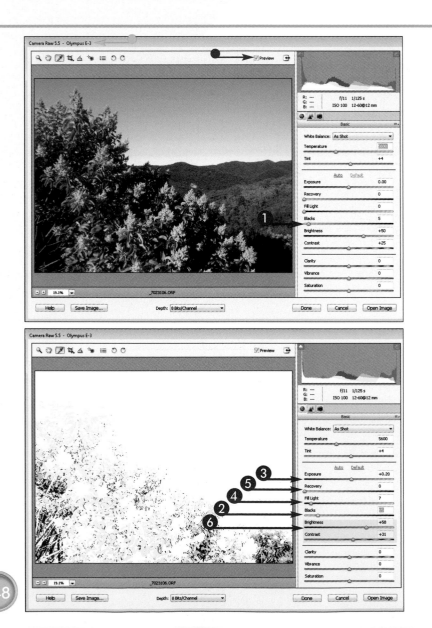

① When working in Camera Raw, the adjustment controls have different names, such as Blacks, but you can follow the same tonal and color adjustment order from the rest of this chapter.

● The Adobe Camera RAW program lists the Camera Raw version and camera in the title bar.

● This check box controls the image preview.

② Adjust blacks with Blacks (use the Alt/Option key to see the threshold screen as seen here).

③ Adjust whites with Exposure (use the Alt/Option key to see the threshold screen).

④ Brighten near-black tones with Fill Light.

⑤ Tone down near-white tones with Recovery.

⑥ Adjust midtones with Brightness and Contrast.

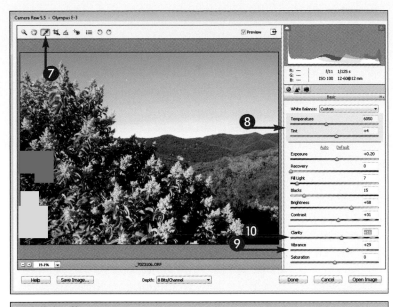

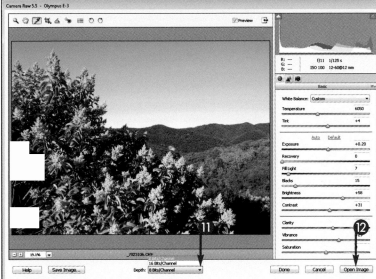

⑦ Colorcasts are adjusted with the White Balance eyedropper — click whatever needs to be a neutral tone.

⑧ Fine-tune colorcasts with the Temperature and Tint sliders.

⑨ Color intensity is adjusted with the Vibrance slider. The Saturation slider can be used, but it can also be rather heavy-handed in its adjustment.

⑩ Adjust midtone detail contrast with Clarity. Clarity adjustments vary depending on the subject, but overusing it makes the image look harsh.

⑪ Click here and select 8 or 16 Bits/Channel (most of the time, 8 Bits is fine and requires less of your computer's memory).

⑫ Click Open Image to apply your changes, close the dialog box, and open the converted image in Photoshop Elements.

Done saves your adjustments as a special instruction file that Camera Raw recognizes every time a particular file is reopened.

#74

DIFFICULTY LEVEL

TIPS

Did You Know?

Camera manufacturers provide their own proprietary RAW image file converter software. However, generally the converters included with the camera are not as easy or convenient to use as those provided by third-party vendors. Popular RAW converters include Adobe's Camera Raw program (which comes with Photoshop Elements, and a more advanced version comes with Photoshop), Adobe Photoshop Lightroom, and DxO Optics Pro Software (www.dxo.com).

Did You Know?

There are advantages and disadvantages to shooting either RAW or JPEG. JPEG has some speed advantages in the camera and so is often used for sports. RAW files are typically used for scenic and nature photography because of the range of tonal detail they hold. You can use JPEG-captured images and process them to very high-quality photos. However, JPEG images must be shot carefully because they have less data that can be processed if exposure or color is not captured correctly.

Understanding
COLOR SPACE

Photoshop Elements has not traditionally made a big issue of color space, yet it is important to know and understand, especially because version 8 has strong color space settings. Photoshop Elements calls this simply color settings, and they are found in the Edit menu for both the PC and the Mac.

You may see color space described only as a quality issue. It is not. It is an adjustment control. Color space affects the range of color that can be adjusted in a photo, which you may or may not need.

Photoshop Elements gives you two choices, sRGB and AdobeRGB. These are first set in your camera (check your manual to see how, though many compact digital cameras offer only sRGB) or from the Camera Raw conversion.

AdobeRGB is the larger color space and offers more flexibility in controlling colors. However, sRGB (in spite of its reputation as the "monitor colors") often gives beginning Photoshop Elements users good results faster for printing because change is more limited. With experience, though, most photographers choose AdobeRGB for its control.

You cannot tell from looking at a photo if it comes from an AdobeRGB or sRGB color space. The color space affects how well you can adjust certain colors.

Consider color space like buckets of color: Adobe RGB is a big bucket with more choices than sRGB, a small bucket.

① Click Edit.

② Select Color Settings.

The Color Settings dialog box opens.

③ Click Always Optimize Colors for Computer Screens if your original image is in the sRGB color space (● changes to ○).

④ Click Always Optimize for Printing if your original image is in the AdobeRGB color space (● changes to ○).

You will usually choose one of these two options; the other two are specialized choices uncommonly used by photographers.

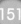

TIPS

Caution!

Although you can simply change color settings arbitrarily from sRGB to AdobeRGB or vice versa, that is not a significant benefit. Photoshop Elements should be set to match how your camera captured the colors. If you shoot RAW, however, the color space is based on whatever you have set in the Color Settings dialog box.

Did You Know?

Color space settings in a digital camera are usually found in the camera or setup menus. Once you set a color space, all images are recorded with that space. In RAW, however, no color space is recorded, so it can be changed at any time by resetting the Color Settings and reconverting the RAW file in Camera Raw.

REVEAL DARK AND LIGHT DETAIL
with Shadows/Highlights

Sometimes results can be startling when you see certain adjustment tools in action in Photoshop Elements. They can do some amazing enhancements to the image. The Shadows/Highlights control (click Enhance and then Adjust Lighting) is one such adjustment. This can help bring detail out of very dark parts of a photo and tone down very bright parts, so much so at times that the results can be quite striking.

This works so well, however, that photographers want to use this control right away when they see too-dark or too-light parts of an image, before other adjustments have been made. This should be avoided. Follow the workflow that this chapter uses — set your blacks and whites, and then adjust midtones before going to Shadow/Highlight.

There is also a strong temptation to overuse this control. The default of 25 for lightening shadows is a good place to start; 20 is a good maximum for darkening highlights. Higher amounts make the image look unnatural because the resulting highlights and shadows do not have the balance we expect to see in a photograph.

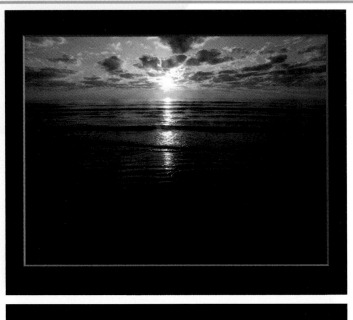

This is the original image of a sunrise on the Atlantic Ocean in Florida, properly adjusted with blacks, whites, and midtones, yet the dark bottom of the photo is too dark to really see the reflections and the bright areas around the sun too bright.

Here is the same image with Shadows/Highlights adjustments applied. Notice how much more detail shows in the shadows, including reflections and color. The bright sun did not need a lot of correction, but there is a little more color there, too.

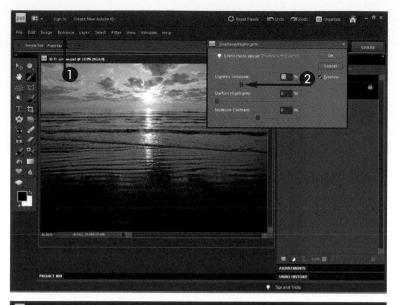

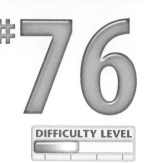

① Click Enhance, Adjust Lighting, and Shadows/Highlights to open that control.

The Shadows/Highlights dialog box opens.

② Adjust the shadows first by clicking and dragging the Lighten Shadows slider.

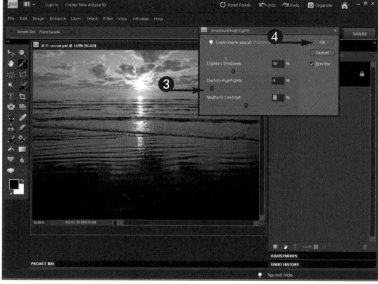

③ After the shadows look good, try tweaking the highlights and the midtone contrast. Often you can get a very rich image this way, but still be wary of overadjusting any of these sliders or the photo will look very "adjusted" to the viewer.

④ When you like the way the image looks, click OK.

TIPS

Did You Know?
Noise is a common problem in digital photos. It is like grain in film and appears like someone put a layer of sand across the photo. It is worst in small-sensor cameras, under high ISO settings and shadows. Sometimes you may hear that Shadows/Highlights increases noise. It does not. What it does do is reveal any noise in the shadows. Underexposed, dark areas typically hide noise, so as you brighten them, noise is revealed.

Did You Know?
Highlights need some detail and tone, even if very bright, in order to make them look right in Shadows/Highlights. A completely overexposed photo with blown-out highlights will not look better through the use of this control. You need to be sure to expose properly when shooting.

 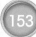

Adjust a
SELECTED AREA

Sometimes you may want to process your image in selected areas isolated from the rest of the photo. You need to do this in order to make an adjustment to only a portion of the image so that the rest of the photo is unaffected. To do this, you must first select the area that you want to edit. Photoshop Elements offers many different tools for selecting parts of an image. Depending on the characteristics of the area that you want to select, one tool may be more appropriate than another. Or you can use more than

one tool and keep adding to a selected area until you have selected all of the area that you want.

Good tools for selecting parts of an image include automated selection tools like the Magic Wand and Magnetic Lasso, plus the shaped Rectangular and Elliptical Marquee tools, the point-to-point Polygonal Lasso tool, and the easy-to-use Selection Brush tool. All of these tools enable you to select parts of an image, and then add or subtract from the selection by changing the selection mode in the tool's options bar.

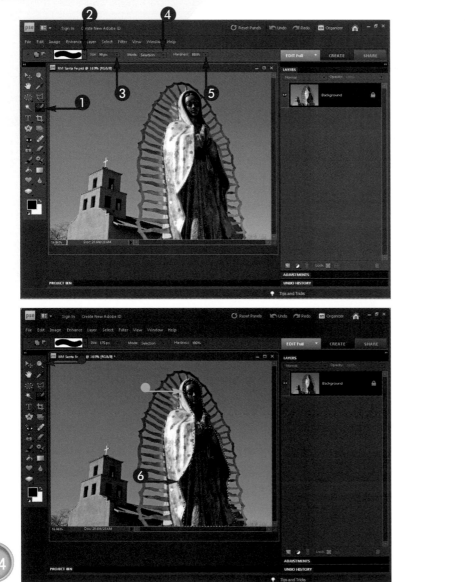

① Click the Selection Brush tool.

② Click here to select a brush style.

③ Click a brush size.

④ Click here and choose Selection.

⑤ Click here and choose how hard-edged the selection will be.

Soft edges often blend better, so try 0% before making the edge harder.

⑥ Using the Selection Brush tool, click and paint across the part of your photo that you want to select.

● A dotted line appears, showing your selection.

● Use the Zoom tool as needed to zoom in on the area that you want to select.

7 Click here to change the size of the brush to refine your selection.

8 Press and hold Alt/Option while you click and drag with the brush to subtract from the selection.

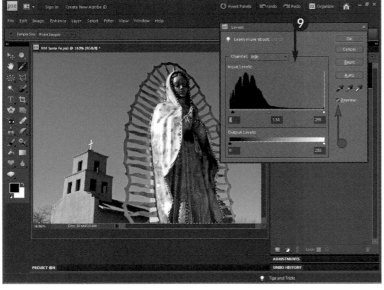

9 Make any changes that you want.

Note: *Any adjustments that you make will be limited to just the selected area.*

In this example, a Levels adjustment was applied to just the shadowed part of the statue in the foreground.

● Clicking the Preview check box displays your changes in the image as you work (■ changes to ☑).

TIPS

Did You Know?
When you are making a complex selection and then you move on and do other things in the photo, the selection is lost. If you think you may need to perform additional adjustments on a selected area or you just want to retain a really tough selection, you can save that selection in the Select menu under Save Selection. When you need it again, just go to Load Selection in the Select menu.

Adjust It!
Use multiple selection tools to refine a selected area. For example, start with the Selection Brush and then go to the Rectangular Marquee to deal with a shape like a window. Simply press Shift to use any selection tool to add to a selection and press Alt/Option to subtract from a selection.

KEEP TRACK
of your adjustments

One of the great things about working with Photoshop Elements is that you can experiment and try adjustments through a process of trial and error. If you do not like the results, the program gives you two really great options to back up and try something else. First, you can simply use the keystrokes Ctrl/Cmd+Z to step backward through what you just did.

Second, the Undo History panel makes it easy to back up through your adjustments. Photoshop Elements keeps track of each processing step (called a *history state*) you make. When you exceed the maximum

number of history states set in Preferences (in the Edit menu for Windows and the Photoshop Elements menu for Mac), Photoshop Elements deletes the earliest history state each time that you add a new one.

Using the Undo History panel, you can back up one or more steps and then move forward again by clicking each step in the panel while comparing the results. When you back up one or more steps and then make a new adjustment, however, Photoshop Elements discards all unused steps from that point on.

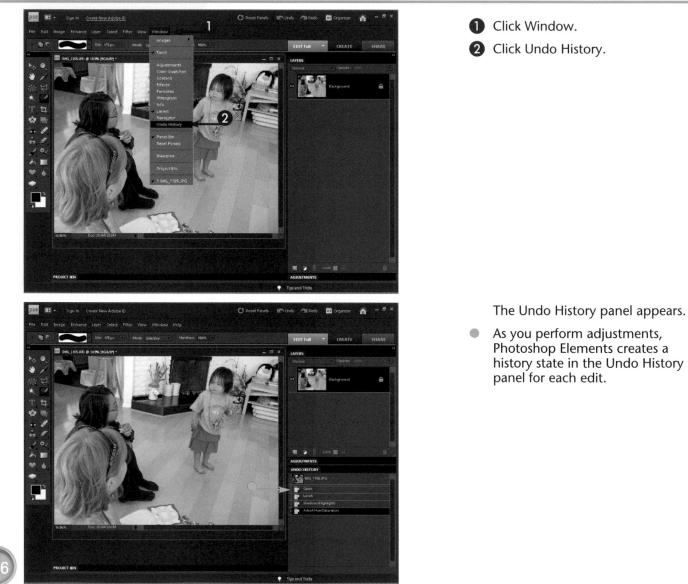

❶ Click Window.

❷ Click Undo History.

The Undo History panel appears.

● As you perform adjustments, Photoshop Elements creates a history state in the Undo History panel for each edit.

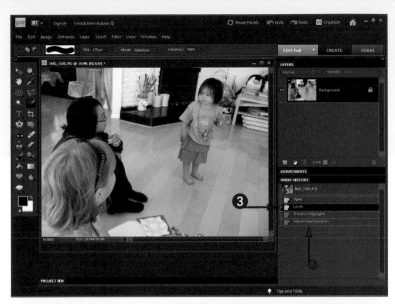

3 Click the history state at which you want to view the image.

● History states occurring after that time are "grayed out" and not in use.

If you want to adjust the image differently from that point on, perform the next adjustment, and the Undo History panel will reflect the new adjustment history.

● In this example, the Hue/Saturation command was applied at a different point in the process.

TIPS

Did You Know?

When you are working on a large image, it can take considerable memory to maintain a long list of history states in the Undo History panel. You can increase or decrease the amount of Undo History states that are saved by changing the value in the History States box in the General Preferences dialog box (click Edit, Preferences for Windows or Photoshop Elements, Preferences for the Mac, and then General). The default value is 50.

Did You Know?

Many photographers like to use a second monitor with Photoshop Elements and other image-processing programs. This allows them to drag the segments of the right side panel to the second monitor, freeing up space for the photograph on the first monitor. On most newer computers, adding one is as simple as plugging in its cable to the second monitor port. On older computers, you may have to add a special dual monitor display card to the unit.

Beyond the Basics with Photoshop Elements

Consider this: Ansel Adams is considered one of the great darkroom craftsmen. His dramatic and stunning prints are considered among the finest art by collectors everywhere. Yet, the only controls he had were making a photo lighter or darker, increasing or decreasing its contrast, and changing isolated parts of the photo apart from the rest. You can do all of that and more in Photoshop Elements.

In this chapter, you learn to go further with your image. You will learn something that scares a lot of photographers: layers. Go through this chapter carefully to discover how powerful layers are, and then try out the tasks with your own photos. You will learn to use layers — with a little practice! You have to

practice, try the ideas, make mistakes, and then learn from them until you succeed. And you will! Remember the four letters of task #2.

As you work with Photoshop Elements, you will discover so many things you can do. You may also discover a lot of added controls not in this book. Use them if you find they help you, but do not feel you have to know everything in order to succeed with Photoshop Elements. Always remember how much Ansel Adams did with very little compared to what can be done on the computer today. Knowing a lot of tools in Photoshop Elements is less important than being able to carefully craft your photo well with a few tools.

Top 100

Understanding
LAYERS

Many photographers stop learning Photoshop Elements when they hit layers, yet layers can be crucial to going further with your photos. Layers are an extremely valuable part of Photoshop Elements and well worth learning. They split the photo into "sheets" stacked on top of each other, isolating picture elements so that you can target your adjustments and changes to the photo. In fact, they allow nondestructive adjustments, including experimenting, with no cost to image quality.

One of the very cool things about layers is that they give you the flexibility to go back and change those

adjustments without hurting any pixels in your original photo. That is a big deal because when you adjust actual pixels in an image that has no layers, you are reducing your ability to make further changes without resulting quality issues.

Another great feature of layers is that they can be saved as a PSD (or Photoshop) file. You can then close an image, reopen it later, and the layers are there, exactly as they were when you saved them. You can then readjust any layer as needed.

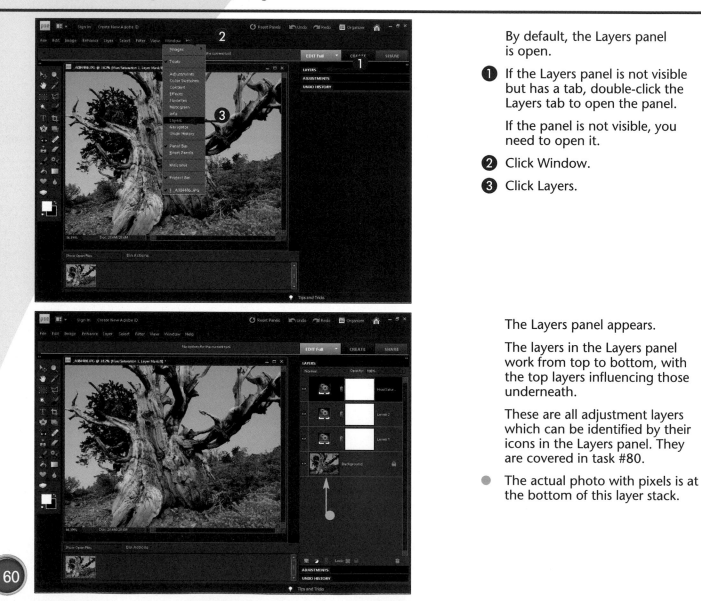

By default, the Layers panel is open.

1 If the Layers panel is not visible but has a tab, double-click the Layers tab to open the panel.

If the panel is not visible, you need to open it.

2 Click Window.

3 Click Layers.

The Layers panel appears.

The layers in the Layers panel work from top to bottom, with the top layers influencing those underneath.

These are all adjustment layers which can be identified by their icons in the Layers panel. They are covered in task #80.

● The actual photo with pixels is at the bottom of this layer stack.

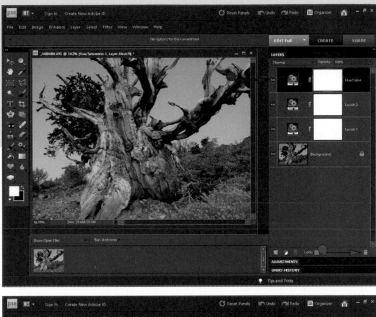

- Layers can be turned off by clicking the eye icon.

- You can delete layers by clicking and dragging them to the trash can icon.

- Layers can be renamed to help you remember what they are doing to your photo by double-clicking the name and then typing a new one.

TIPS

Adjustment Tip!

Layers offer a great deal of flexibility. If your layer seems too strong after looking at its effect, you can very simply reduce its effect by lowering its opacity. The Opacity control is at the top right of the Layers panel. A quick and easy way to change it is to click directly anywhere on the word *Opacity* and then drag your cursor left and right as you watch the percentages change and your layer's intensity adjust.

Processing Tip!

When you have created layers, save them in a master file for your photo. Do this by selecting Save As from the File menu, and then choose Photoshop (*.PSD) for the format. Rename your image file so you can find it again, using a name appropriate to the subject and adding *Master* to the name. Save it to a folder on your hard drive so it is in a folder that you have chosen.

USE ADJUSTMENT LAYERS
to gain flexibility

Whenever you apply any adjustment directly to the photo, you make permanent changes to the pixels in the image. Once you make a series of adjustments, pixels are altered so that you cannot go back and make minor changes to your adjustments unless you use the Undo History panel. Then, if you change settings, you lose all the steps following that step.

Adjustment layers change this and make adjustments nondestructively — you can always return to that layer and make changes to the settings with no quality cost. An adjustment layer is like a filter on the

camera — it does not change the scene (or pixels), but it alters how you see the scene (or pixels). In Photoshop Elements 8, adjustment filters include the key controls in Levels and Hue/Saturation, as well as other controls that you can try.

The easiest way to create an adjustment layer is to click the adjustment layer icon just at the bottom left of the Layers panel. It is a circle, half dark gray and half white. Click it to access a drop-down menu of adjustment layers you can use.

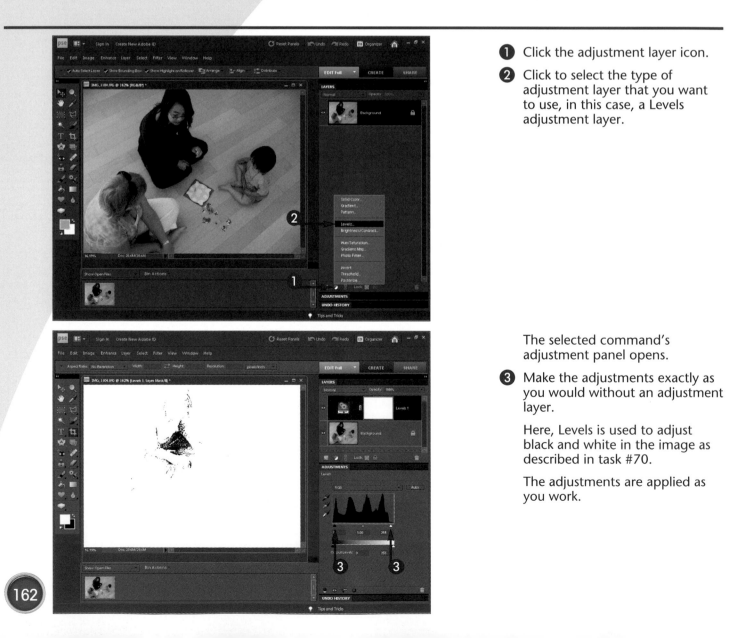

① Click the adjustment layer icon.

② Click to select the type of adjustment layer that you want to use, in this case, a Levels adjustment layer.

The selected command's adjustment panel opens.

③ Make the adjustments exactly as you would without an adjustment layer.

Here, Levels is used to adjust black and white in the image as described in task #70.

The adjustments are applied as you work.

162

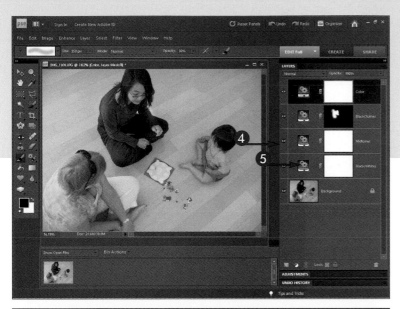

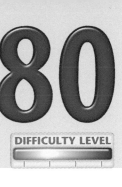
#80

④ Add adjustment layers to follow your image processing workflow.

The adjustment panel has been closed to allow the Layers panel to display fully. Double-click the tab to open and close a panel.

The BlackClothes layer includes a modified layer mask which is covered in task #82.

⑤ To modify previous settings, double-click the adjustment layer thumbnail.

The adjustment panel appears. This example shows whites in Levels being adjusted.

⑥ Make any adjustments to the initial settings that you want.

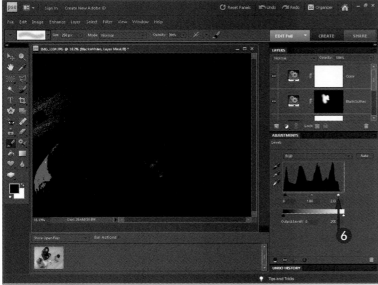

TIPS

Did You Know?

You can turn on, or turn off, the effects of one or more adjustment layers by clicking the Layer Visibility eye icon (👁) at the far left of each adjustment layer in the Layers panel. This is a simple way of looking at what the adjustments are or are not doing to your photo.

Did You Know?

When you are sure that you do not need to make any further changes to an adjustment layer, you can flatten your image to reduce its file size. Click the layer that you no longer need to make it the active layer, then click the panel menu button in the upper right corner of the Layers panel to get a drop-down menu. Click Merge Down to flatten one layer or click Flatten Image to flatten all the layers in the Layers panel.

USE LAYER MASKS
to isolate your changes

Layer masks offer tremendous benefits. They come automatically attached to adjustment layers and allow you to control precisely where you want the adjustment to happen and where to block it. They also let you change your mind and replace where the adjustment occurs and where it does not.

Layer masks include white, black, or both; those tones show up in the layer mask icon to the right of the adjustment icon in an adjustment layer. Consider white to be clear — it has no effect on the adjustment in the layer. Black, though, blocks any adjustments.

The default is a white layer mask that allows all — you then paint black in small areas to block the effect. Use a soft-edged brush and choose a size appropriate to the area you want to affect. The foreground color in the Toolbox is the color that will be painted. You can also fill a layer with black to block everything by clicking Edit, Fill Layer, and selecting black. You then paint white in small areas to allow the effect.

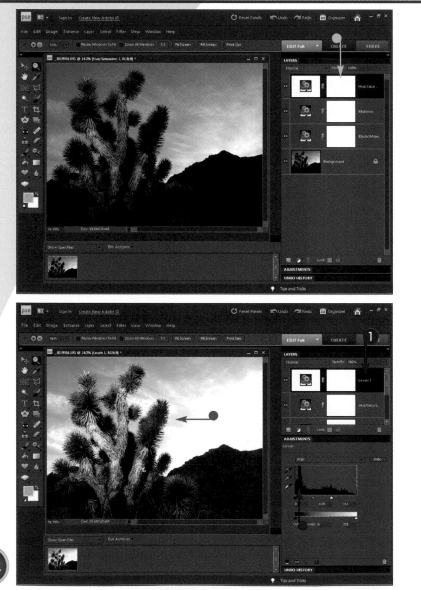

● All adjustment layers come with a layer mask (white by default).

The layer masks in this screen add nothing to the layers at this point.

① Add an adjustment layer to affect a specific part of the photo.

● In this case, Levels was opened to adjust the dark parts of the Joshua tree in front of the sunset.

● In this picture, the dark areas of the Joshua tree were lightened, but the overall adjustment made the sky too bright.

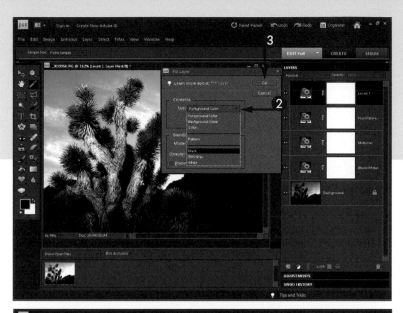

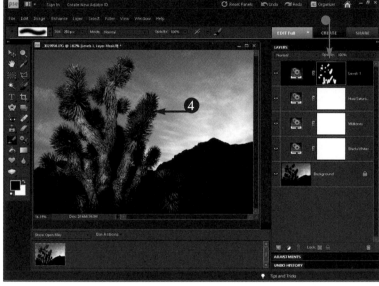

Here, the adjusted areas need to be small, so you need to fill the layer mask with black to block the overall adjustment by clicking Edit, and then Fill Layer.

② Click here and select Black.

③ Click OK to apply the settings.

The adjustment is blocked over the whole image.

④ Paint in white using a brush sized for the area to allow the adjustment in those places.

Paint black over white areas if you go too far.

The dark areas of the Joshua tree are now revealed.

● The layer mask icon shows black for the blocked areas and white for the allowed adjustment.

TIPS

Did You Know?

Layer masks have no direct control over the image. They only affect what an adjustment layer does. Painting black could make the picture lighter or darker — that all depends on the adjustment it affects. Black or white can only turn that adjustment off or on. Layer masks work only on the layer and have no effect up or down in the layer stack.

Did You Know?

Layer masks give another way to make nondestructive adjustments to your photo. They isolate areas for change similar to selections (more on that in task #82), and they are infinitely adjustable themselves. To get exactly what you want, you can still alter the mask on the adjustment layer after it is set by adding to the mask (white) or subtracting from the mask (black).

Chapter 9: Beyond the Basics with Photoshop Elements 165

COMBINE SELECTIONS
with layer masks

DIFFICULTY LEVEL

Selections are a great way to start a layer mask. It actually can make the process easier because Photoshop Elements automates the use of black and white areas where you need them based on your selection. A selection means you allow an adjustment inside the selected area and block it outside that area — exactly what a layer mask does. Different than a selection, though, the resulting layer mask can be altered as needed by simply painting on white where you want the effect returned or black where you want it blocked.

All you have to do is make a selection before opening an adjustment layer. Then, when you open any adjustment layer, the layer mask that now appears is not the white default layer mask, but a mask precisely based on the selection. The selected area is white in the mask; the rest is black. You can even get the selection back again by Ctrl (Windows) or Cmd (Mac)+clicking the layer mask icon. This gives you a tremendous tool for isolating your adjustments to specific parts of your photo.

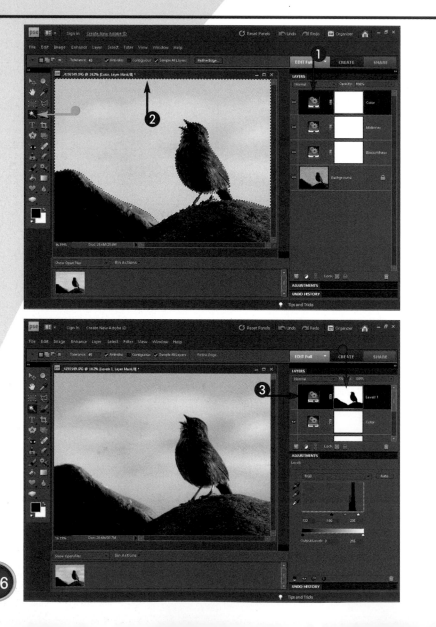

❶ First make your main, overall adjustments.

❷ With your top layer active, create a selection of an area you want to isolate in its adjustment.

In this case, the sky needed to be adjusted separately from the sparrow and rocks.

● This selection was made with the Magic Wand tool.

❸ Add an adjustment layer to affect a specific part of the photo.

In this photo, Levels was used to darken the background and make the sky look better.

● The layer mask is automatically created based on the selection.

LIGHTEN OR DARKEN
a portion of an image

#83

The camera simply does not see the world in its colors and tonalities the same way that we do. In fact, it can give very misleading interpretations of a scene that really does not represent what you see. Often this is based on the camera seeing contrasts, the difference between light and dark parts of your photo, much differently than we do. By using a Levels adjustment layer to lighten or using a Brightness/Contrast adjustment layer to darken, you can use their layer masks to selectively adjust the brightness of specific areas in a photo to help it better interpret your original intent for the image.

In addition, you may often find it helpful to darken or lighten a background around your subject so that you can better make the subject stand out in the photograph. To do this, select the easiest part of the scene. If that is the background, you may be able to use one tool and then perform some clean-up work using a lasso tool. If the easiest selection is your subject, you can then get the background selected by inverting the selection (choose Select, and then Inverse).

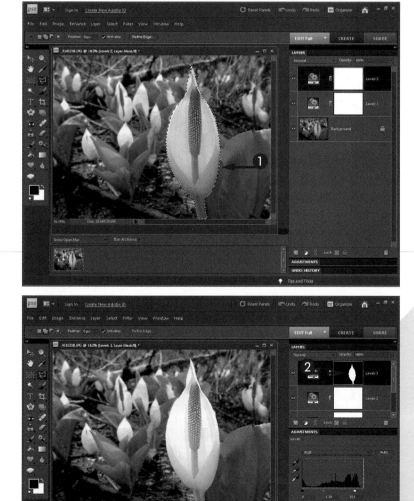

Note: The main adjustments should be done before completing this task.

1 Select the easiest part of the scene related to what needs to be changed.

In this case, the foreground flower head of western skunk cabbage needed to be lightened, and it selected fairly easily with the Magic Wand plus the Polygonal Lasso tool.

2 Add an adjustment layer to darken or lighten the specific area now isolated in white in the layer mask.

In this case, Brightness/Contrast was used to brighten the foreground flowers to make them stand out better.

If the selection edge looks too harsh, use the Gaussian Blur filter to soften the layer mask edges (click Filter, Blur, and Gaussian Blur).

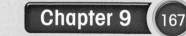

CORRECT EXPOSURE
problems

A common problem with photos is that they are either underexposed or overexposed. Although this is often a subjective evaluation, you can quickly lighten or darken an image by applying a few of the layer blending modes available in Photoshop Elements. Blending modes tell Photoshop Elements how to compare what is in different layers and then enable you to change the way pixels or instructions mix between two layers of an image. Photoshop Elements offers a very large number of choices for blending modes, but you need to know only two, Screen and Multiply, for this task.

Screen always makes the image appear brighter and is often used for underexposed photos. The Screen blending mode gives you about one full f-stop increase in exposure.

The Multiply blending mode darkens the image colors and tones, which is ideal for overexposed photos. Multiply gives you about one full f-stop decrease in exposure. You also use the Multiply blending mode to intensify image colors.

With either blending mode, fine-tune the exposure by adjusting the layer's Opacity setting found at the top of the Layers panel.

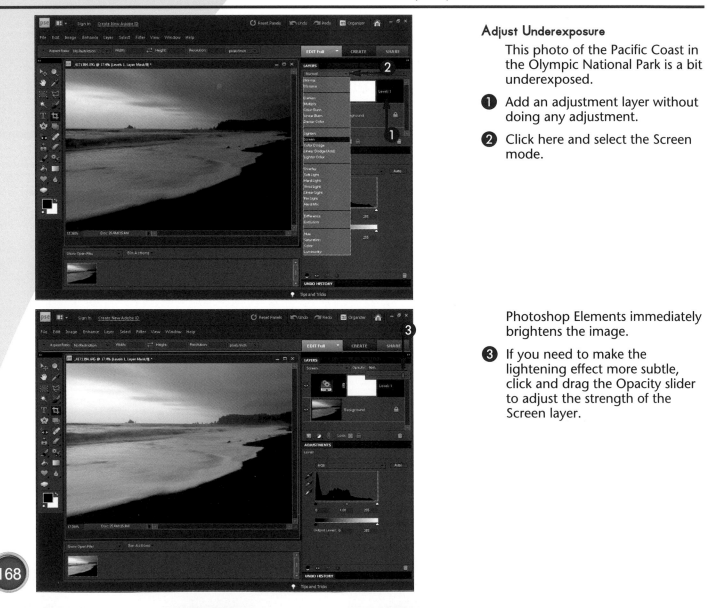

Adjust Underexposure

This photo of the Pacific Coast in the Olympic National Park is a bit underexposed.

① Add an adjustment layer without doing any adjustment.

② Click here and select the Screen mode.

Photoshop Elements immediately brightens the image.

③ If you need to make the lightening effect more subtle, click and drag the Opacity slider to adjust the strength of the Screen layer.

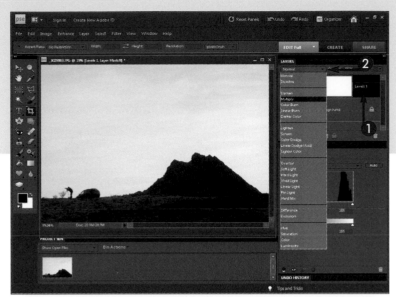

Adjust Overexposure

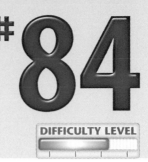

This photo of a landscape and photographer in the Lake Mead National Recreation Area is a bit overexposed.

1 Add an adjustment layer without doing any adjustment as before.

2 Click here and select the Multiply mode.

Photoshop Elements immediately darkens the image.

3 If you need to make the darkening effect not as strong, click and drag the Opacity slider to adjust the strength of the Multiply layer.

TIPS

Did You Know?

Although you may be tempted to apply the Brightness and Contrast feature in Photoshop Elements to correct overall exposure and contrast problems, this feature does not correct overly light or dark images. Instead, it either raises the brightness values in an image to make all the pixels brighter or lowers the values to make all the pixels darker. For most photos, you do not need to adjust all the pixels, just the ones affected by the exposure problem. For best results, use the blending modes and adjustment layers to correct exposure problems.

Try This!

Brightness and Contrast is useful as an adjustment layer after you have applied all of your standard processing to an image. You can then use a minus brightness to create a darkening layer for local effects. Fill the layer mask with black to block the effect, and then paint in white where you need something darkened.

Chapter 9: Beyond the Basics with Photoshop Elements 169

Create a
PANORAMA

Sometimes you stand in front of a wide-spreading scene and find that your camera just cannot capture it all when you look through the viewfinder. Sure, wide-angle lenses can capture a wide-angle view of the scene, but they still do not capture as much of that wide scene as desired. With Photoshop Elements at hand, you can create a dramatic, wide-spreading panorama to show off that wide sweep of a scene.

Task #53 offers tips on how to take photographs that you can later digitally stitch into one panoramic print. You have to have shot the photographs in order to

put them together! That may seem obvious, but it is a reminder that you must think about what you will do in Photoshop Elements as you are shooting. Once you have taken pictures for such a purpose, you are ready to use the Photomerge command in Photoshop Elements to do the stitching. You quickly learn, however, that the steps in task #53 are very important. You must overlap your shots properly so that they merge well in Photoshop Elements.

① Click File.

② Click New.

③ Click Photomerge Panorama.

The Photomerge dialog box appears.

④ Click Reposition Only
(◎ changes to ◉).

⑤ Click Browse.

The Open dialog box appears.

6 Find and select the folder that contains the images you want to combine.

7 Press Ctrl (Cmd for Mac) and click each file to select it.

8 Click OK to close the Open dialog box.

● The selected files appear here.

9 Click OK to launch the Photomerge process.

TIPS

Try This!

Photoshop Elements provides a number of Layout options for putting together your panoramic image — Auto, Perspective, Cylindrical, Reposition Only, and Interactive Layout. Try them all to see what they do with your photos. Most photographers find that Reposition Only works well and gives the results they need. On some scenes, particularly those with buildings, you may find that Perspective or Cylindrical work better. Auto can work but it gives less control.

Did You Know?

You can take multiple photos of vertical subjects and create vertical panoramas as easily as you can create horizontal panoramas. Good subjects for vertical panoramas include tall trees and buildings. Shooting from a distance with a telephoto lens helps minimize unwanted perspective distortion caused by using shorter focal length lenses.

Create a
PANORAMA

On many images, you may find that the overall panoramic looks good, but tiny white lines along blending edges show up. They look like cracks in the photo. These are easily fixed by using the layer masks generated with the panoramic. Click the eye icon of what you guess to be the layer with the problem to see the problem edge's location. Then use a small, soft-edged, white paintbrush to go over the edge lines. If this does not do the job, change to the next lower or higher layer and try again. This usually helps you fine-tune the blending.

On rare occasions, Photomerge is not able to automatically align your digital photos. When that occurs, you see the photos placed in a window at the top of the Photomerge dialog box. To align the images, simply drag and place the images that were not automatically aligned. When you get the images close to where they should be, Photomerge should be able to automatically and precisely position them.

● Photomerge automatically lines up the images and stitches them together.

● The panorama appears with layers aligned to make a panoramic image. Layer masks also appear with the areas used to blend the images.

⑩ Look over the overlapping edges of the photo and look for problems such as white lines.

⑪ Use a white or black brush on the layer mask to fix those problems.

If white or black shows up directly on the photo, it means you are painting on the photo and not the layer mask. Click the layer mask.

⑫ Select the Crop tool.

⑬ Click and drag over the photo to clean up the edges and crop the image.

⑭ Click the green check mark to finish the crop.

TIPS

Image Processing Tip!

Sometimes no matter what you do in shooting, the photos do not merge perfectly in Photoshop Elements. You end up with dark shadow-like lines or other mismatches in the final panorama. This can often be fixed by cloning over the area until it blends (see task #86). It especially helps to clone to a new, empty layer over the panoramic that keeps the cloning separated from the original.

Photo Tip!

If you find that your panoramas consistently have trouble merging, check your photo technique when you are capturing the images for Photomerge. You need to be sure you have enough overlap of the photos, even up to 50 percent, plus you need to look for distinct objects in the overlapped areas that Photoshop Elements can find and match in the merge of images. It can be worth changing the overlapped areas of the separate shots just to be sure you have those distinctive objects.

REMOVE UNWANTED ELEMENTS
with the Clone Stamp tool

#86

DIFFICULTY LEVEL

You can remove a variety of unwanted elements from your photos with Photoshop Elements. You can remove everything from distracting telephone lines or vehicles in landscape photos to people or objects in group photos. Without question, some elements are easier to remove than others. Most often, the Clone Stamp tool can be used to copy or "clone" existing areas over the unwanted elements.

The Clone Stamp tool enables you to set a source point in the image you are editing, or even another

image. You then copy the area around that point over the problem area. The key to using the Clone Stamp tool is to blend the cloning well into the image. It helps to clone to a new layer because this lets you keep all of your other layers in their original state.

Enlarge the image with the Zoom magnifier tool to better see the problem area. Then click and clone in steps (do not paint the clone in strokes), change the size of the brush as you go, change the source point as you clone, and use a soft brush.

❶ Use the Zoom tool to zoom in on the area that you want to cover.

Note: Make sure to keep the area to use as the source area visible.

❷ Add a blank layer with the Add Layer icon at the bottom of the Layers panel.

❸ Double-click the layer name and change it to "Cloning."

❹ Click the Clone Stamp tool.

❺ Click here to select an appropriately sized soft-edge brush.

❻ Click Sample All Layers (■ changes to ☑).

❼ While pressing and holding the Alt (Option) key, click on the photo to set the source point.

❽ Click on the photo over the unwanted element.

The cloned image area appears in the new cloning layer and can be revised or deleted without affecting the rest of the photo.

CONVERT
color to black and white

#87

Black and white is a very creative tool for making beautiful, unique images. Black and white is not simply a color image with the color removed. How that color is removed affects how each color is translated into the tonalities seen in the black and white. If, for example, color was simply removed from a green and red photo, the green and red would translate into the same shades of gray — not very interesting.

For effective black-and-white conversion, first make your adjustments to blacks, whites, and midtones so you are starting with a properly processed image

(flatten it if necessary by choosing Layer, Flatten Image, but save the original first as a master). The Convert to Black and White control in the Enhance menu lets you adjust the intensity of three colors to control how colors appear in tones of gray. This is a very visual interface with a before-and-after image and an additional choice of Select a style that gives a variety of black-and-white processing styles. Work your adjustment so that your photo elements separate as tones of gray.

DIFFICULTY LEVEL

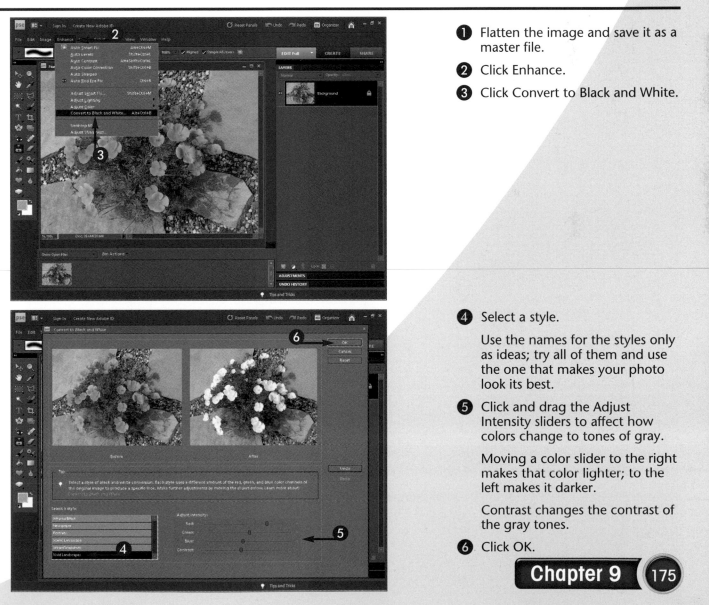

① Flatten the image and save it as a master file.

② Click Enhance.

③ Click Convert to Black and White.

④ Select a style.

Use the names for the styles only as ideas; try all of them and use the one that makes your photo look its best.

⑤ Click and drag the Adjust Intensity sliders to affect how colors change to tones of gray.

Moving a color slider to the right makes that color lighter; to the left makes it darker.

Contrast changes the contrast of the gray tones.

⑥ Click OK.

DOUBLE-PROCESS RAW
for more detail

Certain photos just do not adjust properly for highlights and shadows. If one looks good, the other does not. A great way to deal with this challenge is to shoot RAW and process the image twice in Camera Raw. You can then concentrate the first time on the shadows, getting them looking their best without concern for the highlights. You process a second time for the highlights without concern for the shadows.

This results in two images opened into Photoshop Elements. When you open the first one, you must save this file with a new name. Photoshop Elements

does not allow you to process another version of the image if it has the same name. You do not need to do a Save As with the second file, though it never hurts for protection against system crashes or other problems. Next, you must put the two photos together. Put the image that looks best overall on top. Then you erase the problems of the top layer (literally, this is cutting holes in it) to reveal the better detail from the layer below.

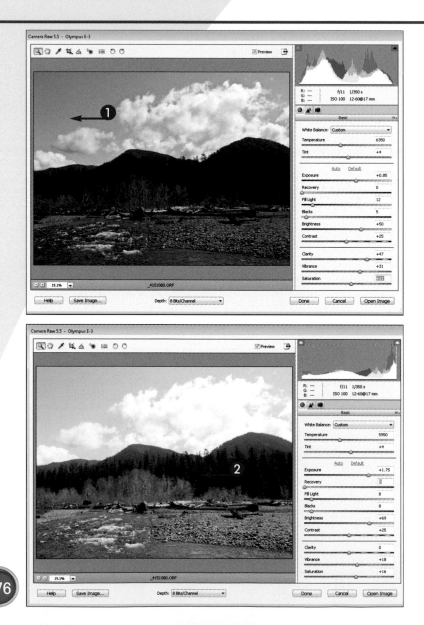

This scene in the Olympic National Park was very difficult to adjust in one Camera Raw session so that both the sky and the landscape of early spring trees looked their best.

① Open your RAW file in Camera Raw and process it so the sky looks its best.

This example uses the sky for the first adjustment, but the order is not important.

Note: Ignore what happens to the dark areas.

When the file opens in Photoshop Elements, save it with a new name. You must do this in order to process the file twice.

② Open the same RAW file in Camera Raw and now process it so the dark parts of the scene look their best.

Note: Ignore what happens to the highlights — the clouds in this example.

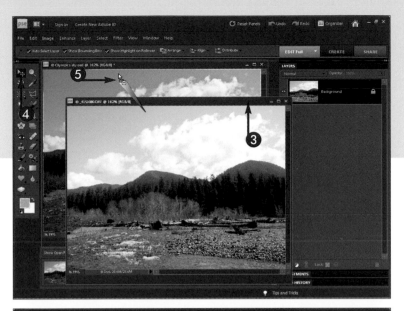

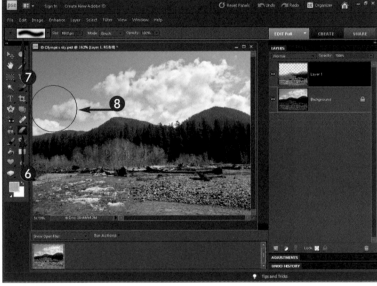

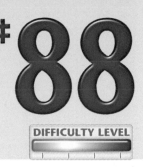

③ Click the top frame of the top photo and drag it so the bottom photo is showing.

④ Click the Move tool in the Toolbox.

⑤ Press and hold Shift, and then click one of the photos and drag it on top of the other.

You know you are on the other photo when the cursor changes and the edges of the second photo change.

Note: You must press and hold Shift through the entire move, and release the mouse button first. If you do not, the moved photo will not be placed properly.

⑥ Click the Eraser tool in the Toolbox.

⑦ Use the tool's options bar to select a large, soft-edged eraser brush.

⑧ Erase the weak part of the top photo so that the underlying photo's good area shows through.

TIPS

Important!

In Photoshop Elements 8, photos no longer float in the interface by default. They are set in place with tabs. You need floating images to complete this task. You need to tell Photoshop Elements 8 to allow floating images in Preferences under the Edit menu for Windows or the Photoshop Elements menu for Mac. In the General section of Preferences, check the item that says "Allow Floating Documents in Full Edit Mode."

Processing Tip!

As you blend the two processed images together, try changing the opacity of the Eraser brush. You can always undo too-obviously erased edges by using the Undo History panel, and then redoing the erasure with less opacity or intensity to the Eraser brush. Also experiment with changing the size of the brush.

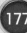

COMBINE TWO EXPOSURES
for a better tonal range

Sometimes the world throws such a high-contrast scene at the camera that its sensor cannot possibly handle the full tonal range of the subject.

There is a way around this limitation of the technology. Take two photos of the scene, one exposed to gain optimum detail in the shadows, one exposed to gain optimum detail in the highlights. You then blend the two exposures together with a new feature in Photoshop Elements 8, gaining detail in shadows and highlights from the two exposures that would have

been impossible from one exposure. You can even shoot more exposures to deal with higher contrast conditions. Although this example uses one photo, you can use three or four (more gets unwieldy).

To do this, though, you must lock your camera securely to a tripod. Otherwise, you will find it very hard to match up and blend the two images together. A good way to get the two exposures is to use auto exposure bracketing if your camera offers it — set it to a one to two f-stop change.

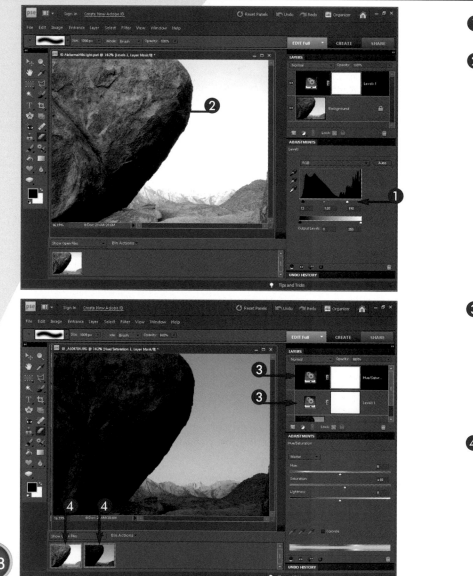

① Adjust the first image the best you can for its exposure.

② Concentrate on the best tonalities and color of the image and ignore the rest.

In this photo, the nearby rocks of Alabama Hills in California gain better color and tonality by the exposure and the processing, but the sky is washed out and the mountains have lost highlight and color detail.

③ Adjust the second image the best you can for its exposure and color.

In this photo, the sky and mountains gain better color and tonality by using adjustment layers to control their brightness and color.

④ Select both of the images in the Project Bin by Ctrl or Cmd+clicking both.

⑤ Click File.

⑥ Click New.

⑦ Select Photomerge Exposure.

DIFFICULTY LEVEL

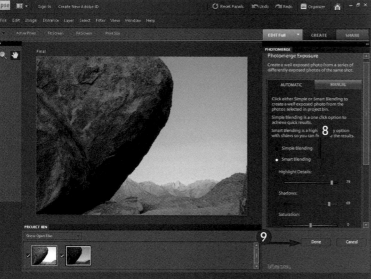

The Photomerge Exposure window opens.

⑧ Adjust the controls for highlights, shadows, and saturation until you like the results.

⑨ Click Done to finish the blending of exposures.

TIPS

Did You Know?

Photographers sometimes wonder why they should bother with two exposures when the Screen technique from task #84 would lighten dark areas, too. The advantage of two exposures, one specific for the dark areas, is image quality. Color, tonality, and noise are much better when the exposure is correct for the area, compared to "fixing it" with Screen in Photoshop Elements.

Processing Tip!

Photomerge Exposure includes an option called Simple Blending. You can always try this with no penalty, but it usually does not match the much better Smart Blending. With Smart Blending, not only is Photoshop Elements working harder for you, but you also gain more control with the Highlight Details, Shadows, and Saturation sliders. There is no rule to using them because their results are entirely dependent on your photos.

Chapter 10

Make Photographic Prints

Even though taking pictures with a digital camera makes it easy to share photos electronically — on a Web page, as an e-mail attachment, or on a computer or TV screen — a photographic print on paper is still what photography is all about to many people. You can make photo-quality prints from digital photo files in many ways, including printing them on a desktop photo printer, ordering prints from an online photo-printing service, or using a local photo-processing lab.

Before you are ready to make prints, however, you may need to perform some basic image processing to get the best results. The workflow described in Chapter 8 strongly affects the appearance of a print. To make

prints that are more predictable, you need to take the time to calibrate your monitor with a monitor-calibration device and software such as the DataColor Spyder or X-Rite i1Display calibration systems.

Besides making basic adjustments to your digital photos, you also need to size the image properly for the print dimensions and sharpen the photo appropriately for that size and the subject. If you are using your own desktop photo printer, you can use Photoshop Elements or another imaging program to precisely position photos on a page, create multiple photo page layouts, or crop photos that will be printed in a book using an online printing service.

Top 100

UNDERSTANDING
color management

Your digital camera, computer screen, and printer all reproduce color in different ways, and each one has unique limitations on how it can display color. *Color management* is a system of hardware and software products that have been configured to ensure predictable and more accurate color across all devices. In other words, if you have implemented color management properly on your hardware, the barn-red barn in front of the soft, pale blue sky that you see on your computer monitor is interpreted as barn red against a soft, pale blue sky in your prints.

Important steps in color managing your hardware include calibrating your computer display and using the right color profiles for the specific combination of printer, ink, and paper that you are using. Taking, editing, and printing digital photos can be a joy and easy to do when you have predictable color across your hardware and software. Without some sort of color management, the process of taking, editing, and printing digital photos can become frustrating as you see inconsistent color across them.

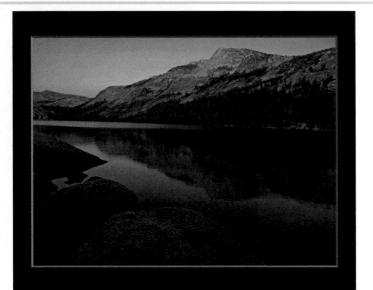

Your computer needs to interpret color accurately and predictably for display and printing. This late-light scene from Yosemite National Park needs to consistently look like a late-light scene.

Calibrating your monitor is an important step to ensure color consistency. Today's calibration systems are easy to use.

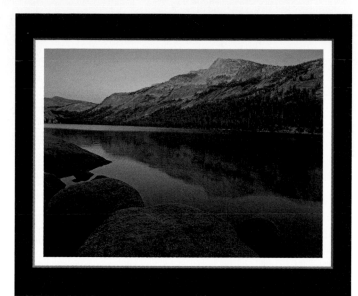

This print of Tenaya Lake at late light is an accurate representation of the colors seen on the monitor and in life.

The late light on the mountains around Tenaya Lake has a consistent appearance when seen in Photoshop Elements on your monitor, on the print, and when the photo was taken.

TIPS

Did You Know?

Your print and monitor never match exactly because you are working with two different media — a monitor with glowing red, green, and blue colors compared to a print with reflective paper and inks based on cyan, magenta, yellow, and black. However, you do want to achieve some sort of consistency between monitor and print so that your changes to the image seen on the monitor are reflected accurately on the print. Consistency is very important to how colors are changed and displayed.

Did You Know?

The best and most accurate way to calibrate your computer monitor is to use a hardware/software color calibration system such as the DataColor Spyder3 (www.colorvision.com) or the X-Rite i1Display LT system (www.xrite.com). A special sensor sits on your computer display so that it can read colors that the special software presents to create an accurate profile of the colors displayed by your monitor.

SIZE PHOTOS
for printing

All digital cameras sold today have more than enough pixels to make standard-size prints up to at least 11x14 inches. If you need to make very large or very small prints, you need to resize the image. Your printer can only handle so much data and throws out a lot of data to get to a small 4-x-6-inch print from a standard digital camera file, for example. You need to resize your photo appropriately in Photoshop Elements.

Printing resolution should be set to 200–360 ppi. Photoshop Elements makes it easy to check this size in its Image Size control (choose Image, Resize, and

then Image Size). First, make sure the Resample option (for interpolation bigger or smaller) is not checked. Then type 200 ppi (pixels per inch) in the Resolution box to see the largest print size you can make and 360 to see the smallest. For any print size in between, just type a dimension you want to use.

To enlarge an image, use 200 ppi, check Resample Image, choose Bicubic Smoother, and then type a dimension you need. To reduce the size of an image, use 360 ppi, check Resample, and choose Bicubic Sharper before typing the desired dimension.

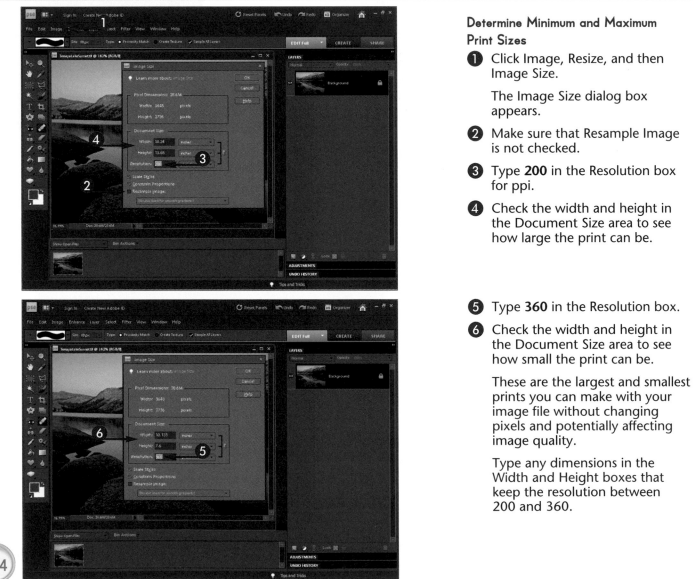

Determine Minimum and Maximum Print Sizes

1. Click Image, Resize, and then Image Size.

 The Image Size dialog box appears.

2. Make sure that Resample Image is not checked.

3. Type **200** in the Resolution box for ppi.

4. Check the width and height in the Document Size area to see how large the print can be.

5. Type **360** in the Resolution box.

6. Check the width and height in the Document Size area to see how small the print can be.

 These are the largest and smallest prints you can make with your image file without changing pixels and potentially affecting image quality.

 Type any dimensions in the Width and Height boxes that keep the resolution between 200 and 360.

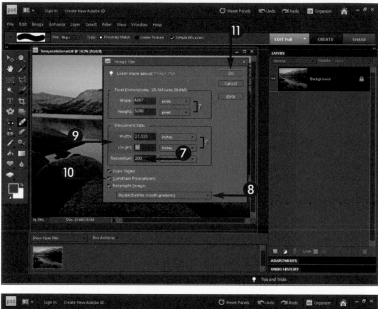

Print an Enlarged Photo

⑦ Type **200** in the Resolution box.

⑧ Click Resample Image (■ changes to ☑) and choose Bicubic Smoother.

⑨ Type the width or height that you want in either the Pixel Dimensions area or the Document Size area.

⑩ Make sure that Constrain Proportions is checked.

⑪ Click OK.

Print a Reduced Photo

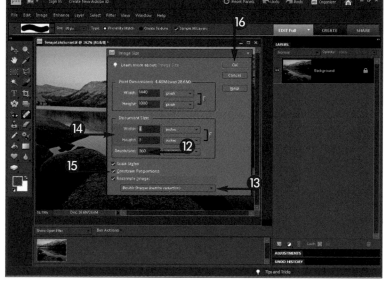

⑫ Type **360** in the Resolution box.

⑬ Click Resample Image (■ changes to ☑) and choose Bicubic Sharper.

⑭ Type the width or height that you want in either the Pixel Dimensions area or the Document Size area.

⑮ Make sure that Constrain Proportions is checked.

⑯ Click OK.

#91

DIFFICULTY LEVEL

TIPS

Did You Know?

When resizing images using the Image Size feature, you need to be careful to choose the most appropriate resampling algorithm. Bicubic is the default setting for resampling, but it uses an old algorithm that is okay for noncritical use. You will get best results if you use Bicubic Smoother when enlarging an image and Bicubic Sharper when reducing the size of an image.

Caution!

When enlarging or reducing any image, you should always save the resampled image to a new file and not overwrite the original image. Keep your original image as a master file with the original pixels plus any layers you used so that you can always reuse the layers and the original file's pixels for new image sizes. Save your master as a PSD file and sized files as TIFF files to help keep them separate.

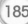

SHARPEN
a digital image

Sharpening is not about making a badly focused image sharp. You cannot do that. Sharpening is about revealing the maximum sharpness of your lens in the digital file. Digital cameras do not capture sharpness the same way that film cameras do. The digital process has some inherent softness to it that needs correction.

Using Photoshop Elements, you can bring back the correct sharpness of your photos and reveal what the lens actually captured. One easy way to sharpen a photo is to use the Unsharp Mask filter found in most image-processing software. It includes three specific

settings for the amount of sharpening, the radius of the sharpening effect, and a threshold for when the sharpening occurs.

There are many formulas for Unsharp Mask settings. Different sizes, varied purposes, and specific subjects all need different settings. For example, the best settings for a photograph of a landscape are different from the settings you need to sharpen a portrait of a woman. In addition, you need to sharpen a small file for Web use much less than an image needed for a large print.

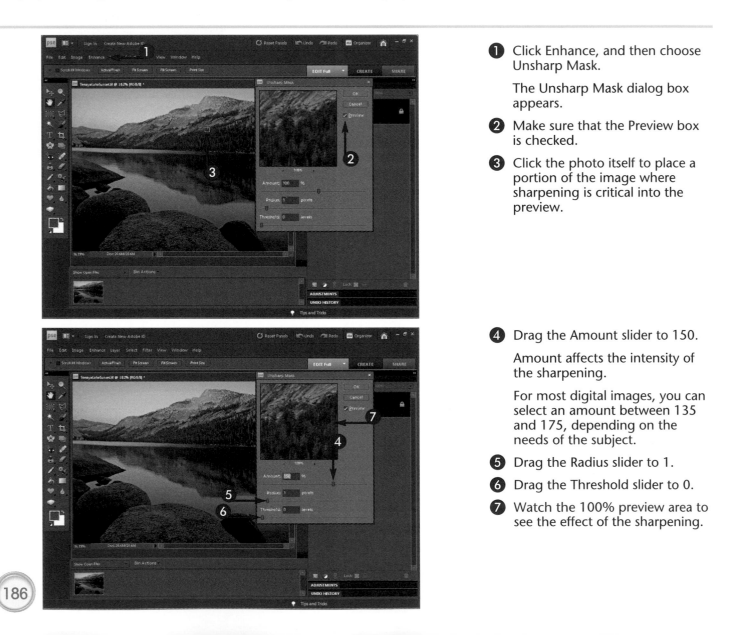

1 Click Enhance, and then choose Unsharp Mask.

The Unsharp Mask dialog box appears.

2 Make sure that the Preview box is checked.

3 Click the photo itself to place a portion of the image where sharpening is critical into the preview.

4 Drag the Amount slider to 150.

Amount affects the intensity of the sharpening.

For most digital images, you can select an amount between 135 and 175, depending on the needs of the subject.

5 Drag the Radius slider to 1.

6 Drag the Threshold slider to 0.

7 Watch the 100% preview area to see the effect of the sharpening.

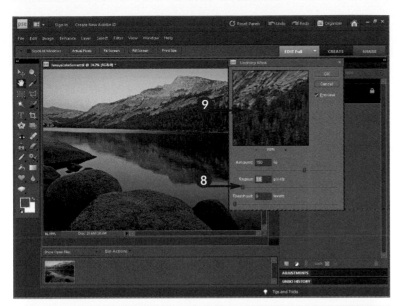

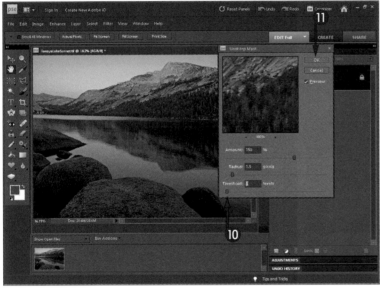

8 Change Radius to increase sharpening.

Radius affects how far sharpening goes from an edge.

Typically, you should use 1–1.5, but never over 2 for standard images.

Use a higher number for larger images (20MB and up) and a lower number for smaller images (under 10MB).

9 Watch the 100% preview for harsh edges or halos appearing around them.

10 Change Threshold to minimize sharpening of noise.

Threshold affects the point at which sharpening occurs and is used to deal with noise.

Most digital images use a threshold of 3–6, but when noise is high, you can go up to 12.

With higher settings of Threshold, you need to increase Amount to compensate for a lowered sharpening effect.

11 Click OK.

TIPS

Did You Know?

You cannot use Photoshop Elements to sharpen a poorly focused digital photo. The Unsharp Mask filter increases only the perceived sharpness of an already well-focused photo. If you want a good photo that appears "tack sharp," you must first shoot it in focus and then apply the Unsharp Mask filter to get the best results. In addition, sharpening often makes the blur in photos that is caused by camera movement worse.

Did You Know?

There is an additional sharpening tool in Photoshop Elements simply listed as Adjust Sharpness under Enhance. It is the same tool as Smart Sharpen in Photoshop. It uses more-advanced algorithms for adjusting sharpness compared to Unsharp Mask, but it does not have a Threshold setting, so it can over-enhance noise. It can be a very good option to use if your image is very "clean," meaning it has little noise because it was shot with a large sensor or low ISO.

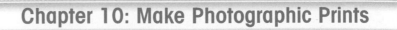

CROP A PHOTO
to a specified size

You can crop your photos when you want to work with only a certain part of them, to revise a composition, or when you need to make a photo meet specific width and height requirements. In task #69, you learn to crop to remove parts of a photo that are not needed. In this task, you learn to crop to a very specific size. These are two different functions of cropping and are done at different points in the workflow. Cropping to a specific size should not be done until you are ready to print or use the photo for a purpose that needs a specific size. To crop to a

specific size, you use the Crop tool, which has a few extra features useful for cropping images as precisely as you want them.

Using the Crop tool, you can not only crop to a fixed aspect ratio, but also crop to a fixed size, specified in inches, and at a specified printer resolution. Additionally, the Crop tool enables you to drag the edges of a selection to select exactly the area that you want; it even enables you to rotate the image if needed.

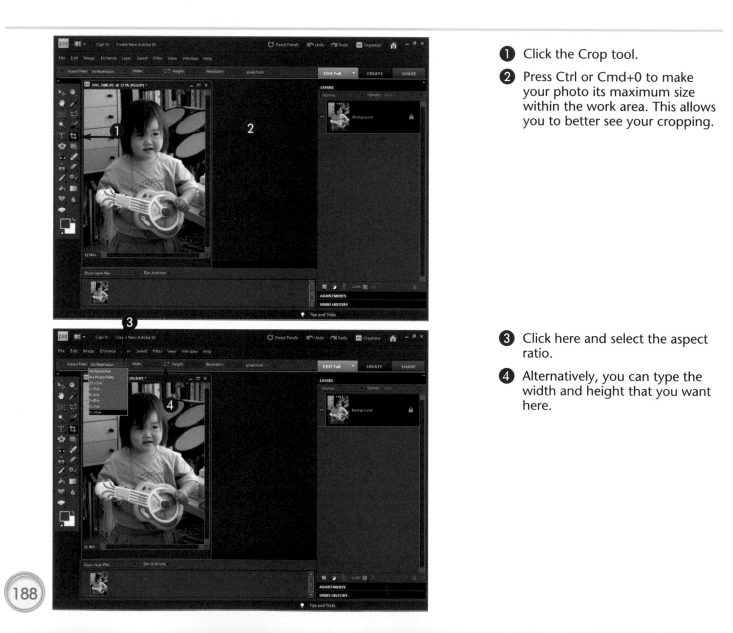

① Click the Crop tool.

② Press Ctrl or Cmd+0 to make your photo its maximum size within the work area. This allows you to better see your cropping.

③ Click here and select the aspect ratio.

④ Alternatively, you can type the width and height that you want here.

5 Click and drag your cursor to select the area of the photo that you want.

6 Position the mouse pointer on any box on the perimeter of the crop selection area.

Click and drag those points to make the selection smaller or larger, but still keeping the proportions of the aspect ratio.

7 Position the mouse pointer inside the crop selection area to drag the area over the image.

8 Click the green check mark to apply the crop.

The image is cropped and resized.

TIPS

Did You Know?

If your image is crooked, you can also rotate it during this step. This can be used to straighten horizons, for example. Position the mouse pointer outside a corner of the crop selection area. The cursor changes to indicate that you can rotate the image. Click and drag to rotate the selection until it appears as you want it.

Caution!

When you crop an image, its total pixel resolution is lowered because you are removing pixels. This could make the image smaller than needed for a good print. If you choose a specific resolution in the crop options bar, you can ensure you remain at a printable resolution. You can also choose Image, Image Size, and then Resize Image Size to set the resolution.

PRINT
your photos

Now that you have done all of your processing, your sizing, sharpening, and so on, you are ready to make a print. You can make stunning prints with nearly any inkjet printer on the market today, but you can also make very bad prints from the same printer. You have to set up both Photoshop Elements and your printer to communicate properly so that you get the best print. They have to know which one is in charge of color management as well as what type of paper you are using.

This book cannot make you a master printer, but the next four pages give you some ideas on how you can make better prints with your own inkjet printer. Photo-quality inkjet printers are available today at very reasonable prices all the way up to expensive pro-level printers. True photo printers have more ink colors to give better color and tonal gradations within a print. Lower-priced printers tend to be slower, even though the image quality is high, and have fewer advanced features.

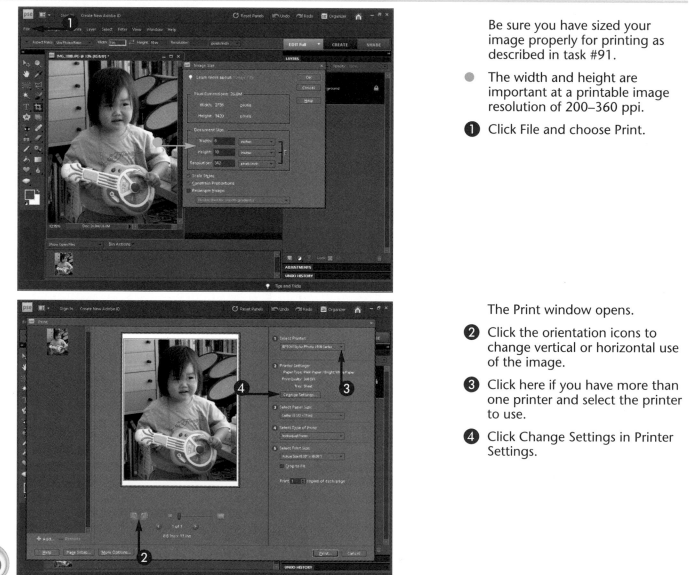

Be sure you have sized your image properly for printing as described in task #91.

● The width and height are important at a printable image resolution of 200–360 ppi.

❶ Click File and choose Print.

The Print window opens.

❷ Click the orientation icons to change vertical or horizontal use of the image.

❸ Click here if you have more than one printer and select the printer to use.

❹ Click Change Settings in Printer Settings.

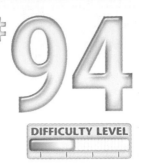

The Change Settings dialog box appears.

5 Choose the correct paper type based on what you are using.

6 Choose the paper size that you are using.

7 Click OK.

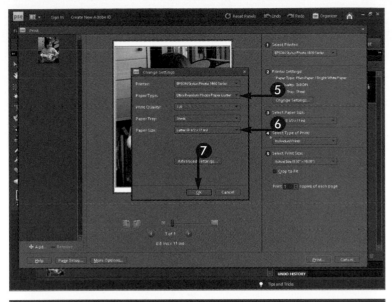

8 Click here to set a size for the image on the paper.

9 Click More Options to open the More Options dialog box.

10 Click Color Management.

11 Click here to choose Printer Manages Colors or Photoshop Elements Manages Colors.

Canon and Hewlett Packard as well as lower-priced Epson printers often do well with Printer Manages Colors.

Higher-end Epson printers usually do best with Photoshop Elements Manages Colors.

12 If you chose Printer Manages Colors in step 11, click Printer Preferences now. Skip the next step.

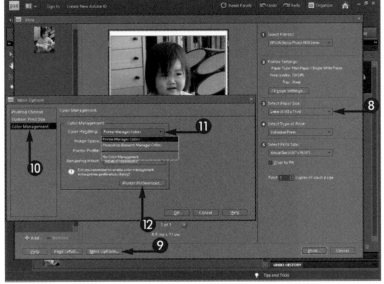

TIPS

Did You Know?

When the printer manages color, it takes the color information from Photoshop Elements and refines it based on the paper used and the color settings of the printer software. You must set the printer driver so it knows what paper you are using and the quality of print you want to make. When Photoshop Elements manages color, a very specific interpretation of color is sent to the printer based on paper profiles, and you still have to tell the printer what paper you are using and the quality of print.

Did You Know?

Printer profiles are specific translations of color and tonality for printing based on testing of specific papers with specific printers. They are also called *paper profiles*. A special pattern of colors is printed on paper, and then the colors are read and interpreted by colorimeters in order to define a profile. A set of profiles comes with your printer based on the printer manufacturer's papers. You can also download profiles from Web sites of paper manufacturers for their specific profiles.

PRINT
your photos

Is your goal to make a print that matches the monitor? Realize that a calibrated monitor that gives predictable results when printing is important, but no one is ever going to comment on how well your print matches your monitor. Your goal should be to make a good *print*. A viewer cares only about the print in front of him or her.

To really work to get the best print means that you have to take your print away from the monitor and

look at it as a print. Do you like the image that you see? Does it have the appropriate brightness and balance of tonalities for the size of the print? Are there colorcasts that show up too strongly in a print but looked okay on the monitor? What you are looking for is a print that you can be proud to put up on the wall. If that means making some correctional adjustments to the image and reprinting, do that and everyone will better enjoy your final prints.

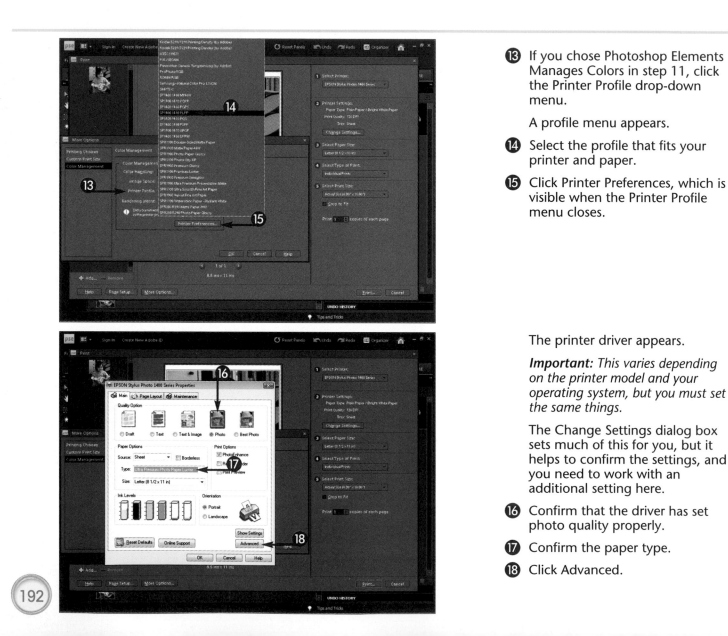

13 If you chose Photoshop Elements Manages Colors in step 11, click the Printer Profile drop-down menu.

A profile menu appears.

14 Select the profile that fits your printer and paper.

15 Click Printer Preferences, which is visible when the Printer Profile menu closes.

The printer driver appears.

Important: *This varies depending on the printer model and your operating system, but you must set the same things.*

The Change Settings dialog box sets much of this for you, but it helps to confirm the settings, and you need to work with an additional setting here.

16 Confirm that the driver has set photo quality properly.

17 Confirm the paper type.

18 Click Advanced.

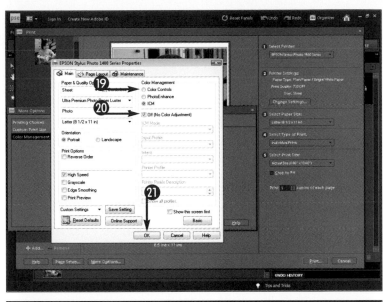

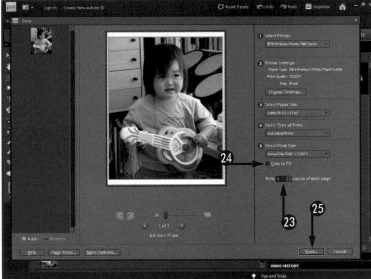

Important: *The following settings are in different places for varied printer models and Mac or PC, so you may have to look for them.*

⑲ If you chose Printer Manages Colors in step 11, leave Color Controls selected in the Color Management section.

⑳ If you chose Photoshop Elements Manages Colors in step 11, select No Color Adjustment (or No Color Management in some printer drivers) in the Color Management section.

㉑ Click OK to close the printer driver.

㉒ Click OK to close the More Options dialog box.

㉓ Choose a number of prints to make.

㉔ Click Crop to Fit if you want the photo itself to fit a specific paper size (■ changes to ☑).

㉕ Click Print.

TIPS

Try This!

Traditional darkroom workers almost always consider their first print a work print. They examine this print carefully to decide what else is needed to make the print better. Many photographers consider a work print a good idea for digital printing as well. This means that you expect that the first print from your printer is simply something to examine for ideas on how to go from a good to a better print. Take the print away from your computer and look at it in good light for proper evaluation.

Did You Know?

Printer resolution and image resolution are two different things. This is a very important thing to keep straight. Printer resolution is set by the printer driver and affects how ink droplets are put on the paper. This is usually set by the printer when you tell it what type of print to make. Image resolution is set by Photoshop Elements and is based on the pixels in the photograph. There is little direct relationship between the two that is important to most photographers.

PRINT MULTIPLE PHOTOS
on a page

Sometimes a single photo just does not do the job for you. You want more than one photo on a page of printing paper. Maybe you want a number of pictures to represent a recent trip, or you may want to print several photos on a single sheet of printing paper to make your printing more efficient and to save money.

This is very easy to do within the Organizer. There you can see all of your pictures from an album or a particular time and then choose the pictures that you

want for printing by using the rating stars. It can be hard to select a variety of pictures throughout a large group of images, but you can click the individual pictures that you want to use and then give each one a rating, such as five stars. You then simply sort your images to those five-star pictures. You can quickly process each one for optimum image quality and then select them all for printing.

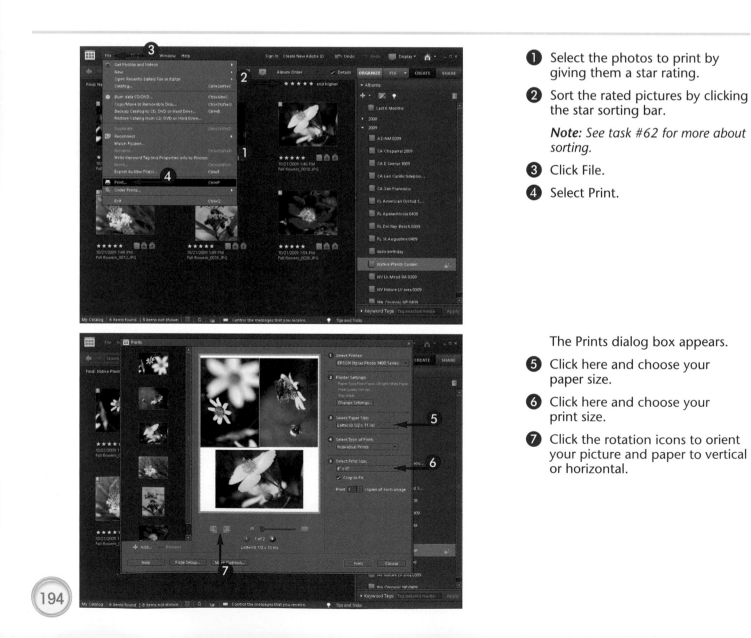

① Select the photos to print by giving them a star rating.

② Sort the rated pictures by clicking the star sorting bar.

Note: *See task #62 for more about sorting.*

③ Click File.

④ Select Print.

The Prints dialog box appears.

⑤ Click here and choose your paper size.

⑥ Click here and choose your print size.

⑦ Click the rotation icons to orient your picture and paper to vertical or horizontal.

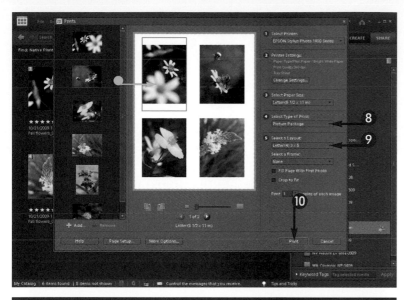

8 Click here and choose Picture Package.

9 Click here and choose the layout that you want for your pictures.

● As soon as you select an option from Select a Layout, it appears in the center display.

⑩ Click Print to have the printer manage colors.

Important: *You must also set up your printer driver as described in task #94.*

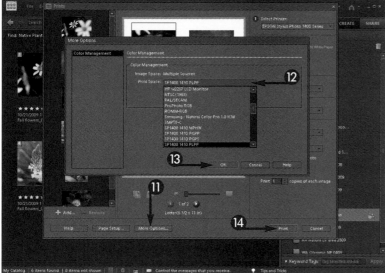

⑪ Click More Options to print with Photoshop Elements managing colors.

The More Options dialog box appears.

⑫ Click here and choose the paper profile for your paper and printer.

The option Same as Source has the printer manage colors.

Important: *You must also set up your printer driver as described in task #94.*

⑬ Click OK.

⑭ Click Print.

TIPS

Keyboard Trick!

Ctrl/Cmd+P is the standard keyboard command for print. It allows you to print a picture whether you are in Editor or Organizer. You can use keyboard shortcuts for many of the commands in Photoshop Elements. This can speed up your image processing. Keyboard shortcuts are listed at the right of the command in each menu. Although not all commands have shortcuts, most of them do.

Try This!

You will notice two unique choices in the Layout portion of the Prints window, Fill Page With First Photo and Crop to Fit. With Fill Page With First Photo, you can create a page that prints only one photo multiple times on that page. With Crop to Fit, your image is cropped to fit the exact size of the layout dimensions. You can click and drag your photo within the image area to make the crop look better. If the crop does not fit your photo, do not check that box.

ORDER PRINTS
online

Maybe you like the idea of prints, but you want a print larger than what is possible from your printer; or maybe you want a special surface and mount for the print; or perhaps you do not want to make prints yourself. You can have professionals do the printing for you via the Internet. Two services are accessible directly from Photoshop Elements: Shutterfly and the Kodak Gallery.

Both services offer an excellent selection of print possibilities and allow you to select, edit, upload, and order photo prints from your computer any time you

want. After uploading your photos to an online printing service, your photos are printed and delivered to your mailbox within a few days.

Besides being able to order prints for yourself after you have uploaded them, you can also send a link via e-mail to other people with whom you want to share the photos. They can view the photos online in a Web browser; if they want, they can order prints themselves at their own expense, or you can order prints to mail to them.

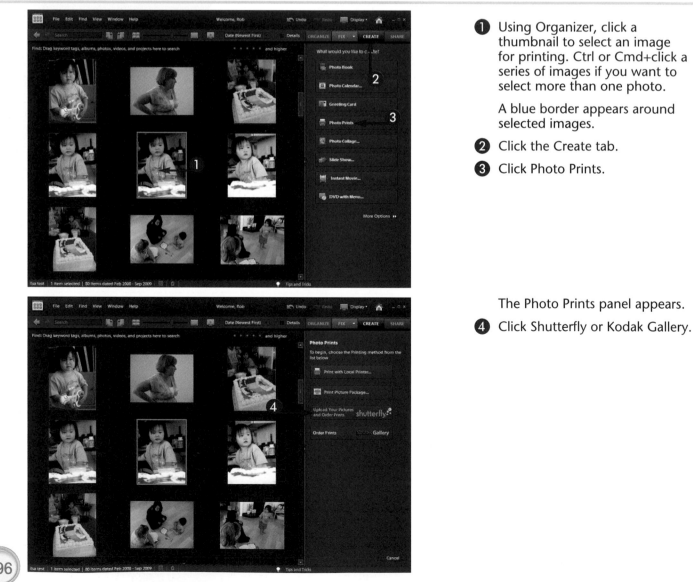

1 Using Organizer, click a thumbnail to select an image for printing. Ctrl or Cmd+click a series of images if you want to select more than one photo.

A blue border appears around selected images.

2 Click the Create tab.

3 Click Photo Prints.

The Photo Prints panel appears.

4 Click Shutterfly or Kodak Gallery.

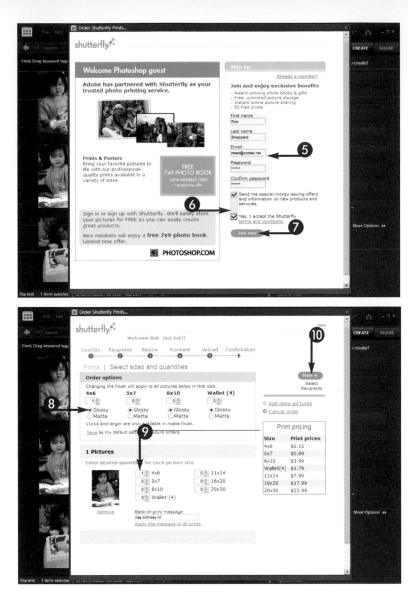

The Welcome to Photoshop page appears. You must create an account if you do not already have one.

5 Fill in your name and e-mail, and choose a password.

6 You must check the terms and conditions agreement to go further, but you do not have to check the special offers.

7 Click Join now.

The order page appears.

8 Choose a finish for your prints.

9 Choose a size and quantity for your prints.

10 Complete the order following the Next buttons through all of the Shutterfly instructions.

You are asked to provide delivery information.

You are then asked to provide billing information.

Finally, you upload the images to the Shutterfly service and confirm details.

Did You Know?

A great way to use an online photo-printing service is to crop, edit, and place all the photos that you want printed into a single album in Organizer or a single folder on your hard drive before uploading them to the service. Crop each of the photos to the aspect ratio of the print size that you want to order and do a Save As in an appropriate file format. This keeps your images conveniently in one place for ordering. See task #63 for more about albums.

Did You Know?

Check the Shutterfly and Kodak Gallery online sites before making your orders through Photoshop Elements. Go to Shutterfly at www.shutterfly.com and Kodak Gallery at www.kodakgallery.com. If you are using a Macintosh, you can also upload and order photo prints and photo books easily by using Apple's iPhoto software. Photoshop Elements 8 does have some integration with iPhoto.

CREATE A PHOTO BOOK
online

There is little that can compare to having family and friends pick up an impressive book of your photography. A printed photo book is an exciting way to share photographs. You can put together a book of favorite images from a great trip, or maybe it could come from a collection of photos of your kids playing soccer over a whole season, or your book might even be a gathering of images from your family's life since the day you were born. Such books can make great holiday gifts.

One of the leading online photo book companies is MyPublisher. The MyPublisher service includes free software that you use to create your books, but your photos must be saved as JPEG files and sized appropriately. To get started, download the MyPublisher software from www.mypublisher.com.

As this book goes to press, MyPublisher offers 5.75-x-7.75-inch pocket books with 20 pages and up to 80 photos for $12.95. If you want a really big book, MyPublisher offers giant 11.5-x-15-inch full-bleed books with a hardcover binding made of imported linen. A 20-page book costs $59.80.

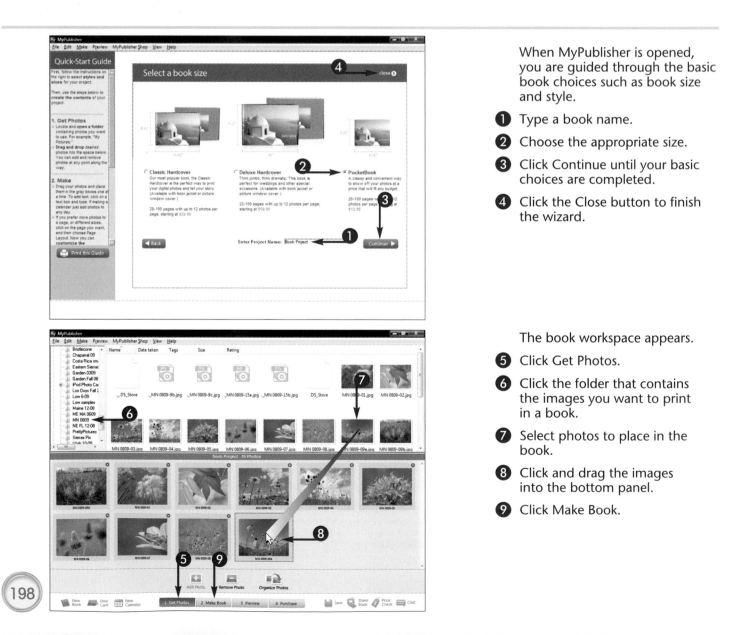

When MyPublisher is opened, you are guided through the basic book choices such as book size and style.

❶ Type a book name.

❷ Choose the appropriate size.

❸ Click Continue until your basic choices are completed.

❹ Click the Close button to finish the wizard.

The book workspace appears.

❺ Click Get Photos.

❻ Click the folder that contains the images you want to print in a book.

❼ Select photos to place in the book.

❽ Click and drag the images into the bottom panel.

❾ Click Make Book.

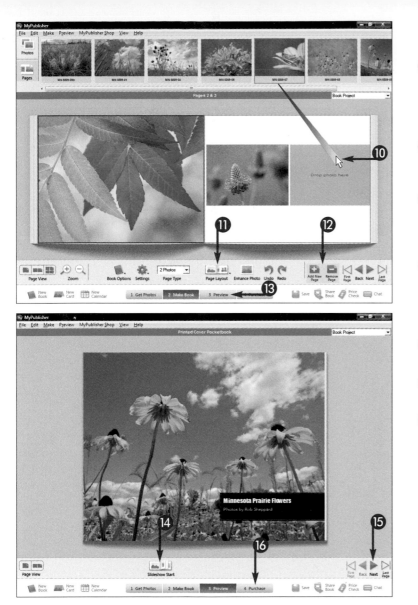

The Pages window appears.

10 Drag and drop photos from the top photo organizer into photo spaces on the book pages.

11 Click Page Layout to change the look of your pages.

12 Click Add New Page or Remove Page to change the number of pages used.

13 Click Preview to preview the entire book project.

The Preview window appears.

14 Click Slideshow Start to get a preview show of the book.

15 Click Next to preview the book page by page.

16 Click Purchase to buy the book.

DIFFICULTY LEVEL

TIP

Did You Know?

If you want to make your own photo books using the paper of your choice and a desktop inkjet printer, you can do so by purchasing a photo book cover made for this purpose. In particular, Unibind's PhotoBook system (www.unibind.com) and Epson's StoryTeller Photo Book Creator (www.epson.com) custom book kits make excellent photo books that can feature your photos printed on your favorite inkjet paper, using a color profile — and printed to your specifications and needs. A great advantage of this way of doing a book is that you control the look of how every photo prints. The disadvantage is that it is a lot more work. Both Unibind and Epson's binding features are easy to use.

Share Your Photos

One of the joys of digital photography comes from how easy it is to share your photos. It can be exciting to know that you can both enjoy and share your digital photos in so many ways. You can attach one or more photos to an e-mail, create slide shows to play on your computer screen or even on a TV screen, publish online photo galleries, create digital photo albums, make collages, and more.

The Web, for example, is so important today that every photographer needs to know how to prepare photos for the many ways of using the Internet. Also, because digital photographers take a lot of pictures, they often want to use more than one photo from a trip or event. Slide

shows, photo montages, and scrapbooking do just that.

Many digital photo projects require software beyond what you use to process your photos. Although Photoshop Elements includes a whole range of possibilities in the Create and Share sections of the software, there are other things that photographers want to do with their photos. Because of the huge interest today in digital photography, the marketplace offers an incredible number of products from which to choose. Often you can choose one additional software product that enables you to complete most or all of your projects.

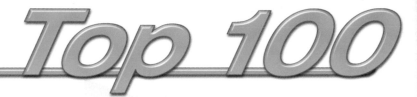

PREPARE
photos for use on the Web

You can convert your digital photos into images perfectly sized and suited to use on a Web page or as an e-mail attachment. Although you can use the Save As command for the same purposes, the Save for Web command has many advantages.

Before you process an image specifically for the Web, you need to resize the image file to a size that works with Save for Web. Most high-megapixel images are too large. You need only a rough file size of approximately 12MB. Task #91 offers details on how

to resize an image; the megabyte size of the image is in the top section of the Resize window.

When you save digital photos for use with e-mail or on a Web page, you are faced with a trade-off between image file size and image quality. The smaller the dimensions of the image and the more that you compress an image, the faster it downloads and displays; yet the more an image is compressed, the more the image quality is reduced.

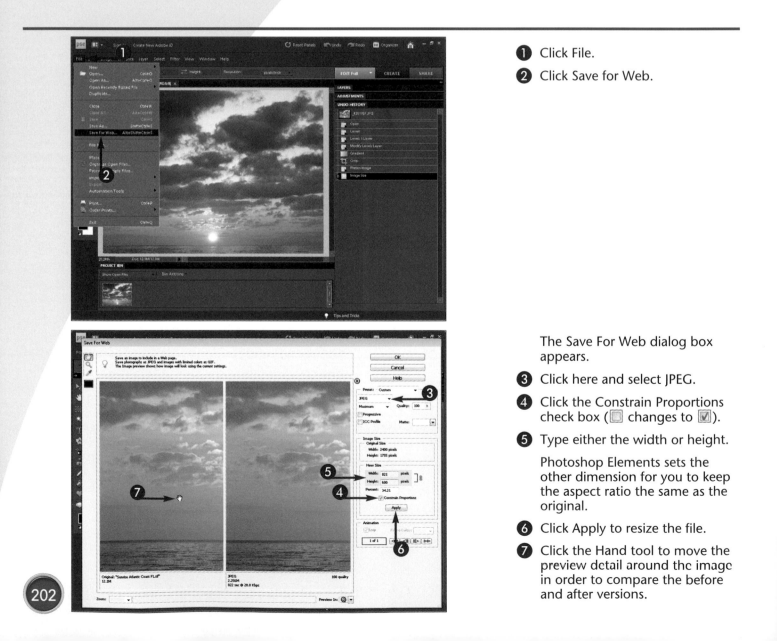

① Click File.

② Click Save for Web.

The Save For Web dialog box appears.

③ Click here and select JPEG.

④ Click the Constrain Proportions check box (☐ changes to ☑).

⑤ Type either the width or height.

Photoshop Elements sets the other dimension for you to keep the aspect ratio the same as the original.

⑥ Click Apply to resize the file.

⑦ Click the Hand tool to move the preview detail around the image in order to compare the before and after versions.

8 Click here and select JPEG Medium.

Note: JPEGs are compressed images that are small and useful for displaying on Web pages.

● In this example, the size of the image on the right is 162.9KB instead of 12.1MB.

9 Click OK.

The Save Optimized As dialog box appears.

10 Click here and select a folder in which to save the file.

11 Type a name for the file.

12 Click Save.

The image is saved, optimized for the Web.

#98

DIFFICULTY LEVEL

TIPS

Caution!

If you are shooting with any of the high-megapixel cameras common today, you get a warning from Photoshop Elements when you try to use Save for Web. It tells you the image exceeds the size Save for Web was designed for. It is hard to know what Adobe is thinking given how common high-megapixel cameras are, but you should resize these photos down first by clicking Image, Resize, and then Image Size.

Did You Know?

You will often need a specific size for a Web page, so you can use that number for pixel height and width in Save for Web. For e-mail, the pixel size can vary depending on how large an image you want to send. For simple viewing, 800x600 is fine. For images that can be printed, 1200x800 can work. However, 600 is often good as the low number for either dimension and works well for both Web pages and e-mail.

Create a
PDF SLIDE SHOW

Slide shows have long been a popular way of sharing photos with others. They become very easy to do with digital photos. Photoshop Elements enables you to quickly and easily create a PDF slide show. A *PDF* (portable document format) is a special file that can be read using Adobe Acrobat or the free Adobe Acrobat Reader. You can view PDF files on all computers — at most all someone would have to do is download the free Acrobat Reader. So, you can create a slide show using a PC or Mac and share it with anyone, no matter what computer he or she is using.

After you have created a PDF slide show, all the photos and the settings that you selected for playback are contained in a single file. A significant advantage to sharing your digital photos in PDF format is that a number of useful features are built into Acrobat Reader that allow the images to be exported, edited, printed, and so on, which you cannot do with other slide shows. The disadvantage is that music and narration capabilities are limited.

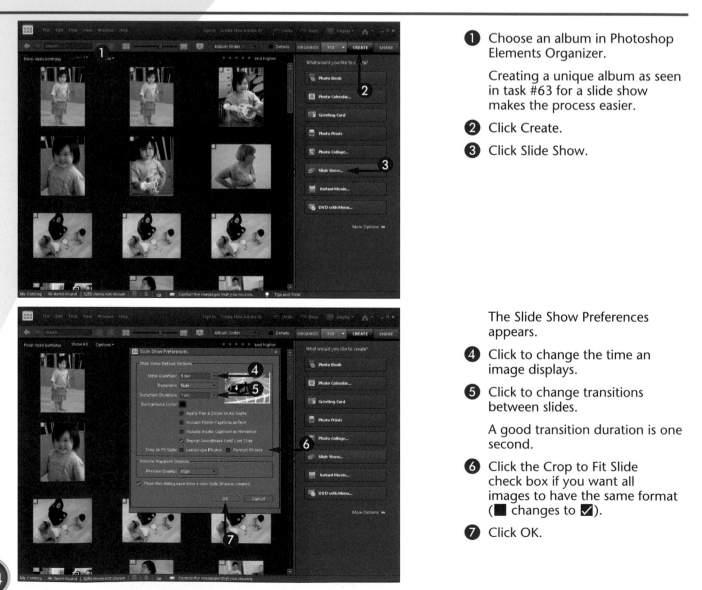

① Choose an album in Photoshop Elements Organizer.

Creating a unique album as seen in task #63 for a slide show makes the process easier.

② Click Create.

③ Click Slide Show.

The Slide Show Preferences appears.

④ Click to change the time an image displays.

⑤ Click to change transitions between slides.

A good transition duration is one second.

⑥ Click the Crop to Fit Slide check box if you want all images to have the same format (■ changes to ☑).

⑦ Click OK.

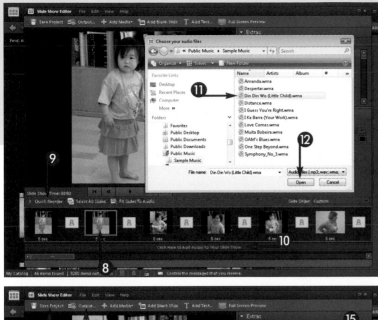

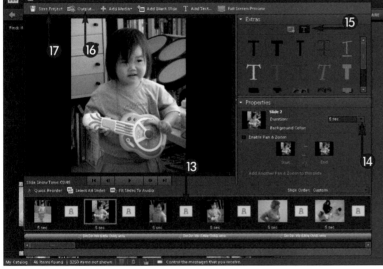

The Photoshop Elements Slide Show Editor window appears.

#99

⑧ Click a photo and press Delete to remove from show.

⑨ Click Quick Reorder for a slide table view that allows rearranging of slides.

DIFFICULTY LEVEL

⑩ Click Click Here to Add Audio.

The Choose your audio files window opens.

⑪ Navigate to a folder with music and pick a file.

⑫ Click Open.

You are returned to the Slide Show Editor window.

⑬ Click a transition icon to change an individual transition.

⑭ Click here to change a specific slide duration time.

⑮ Click the Text icon to add graphics and text to the photo.

⑯ Click Output to save the slide show as a PDF file.

⑰ Click Save Project to save the slide show as a project that can be revised.

TIPS

Did You Know?

When traditional slide shows were popular, a photographer had to use multiple slide projectors connected to a tape deck through a synchronizer in order to get even simple dissolves and a music track. This was complicated, expensive, and often got out of synchronization. With a digital slide show, you can do better than the old projector-and-tape-deck slide shows with more control, and your slides never get out of sync from music.

Did You Know?

An Acrobat- or PDF-based slide show is easy to create and easy to use for sharing individual photos, too, because there is only a single file instead of one file for each photo, plus additional files for a slide show program and slide show settings. For more control over your slide show, including multiple effects and the ability to precisely work with audio, check out Photodex Pro Show Gold (www.photodex.com) for the PC and Boinx FotoMagico (www.boinx.com) for the Mac.

Chapter 11: Share Your Photos 205

Create a
VIDEO SLIDE SHOW

A PDF slide show is only one option. You can also output your slide show as a movie file. This gives certain advantages, including giving you more options for transitions, and it also lets you pan and zoom across an image. This is a creative way of showing off your photos, plus showing images on a TV to a group is easier than on a computer screen. Viewers also expect more from a video slide show, so this is a good opportunity to add titles and other text. Spend a little time working out your show and experimenting with these added slide show features.

People create slide shows for many reasons. Maybe you have just returned from an overseas trip with lots of great photos, and you want to share them with friends and family. Maybe you want to create a slide show featuring your children or your parents over the years. Whatever the reason, computers as well as DVD players play many prerecorded media and let you enjoy the benefits of this technology now for your slide shows.

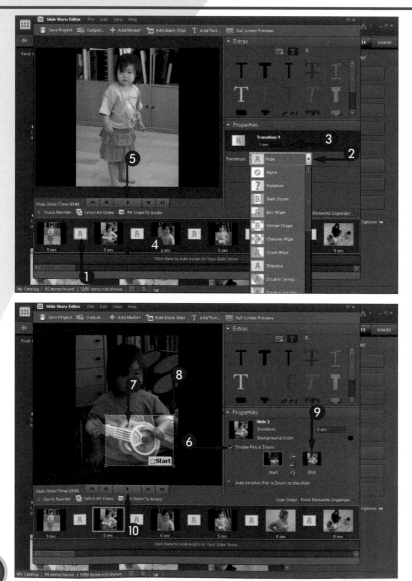

1 Click a transition icon to open the transition options between two slides.

2 Click here and choose an interesting transition appropriate to your show and the photos.

3 Click here to change the transition time.

4 Click here to change the time that the slide appears.

5 Click the play button to see how the transition looks as well as to watch the entire show.

6 Click this check box to enable pan and zoom (■ changes to ✓). This allows you to do something called the Ken Burns effect of using movement across a still photo.

7 Click and drag the start box to where you want the pan or zoom to begin.

8 Drag the box corners to change the size.

9 Click here to set the end box of the pan and zoom.

10 Click the play button to preview the resulting effect.

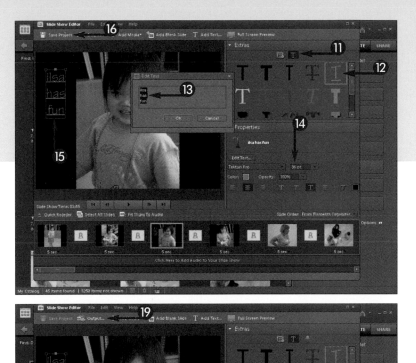

⑪ Click the Text icon to add a title.

⑫ Double-click a letter to open a text box using that style.

⑬ Type your text in the Edit Text dialog box to make it appear over the photo, and then click OK.

⑭ Use these options to change the font, size, color, and more.

⑮ Click and drag text into position.

⑯ Click Save Project.

The Save dialog box opens.

⑰ Type a name for the project.

⑱ Click Save.

⑲ When the Save dialog box closes, click Output.

#100

DIFFICULTY LEVEL

TIPS

Caution!

Be wary of constantly changing transitions between slides. Although it is possible to put a different transition from one slide to another throughout the entire show, this attracts attention to your transitions, not your photos. Your show will look more like a late-night television mattress store ad than a slide show that shows off your subject. Many shows can be done with just one transition, but varied in its duration.

Did You Know?

Panning and zooming across a slide is sometimes known as the Ken Burns effect. Ken Burns is a documentary producer/director known for his special historical programs usually featured on PBS, including shows on the Civil War and the National Parks. He uses pan and zoom techniques for old photos to give them movement and emphasis and make them come alive for a documentary.

Create a
VIDEO SLIDE SHOW

When you have completed a slide show for video, you have several choices for output. Showing your slide show with all of its effects and titles as a WMV (Windows Media Video) movie file on your computer is a great use for your laptop or if projecting from your laptop. You can also output this video file and record it to a USB drive or CD to transport to another computer.

The latter is not the same as a VCD (video CD). You will notice that there is also a choice for DVD and

VCD. To record your show to a DVD, you must have the Photoshop Elements companion software, Premiere Elements. With Photoshop Elements only, you can output to a VCD (which uses a lower resolution video format). Such a disc can be played directly on a computer with a CD-ROM reader and frequently (though not always) on a newer DVD player, but the quality is not as good as what can be burned to a DVD.

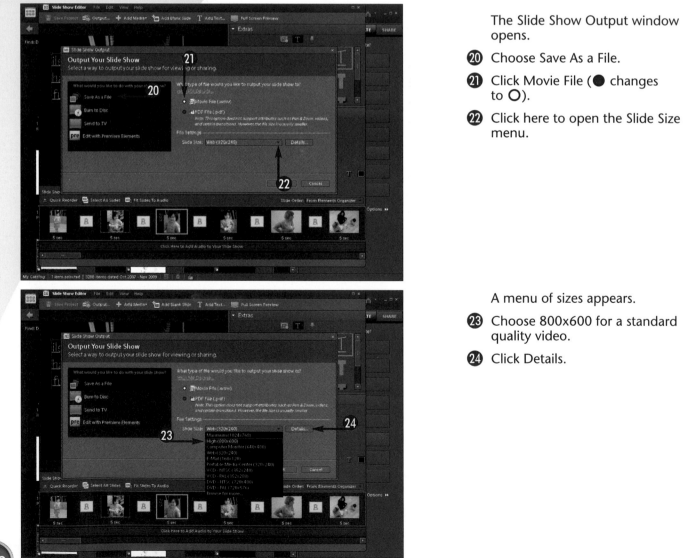

The Slide Show Output window opens.

⓴ Choose Save As a File.

㉑ Click Movie File (● changes to ○).

㉒ Click here to open the Slide Size menu.

A menu of sizes appears.

㉓ Choose 800x600 for a standard quality video.

㉔ Click Details.

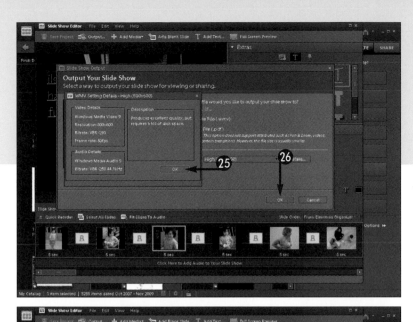

WMV Setting Details appear and give you information about the video and audio settings you have chosen.

㉕ Click OK.

㉖ Click OK.

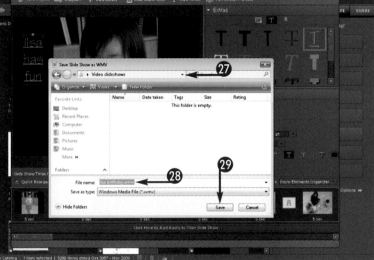

The Save Slide Show as WMV window appears.

If it first appears as a smaller window than seen here, click Browse Folders to expand the folder view.

㉗ Select a folder for your video file.

㉘ Type a name for the slide show.

㉙ Click Save.

The computer takes some time to create and save the WMV file.

TIPS

Important!

You have a lot of choices for size of slides, which is the size of the video. If you choose 800x600, you get a high-quality video that looks good on most computer screens and projectors. You can go to the next higher number for projection from digital projectors that can handle the size. The size 640x480 is a standard video size that has a smaller file size, which might play better on some computers.

Did You Know?

Adobe Premiere Elements is a relatively inexpensive program that integrates nicely with Photoshop Elements. In addition, it gives you even more flexibility for creating a slide show with multitracks of visual and audio elements. Plus, it includes a large set of templates for DVD menus that can be used for your slide shows. Many digital cameras now also offer video, and Premiere Elements lets you edit that video as well.

Create a
DIGITAL PHOTO ALBUM

A slide show is a nice way to show off your photos, but a photo album gives a totally different experience. You can page through an album at your own pace, look at multiple photos at once on two pages at a time, back up to look again at an earlier photo, and so on. You can create the digital equivalent of a photo album with virtual flipping pages with one of the FlipAlbum products from E-Book Systems (www.flipalbum.com). FlipAlbum Standard is free and automatically organizes your photos into realistic page-flipping albums that you can view on a PC

(Mac FlipAlbum is available for a Mac) as well as share on the Internet. FlipAlbum Suite has extra features that enable you to share your albums on CDs or play them on DVD players. FlipAlbum Pro enables you to create albums for sale and includes a disc password option, image encryption, watermark capabilities, and a print lock feature to control how images are printed.

To get started making your own virtual albums, you need to go to www.flipalbum.com, download the Flip Album software, and install it.

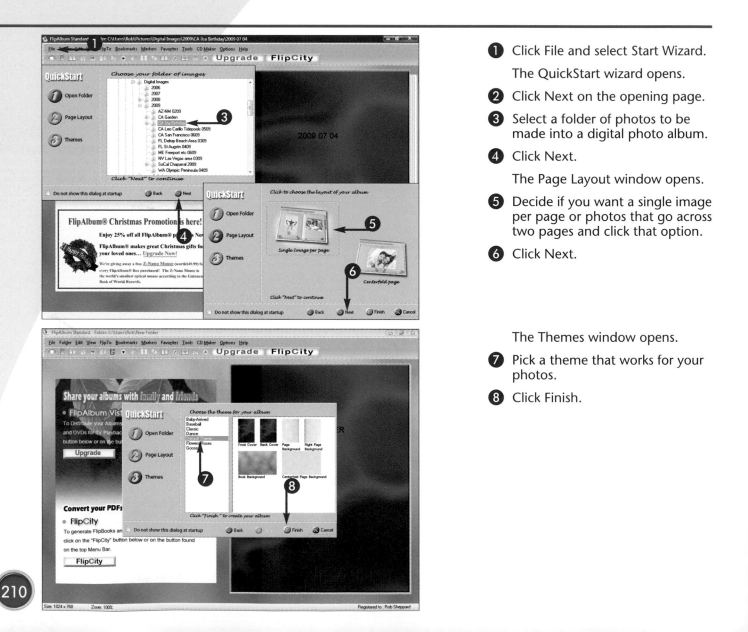

① Click File and select Start Wizard.

The QuickStart wizard opens.

② Click Next on the opening page.

③ Select a folder of photos to be made into a digital photo album.

④ Click Next.

The Page Layout window opens.

⑤ Decide if you want a single image per page or photos that go across two pages and click that option.

⑥ Click Next.

The Themes window opens.

⑦ Pick a theme that works for your photos.

⑧ Click Finish.

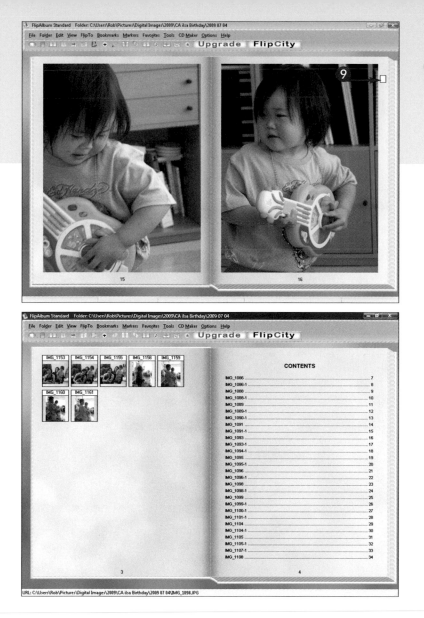

FlipAlbum creates a flip album.

#101

9. To turn a page, click the far side of a page to view a flipping page effect. The cursor changes to a page-turning animation.

Clickable thumbnails and index are automatically generated and placed at the front of the album.

To change the viewing order of the images, you can click and drag and drop the thumbnails.

TIPS

Did You Know?

You can further customize a FlipAlbum by selecting a different cover style or by choosing your own cover color, cover image, texture, and binding. Right-click the cover, for example, and you get a menu including the choice Page properties, where you can choose the color and texture of the pages, the margins, and how the pages "flip." You can add background music and set the entire album to flip automatically.

Apply It!

With FlipAlbum Suite, you can upload your FlipAlbums to the E-Book Systems Web site specifically for sharing FlipAlbums at www. myflipbooks.com. You can then have friends and family view your albums from anywhere they can access the Internet. You can also burn your albums directly to a DVD or CD for sharing.

Create a
PHOTO GREETING CARD

Put your photo on a greeting card! This is such a great way to use your photography. It gets your images off of your hard drive and into the hands of friends, relatives, and even business associates. With Photoshop Elements, you can make your own personalized card especially for the recipient — and that level of personalization is usually very appreciated. As you save your work, you can go back to that file and quickly make another copy of the card or modify it for a new recipient. Keep a standard card

for business thank-yous, for example, and update it to a client's name each time you send a new thank-you. You can also use a standard greeting text and constantly change your photo.

One of the strengths of Photoshop Elements is that the product is designed so that you can download new templates or styles for many of the creation types when they become available. You can also use various online services such as Kodak Gallery and Shutterfly to print your cards.

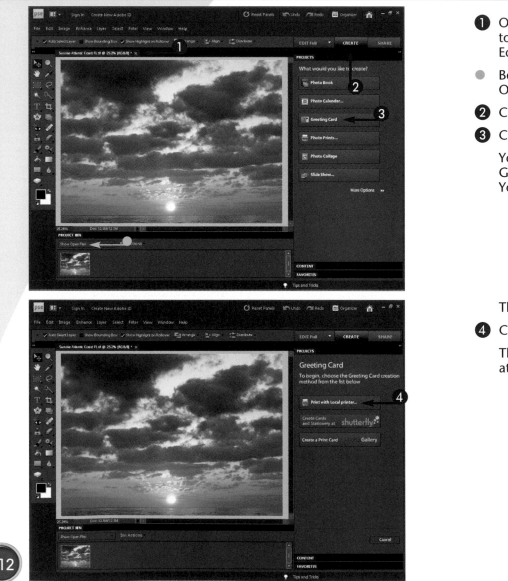

① Open an image that you want to use into Photoshop Elements Editor.

● Be sure the Project Bin says Show Open Files.

② Click Create.

③ Click Greeting Card.

You can also click Create and Greeting Card from Organizer. You go to the same place.

The Greeting Card panel appears.

④ Click Print with Local printer.

This means printing with a printer attached to your computer.

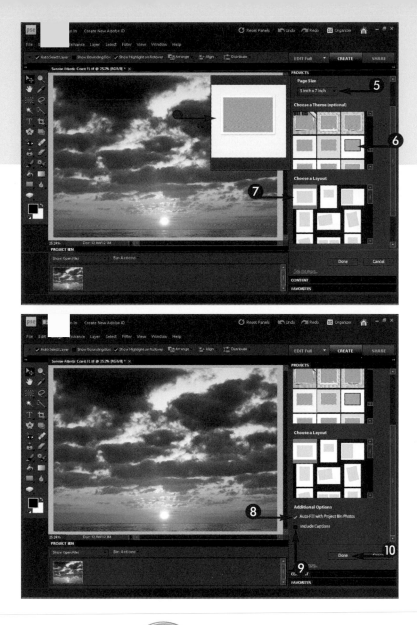

The Projects panel opens.

5 Click here and choose a page size.

6 Choose a theme to get started.

● When you click a theme or layout, a preview appears.

7 Click a layout.

#102

DIFFICULTY LEVEL

Scroll down with the right scroll bar if the whole panel is not showing.

8 Click Auto-Fill with Project Bin Photos (■ changes to ☑).

9 Click Include Captions if you want captions with your photos (■ changes to ☑).

10 Click Done.

TIPS

Did You Know?

The Photoshop Elements Create panel makes it easy for you to print greeting cards with your own desktop printer. You can also publish a card as a PDF file or as an attachment for e-mail; plus, you can save the card to a CD or order the card to be printed professionally from an online service vendor.

Did You Know?

Many stationery vendors make greeting card paper and matching envelopes especially for use with inkjet printers. You can find tinted, glossy, embossed, matte, and many other varieties in a pre-scored format for easy and accurate folding. Check your local office supply store or order online from www.staples.com or www.officedepot.com.

 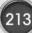

Create a
PHOTO GREETING CARD

As a digital photographer, you will start to have a lot of images on your hard drive. Putting them on greeting cards lets you express your creativity while using some of those many images. In addition, you may find that such cards are always welcome. Hallmark is such a strong name in the business because it has done such a good job in promoting cards and all sorts of holidays. That makes any card appropriate, but your personal card will be more valued.

You can start your own holidays, plus you can make each card a very personal creation specific for a recipient. You can use a person's name in Happy Birthday text, for example. If you save your file as a Photoshop (PSD) file, you can always reuse the photo and text by simply changing the name in the text.

You will find that simple designs for greeting cards generally work best. That means keeping photos and text to a minimum. In addition, keep the text font simple and easy to read.

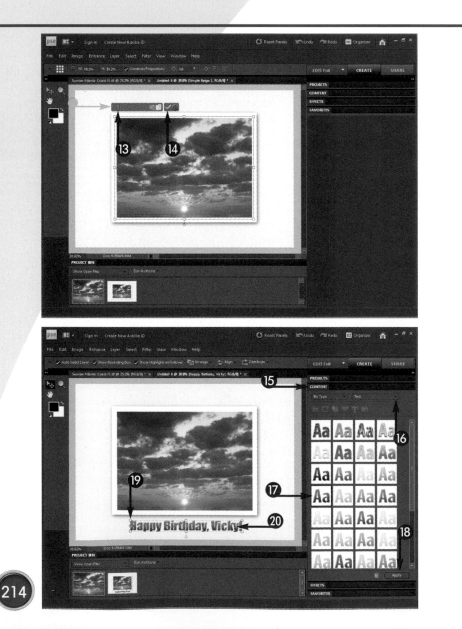

The card design appears based on your layout and theme now with your photo in place.

⑪ Press Ctrl or Cmd+0 to make the project fill the work area.

⑫ Right-click the photo and select Position Photo in Frame from the menu.

● A sizing bar appears.

⑬ Click and drag the slider to change the size of the photo inside its frame.

⑭ Click the green check mark.

⑮ Double-click Content to open it.

⑯ Click here and select Text.

⑰ Double-click a text treatment and type your message.

⑱ Click Apply.

⑲ Click and drag the corners of the text area to resize it.

⑳ Click and drag your text into position.

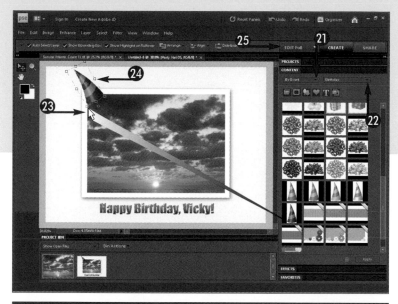

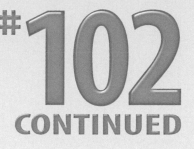

21 Click here and select By Event.

22 Click here and select the type of event.

23 Click and drag a graphic onto your photo.

24 Click and drag the artwork to change its size and position as in steps 18 and 19.

You can click and drag just outside the artwork to rotate it.

25 Click Edit Full.

Your greeting card is ready to print. Choose the right size paper for the card you made.

Your photo is created as a layered file. Save the photo as a Photoshop file without flattening so that you can revise the card later by working with its layers.

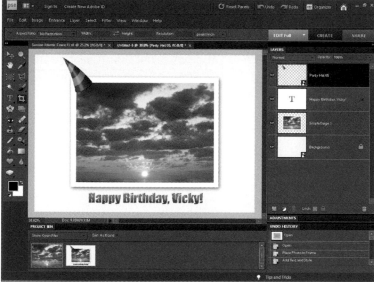

TIPS

Did You Know?

You can create a PDF file instead of printing the greeting card to your own desktop printer. When you complete the card, choose File, Save As, and Photoshop PDF. Then you can select settings to optimize the file for viewing on-screen, for printing, or for full resolution. This is a nice feature if you want to create a greeting card that can be shared easily by e-mail.

Did You Know?

The Content and Effects panel offers many options for customizing your card. You can change backgrounds, background themes, frames around photos, and more. Simply open the section of the panel that offers the choices you need. Click the image in the card and then double-click the effect; the image appears in the card. You can freely experiment with the content and effects by deleting ones you do not like by pressing Delete and double-clicking new ones.

Create a
PHOTOMONTAGE

A fun way of displaying photos is to assemble a group of photos taken on a vacation, a family get-together, or a sporting event. You could put together separate photos by pasting them onto a board to make a collage, but that has limitations. With Photoshop Elements, you can make a very nice photomontage of those photos. Not only are all the photos printed on a single page, which is why it is called a photomontage or photo collage, as Adobe calls it, but the process enables you to size and easily crop each image as needed.

Pick photos that go together and support each other in some way, either from a theme or even a story. Before you begin placing the digital photos on a new blank document, it can help to first roughly size the photos so that you minimize the work that it takes to resize them as you place them. When you have resized each photo, dragging, dropping, placing, and sizing each digital photo is a simple process.

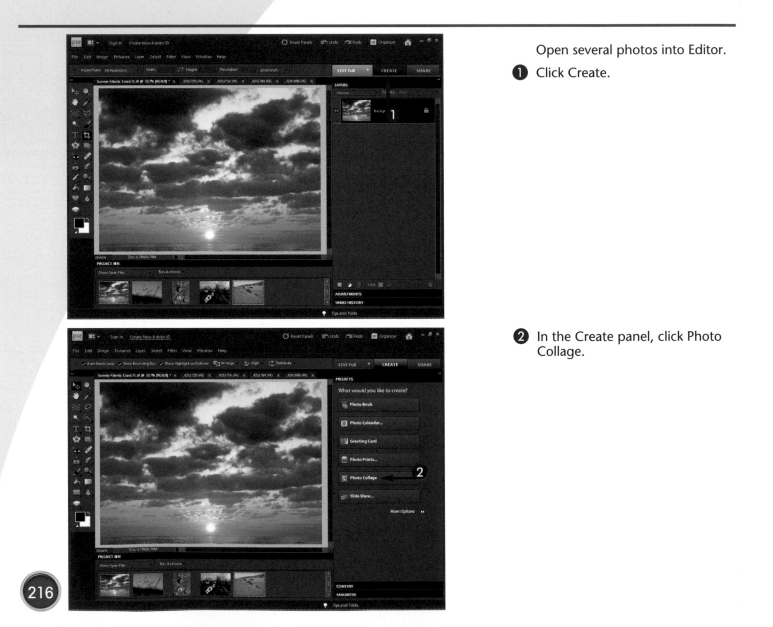

Open several photos into Editor.

1 Click Create.

2 In the Create panel, click Photo Collage.

The Projects panel opens.

3 Click here and choose a page size.

4 Choose a theme to get started.

When you click a theme or layout, a preview appears.

5 Click a layout.

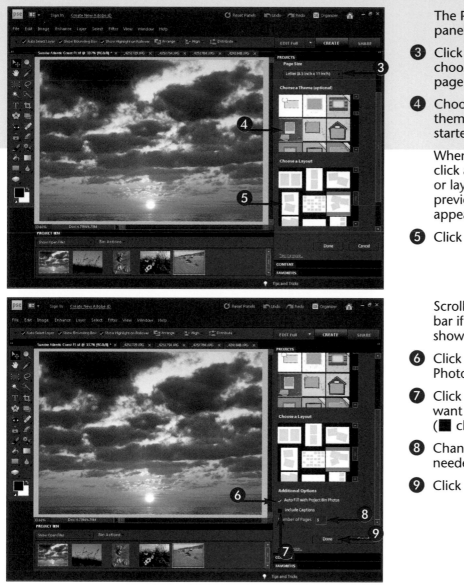

Scroll down with the right scroll bar if the whole panel is not showing.

6 Click Auto-Fill with Project Bin Photos (■ changes to ☑).

7 Click Include Captions if you want captions with your photos (■ changes to ☑).

8 Change the number of pages if needed.

9 Click Done.

#103

DIFFICULTY LEVEL

TIPS

Did You Know?

When arranging photos in a photomontage, keep it simple. With Photoshop Elements, you can certainly add lots of photos, make them all sorts of sizes, and then rotate them in every direction. This will be very confusing for people viewing the montage. Keep your photomontage design simple to make it understandable and enjoyable.

Did You Know?

When you have completed placing, sizing, and ordering all the images in a photomontage, you can easily add a shadow line to each photo to add depth to your work. Simply click each layer in the Layers panel and then click your choice of shadow from the Drop Shadows styles found in the Layer Styles panel.

Create a
PHOTOMONTAGE

Photomontage work is very similar to scrapbooking except that scrapbooking creates pages for a scrapbook. With scrapbooking, photos can go together for many reasons, plus you can use backgrounds to visually support the group. However, the process of creating a physical collage in this manner takes some skill and lots of time.

Photoshop Elements, on the other hand, helps you make excellent scrapbooking pages with the Photo Collage feature. This feature of the program offers many standard and easy-to-use options for photo

layout and backgrounds. Photoshop Elements resizes your photos to fit the page layouts, so you do not have to resize images first. You can, however, change the way Photoshop Elements sizes and places photos by moving them around and resizing them as needed. You can also add any additional images you want.

Scrapbooks make superb gifts. The next time that you need to give a gift, consider making a photo scrapbook, customized for the recipient using your photographs.

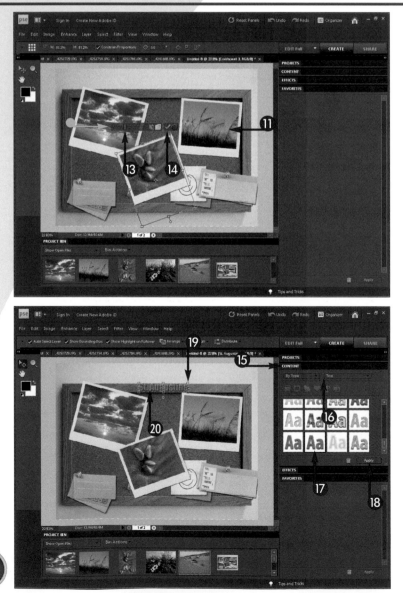

The photo design appears.

🔟 Press Ctrl or Cmd+0 to make the project fill the work area.

⓫ Click and drag photos into new positions.

⓬ Right-click a photo and select Position Photo in Frame from the menu.

● A sizing slider appears.

⓭ Click and drag the slider to change the size of the photo inside its frame.

⓮ Click the green check mark.

⓯ Double-click Content to open it.

⓰ Click these menus and select By Type and Text.

⓱ Double-click a text treatment and type your message.

⓲ Click Apply.

⓳ Click and drag the corners of the text area to resize it.

⓴ Click and drag your text into position.

You can also use your keyboard's arrow keys to move the text.

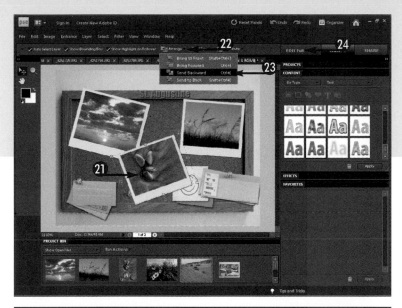

㉑ Click a photo.

㉒ Click Arrange to change how a photo overlaps others.

㉓ Choose to move the photo forward or backward.

㉔ Click Edit Full.

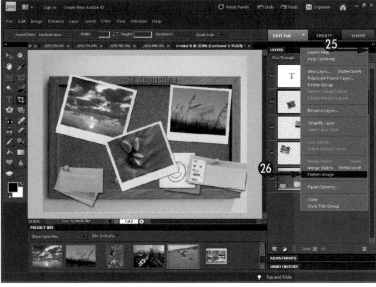

Your photomontage is ready for use.

㉕ Click the Layers panel menu button for its menu.

㉖ Click Flatten Image.

Flattening the image lets you save it as a TIFF or JPEG file that can be used in many ways.

Save the photo as a Photoshop file without flattening so that you can revise the card later by working with its layers.

TIPS

Did You Know?

You may find that with the Create panel you click something and nothing happens. This part of Photoshop Elements is highly RAM- and processor-intensive. That means it is stressing your computer to keep up. You have to be patient as the computer does its calculations in the background to do things such as moving a photo.

Did You Know?

Many scrapbookers like to use 12-x-12-inch pages, which is available in the Photo Collage page size panel, but to do that, you must have a printer capable of printing that size. Standard-size printers are 8.5x11 inches, which can be used with Photo Layouts when that size is selected in the wizard. The next-size-larger printer does up to 13-x-19-inch prints, which easily prints a 12-x-12-inch page.

Index

Index

Index

Index

Read Less-Learn More®

There's a Visual book
for every learning level...

Simplified®

The place to start if you're new to computers. Full color.

- Computers
- Creating Web Pages
- Digital Photography
- Internet
- Mac OS
- Office
- Windows

Teach Yourself VISUALLY™

Get beginning to intermediate-level training in a variety of topics. Full color.

- Access
- Bridge
- Chess
- Computers
- Crocheting
- Digital Photography
- Dog training
- Dreamweaver
- Excel
- Flash
- Golf
- Guitar
- Handspinning
- HTML
- iLife
- iPhoto
- Jewelry Making & Beading
- Knitting
- Mac OS
- Office
- Photoshop
- Photoshop Elements
- Piano
- Poker
- PowerPoint
- Quilting
- Scrapbooking
- Sewing
- Windows
- Wireless Networking
- Word

Top 100 Simplified® Tips & Tricks

Tips and techniques to take your skills beyond the basics. Full color.

- Digital Photography
- eBay
- Excel
- Google
- Internet
- Mac OS
- Office
- Photoshop
- Photoshop Elements
- PowerPoint
- Windows